Groundwork

**Diana Balmori
and Joel Sanders**

Groundwork

**Between Landscape
and Architecture**

The Monacelli Press

Topography

Ecology

Biocomputation

Library of Congress Cataloging-in-
Publication Data
Balmori, Diana.
Groundwork : between landscape and
architecture / Diana Balmori and Joel
Sanders. — 1st ed.
p. cm.
Includes bibliographical references.
ISBN 978-1-58093-313-1
1. Landscape architecture. 2. Architecture.
I. Sanders, Joel, date. II. Title. III. Title:
Between architecture and landscape.
SB472.B345 2011
712—dc22
2011011492

Printed in China

www.monacellipress.com

10 9 8 7 6 5 4 3 2 1
First edition

Project coordinator: David Sadighian

Designed by Pentagram

Acknowledgments

Many colleagues and students have been instrumental in helping us to shape the interdisciplinary design perspective that defines this book. Five Interface Design Studios at the Yale School of Architecture provided a venue to develop the central concept. We thank Dean Robert A. M. Stern for his generous support, and we acknowledge the contributions of our inventive students.

Our design offices helped us to put theory into practice and realize our goal of interdisciplinary collaboration. We thank Mark Thomann, Noemie Lafaurie-Debany, Sarah Wayland-Smith, and Kira Appelhans of Balmori Associates and Chris Kitterman, Martyn Weaver, Aniket Shahane, Jean Suh, Brian Kimura, and Serra Kiziltan of Joel Sanders, Architect.

We are grateful to the colleagues who helped us refine the ideas that inform the introductory essays for *Groundwork*. Joel Sanders acknowledges the support of the Arcus Foundation Scholar-in-Residence Program at Berkeley School of Architecture as well as assistance from Greig Crysler, Greg Castillo, Nicholas de Moncheaux, Marc Treib, and research assistant Ileana Acevedo. He also thanks Diana Fuss for her careful reading of his text. Diana Balmori recognizes colleagues at Dumbarton Oaks Garden and Landscape Studies, specifically Michel Conan, former director, and senior fellows Kenneth Helphand and Mark Laird. Thanks are also due to Elizabeth Segal and research assistant Ron Broadhurst.

Finally, we would like to acknowledge those who helped in the preparation of this book. Our editors at The Monacelli Press, Andrea Monfried, Elizabeth White, and Rebecca McNamara, provided us with insights and suggestions regarding texts and images. Michael Bierut and Yve Ludwig at Pentagram developed graphics that visually express the mingling of building and landscape. Noemie Lafaurie-Debany, Robert Kerchner, and Kevin Wei helped procure and format images. Most of all we would like to thank David Sadighian, our project coordinator. In addition to time-consuming image research, David played an instrumental role in shaping the editorial content of this book.

Preface

Diana Balmori and Joel Sanders

Many books about landscape romanticize nature as a universal palliative and bid designers to consult the "genius of place." This is not one of them. Instead it is an appeal to designers to pursue a new approach that overcomes the false dichotomy between architecture and landscape. Our interest in the union of these areas is motivated in part by urgent ecological concerns that we share with many of our colleagues (and indeed, many outside the design fields). An integrated practice of landscape and architecture could have dramatic environmental consequences: the disciplines would cease to have separate agendas and would instead allow for buildings and landscapes to perform as linked interactive systems that heal the environment.

Beyond any ecological agenda, what truly excites us about architecture and landscape joining forces is that it promises to be a catalyst for creativity. For too long, and with only rare exceptions, buildings in the West have been conceived as isolated objects that float in naturalistic landscapes. Inverting the relationship—that is, considering buildings and landscape as reciprocal entities—instigates the invention of an innovative landscape/architecture design vocabulary that reconciles this longstanding division and taps into the formal and programmatic potential of sustainable design principles. The organic and the synthetic are transformed into fields of

differing intensities rather than opposites that belong exclusively to landscapes or buildings. As a consequence, designers are encouraged to pay particular attention to the seam, or overlap, where indoors and outdoors meet. A critical awareness of the fluid connection between natural and synthetic, exterior and interior space, motivates designers to think of form and materials in entirely new ways: materials become the connective tissue that enacts the passage between landscape and architecture. Exploring the overlaps can generate new ways of thinking not only about form but also about program, positioning human activities in a way that coincides with twenty-first-century notions of what it means to live with nature. It is this design approach—we call it Interface—that has inspired this book.

While our preoccupation with the union of landscape and architecture initially stemmed from our own teaching and practice, many other architects and landscape architects have been reconsidering the relationship between landscape and architecture over the past decade. While the various perspectives are different—from our views and from each other—and the scales diverge greatly, we all share an interest in dissolving traditional distinctions between building and environment. *Groundwork* identifies three design directions that unite this otherwise heterogeneous group: Topographic designers reject the Western paradigm of the object building that discretely sits on the land, instead creating projects that manipulate the ground to effectively merge building and landscape. Built form is treated as synthetic inhabitable topography. Ecologic designers, who work at multiple scales—from the surfaces of buildings to the plans of cities and parks— develop environments that address issues such as energy, climate, and remediation. Finally, Biocomputation designers represent a generation of digital practitioners who employ modeling systems derived from biology to create structures that emulate the performance of living organisms.

Although the projects in this book signal a disciplinary shift that is transforming the nature of contemporary practice, it is important to recognize that there is nothing entirely new under the sun; each of these

trends has emerged out of its own particular history. Various pioneering projects have paved the way for many of the novel schemes illustrated in this volume.

But history has held designers back at the same moment that it has propelled them forward. The overall objective of *Groundwork*—the promotion of inventive modes of interdisciplinary practice—can be achieved only by first understanding and then transcending the deep-rooted cultural, ideological, and area-related prejudices that have determined contemporary circumstances. Accordingly, the introductory section of this book consists of two essays that frame the alliances between landscape and architecture (or lack thereof) within a broader historical context, looking at the field from the nineteenth century until today.

In "Human/Nature: Wilderness and the Landscape/Architecture Divide," Joel Sanders explains why these two spheres have been segregated in the United States at least since the nineteenth century. The ideological roots of the architecture/landscape divide may be traced to wilderness values, which oppose nature and culture, human and non-human—dualisms deeply rooted in Western literature, philosophy, popular culture, and even gender and sexuality. These values have informed the design approaches and codes of professional conduct that shaped the development of landscape architecture from the 1850s to the 1960s. The dualistic mentality spawned an uncritical faith in science and a suspicion of design that haunts the design professions to this day.

Diana Balmori's essay, "Across the Divide: Between Nature and Culture," delves into the new concept of nature that emerged in the 1960s along with two of the great cultural changes of the period: the appearance and dissemination of ecological concepts and the development and application of computer technology to design. From the 1960s to the present, these two forces have evolved notably: ecology has become a philosophy and a science; computer technology, a versatile and creative tool of design able to convert scientific principles into parameters for design.

Erwin Panofsky has said that when work on certain artistic problems
has advanced so far that further study proceeding from the same premises
appears unlikely to bear fruit, the result is often a great recoil or change
of direction. Such shifts, says Panofsky, are associated with a transfer of
artistic leadership to a new country, or a new domain. Architecture, painting,
and sculpture have each, at different times, taken on the role of the mother
art that speaks for all. But the paradigm of a single disciplinary leader is
outmoded given the complex problems posed by our interconnected global
world. Now is the moment for landscape *and* architecture, natural science
and ecology, engineering *and* computation to share this role, seeking a new
formal vocabulary derived from living or geomorphic processes.

As the design professions and their allied fields work together to
explore the potential of natural forms and processes to generate a new
design vocabulary, landscape architects and architects need to adopt a
more inclusive conception of the physical world. Rather than oppose space
and matter, and as a consequence architecture and landscape, design-
ers need to see them as an accumulation of independent processes as
complex as any machine or, indeed, any creature. This awareness of the
environment as a complex system puts architecture and landscape on
equivalent terms and will encourage practitioners to create designs that
approach the efficiency and performance standards of a living being.

Human/Nature: Wilderness and the Landscape/ Architecture Divide

Joel Sanders

The global environmental crisis underscores the imperative for design professionals—architects and landscape architects—to join forces to create integrated designs to address ecological issues. But longstanding disciplinary divisions frustrate this crucial endeavor; at least since the late nineteenth century, architecture and landscape architecture have been professionally segregated. Constituted as independent fields, each has its own curriculum and licensing procedure; more often than not, landscape architects are hired to "decorate" freestanding buildings designed by architects.

The challenge of developing a new model of practice—one that is both formally and programmatically sophisticated and environmentally responsible—requires designers to examine how this impasse ever arose. It is imperative to understand the ideological roots of the architecture/ landscape divide in order to transcend it. The schism can be traced back to antiquity, to another deep-seated yet suspect Western polarity: the opposition between humans and nature and thus between buildings and landscapes. One version of the human/nature dualism finds its home in an influential body of thought that arose in nineteenth-century America, the concept of wilderness. The idea of wilderness is so engrained in the American conscience—through literature, philosophy, and even notions of gender and sexuality—that it has effectively shaped the design approaches and even codes of professional conduct that in many ways still define the relationship between architecture and landscape practice.

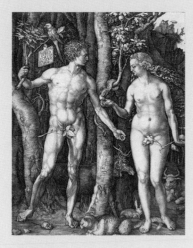

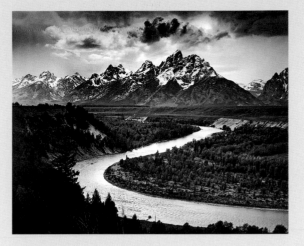

Albrecht Dürer, *Adam and Eve*, 1504

Ansel Adams, "The Tetons and the
Snake River, Grand Teton National
Park, Wyoming," 1942

Scholars have traced the intellectual origins of American environ-
mentalism to Henry David Thoreau, John Muir, and George Perkins Marsh,
American writers active in the second half of the nineteenth century
who advanced the concept of wilderness. Indebted to eighteenth-century
Enlightenment thinkers like Jean-Jacques Rousseau and Romantics like
William Wordsworth, this generation of writers celebrated the ethical and
spiritual benefits of living a life in unspoiled nature, uncontaminated by
America's burgeoning urban industrial civilization.[1]

This account of the relationship between humans and nature marks a
pronounced reversal in American thinking about landscape. Until the sec-
ond half of the nineteenth century, the settlement of the American frontier
was predicated on the Judeo-Christian belief that it was the responsibility
of humankind to cultivate the wilderness, traditionally perceived to be a des-
olate place located on the margins of civilization and associated with terror
and "bewilderment." Moses's forty-year exodus in the desert and Christ's
struggle with Satan in the wilderness are but two biblical examples that
shaped a much older conception of the wild in America: that it was a domain
fraught with moral and spiritual confusion that needed to be tamed by men.[2]

Such a consideration of wilderness perpetuated not only the old
human/nature divide but also engrained ideas about the nature of gender.
Relying on the longstanding personification of nature as a woman, femi-
nist critics like Carolyn Merchant have shown that the rhetoric underlying
the expansion and settlement of the American continent was founded on
biblical accounts of the expulsion from Eden, the fall brought about by a
woman. Wilderness was depicted as an unruly female to be subdued and
ultimately cultivated through the labor of men, whose goal was to recover
the paradise lost on earth. Ralph Waldo Emerson wrote: "This great sav-
age country should be furrowed by the plough, and combed by the harrow;
these rough Alleganies should know their master ... How much better
when the whole land is a garden, and the people have grown up in the bow-
ers of a paradise."[3] For feminists, this biblical injunction was reinforced by

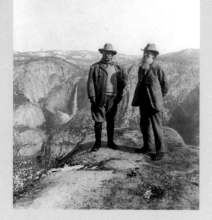

Theodore Roosevelt and John Muir on
Glacier Point, Yosemite Valley, 1903

yet another gendered Western dualism that opposed material and immate-
rial, mind and body: rationalist thinking, considered a male prerogative,
made possible the scientific revolution and a corresponding conception
of Mother Earth as a passive body subjected to male domination through
technology—a worldview that many ecofeminists argue persists today.[4]

But by the mid-nineteenth century, the American frontier had been
settled. Environmentalists like Thoreau, Muir, and Theodore Roosevelt
were confronted with an intimidating prospect not unlike that of today: the
disappearance of wilderness. This impending loss of the majestic scenery
of the American continent, which they believed surpassed even the man-
made monuments of Europe, threatened national identity. Fueled by a
surge in cultural nationalism and nostalgia for the rapidly vanishing frontier,
early environmental activism represented a remarkable shift in wilderness
thinking: the spiritual grounding of the young nation had come to depend on
the preservation of the natural landscape. As Thoreau wrote, "In Wildness
is the preservation of the World."[5]

By the turn of the twentieth century, the vanishing wilderness also
paralleled imperiled male masculinity. Associated with yet another authen-
tically American trait—rugged individualism—wilderness was regarded
as a source of masculine vigor and vitality. The home of the frontiersman
and the cowboy, wilderness represented a safe haven, a refuge where
men could resist the emasculating, domesticating forces of urban cul-
ture. Roosevelt famously championed the establishment of America's first
national parks because they countered "flabbiness and slothful ease" and
promoted "that vigorous manliness for the lack of which in a nation, as in
the individual, the possession of no other qualities can possibility atone."[6]
Ironically, this nostalgic image of the wild was advanced by an elite class
that reaped the benefits of the wealth generated by industrial capitalism
but found its privileges and authority eroded by cultural developments
including immigration and women's rights.[7] For wilderness champions like
Roosevelt and Muir, who both belonged to this moneyed class, nature, the

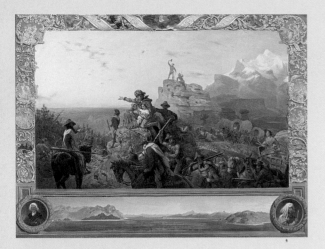

Emanuel Gottlieb Leutze,
*Westward the Course of Empire
Takes Its Way,* mural study,
U.S. Capitol, 1861

Marlboro advertisement

repository of threatened individual authenticity, was recast as a different kind of woman, not as venerable Mother Nature but as a defenseless virgin in desperate need of stewardship by red-blooded American males.

Today many still cling to the nostalgic American myth of unspoiled nature as a setting where the individual can actualize his or her authentic subjectivity, a prerogative traditionally accorded to men. First articulated by writers like Roosevelt and Muir in the nineteenth century, this notion has been disseminated in the twentieth and twenty-first centuries by means of popular culture. The classic Hollywood Western *Stagecoach,* made in 1939, presented John Wayne's angular profile against the backdrop of Monument Valley. Since the 1950s, wilderness has been a favorite setting for print advertisements and television commercials.[8]

Wilderness is no longer an exclusively straight male domain: today films and ads feature women as well men in the great outdoors, driving fast cars and scaling mountains. In a twist on the genre of the Western, 2005's *Brokeback Mountain* naturalizes the same-sex desire of its two leading male characters by setting them against a panoramic mountain range. While these media-manufactured images have become more inclusive, they are nevertheless updated versions of the nineteenth-century dualistic thinking that spawned them: contemporary media continues to generate escapist fantasies that represent untouched nature as the preserve of identity unconstrained by urban culture.

Not only did wilderness as expressed in literature and popular culture form the foundation of American environmentalist thinking, it also exerted a direct and profound influence on the subsequent development of two overlapping but increasingly diverging fields, architecture and landscape architecture. The dualistic conception of humanity and nature only rein-forced the longstanding Western conception of buildings as constructed artifacts qualitatively different from their ostensibly natural surround-ings. Ideologies shape not only design philosophies but also professional

conduct. If buildings were different from landscapes, then a new type of landscape professional was required to fill the gap and complement the work of architects. In 1899, a diverse group of gardeners, horticulturalists, and designers, under the leadership of Frederick Law Olmsted Jr., established a professional academy, the American Society of Landscape Architects (ASLA). Over the years, wilderness core values—valorization of pristine nature as the preserve of authentic individualism; an ambivalent relationship to culture, technology, and the built environment—have resurfaced in various guises, connecting the work of a first generation of nineteenth-century American landscape architects led by Olmsted, who were directly influenced by their wilderness peers, to three generations of twentieth-century modernist critics and landscape designers, including Henry-Russell Hitchcock, Garrett Eckbo, Charles Rose, and Ian McHarg. They even underlie the values of many designers working today.

Yet another undercurrent spawned from wilderness thinking connects this lineage of landscape practitioners. By positing that the human is entirely outside the natural, wilderness presents a fundamental paradox. The historian William Cronon writes, "If we allow ourselves to believe that nature, to be true, must also be wild, then our very presence in nature represents its fall. The place where we are is the place where nature is not."[9] Wilderness, then, presents designers with a particularly thorny dilemma: how to reconcile the ideal of untouched nature with the imprint of humans and human design. The guilty conscience fostered by this conundrum has haunted American landscape architects, and the dilemma was compounded by the negative connotations of designed nature: decoration, domesticity, and femininity. The result is a deep and persistent suspicion of designed nature that still endures.

The pioneering work of Frederick Law Olmsted, the founding father of American landscape architecture, is fraught with contradictions that betray the paradoxes at the heart of wilderness thinking. Unlike Muir, who turned his back on cities to find redemption in the pristine American

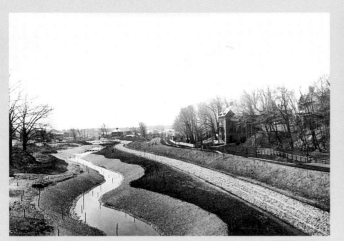
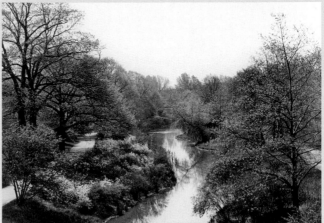

Frederick Law Olmsted,
Riverway, Boston, Massachusetts,
construction photographs

landscape, Olmsted fully embraced making nature accessible to urban
citizens. In his role as the leader of landscape architecture, Olmsted
sought to legitimate the emerging profession by differentiating it from
gardening, insisting that it was an art and not a trade. In a letter, Olmsted
wrote that he had personally elevated landscape architecture from "the
rank of a trade, even of a handicraft, to that of a profession—an Art, an Art
of Design."[10]

Nevertheless, Olmsted's conception of landscape architecture as design
proved inconsistent with the guiding premise of his aesthetic philosophy:
communion with nature depended on exposing people to a simulacrum of
natural scenery unspoiled by evidence of human intervention. Upholding
the notion of a nature/culture polarity, Olmsted conceived of Central Park
as a natural oasis inscribed within the dense metropolis, an oasis that
could offer the weary urbanite refuge from the industrial city through the
rejuvenating effects of the visual contemplation of nature. In a passage
that exemplifies yet another longstanding Western duality, the mind/body
split, he writes: "As what is well designed to nourish the body and enliven
the spirits through the stomach makes a dinner a dinner, so what is well
designed to recreate the mind from urban oppressions through the eye,
makes the Park the Park."[11] For Olmsted, Central Park was not a place for
active recreation, as it is today, but a place for visual observation. Renewal
was predicated on artifice achieved through carefully composed pastoral
views made by "screening incongruous objects" with a new dematerialized
"horizon line, composed, as much as possible, of verdure" that allowed
the viewer "to withdraw the mind to an indefinite distance from all objects
associated with the streets and walls of the city."[12]

In a later project, the Boston Riverway, Olmsted again grappled with
the ostensible incompatibility between nature and metropolitan design.
This massive urban park became America's first constructed wetlands.
Rather than employ a pastoral idiom inherited from the English school,
Olmsted introduced plantings that evoked the regional vegetation of

GROUNDWORK | HUMAN/NATURE

Yosemite, making the national park that he had helped to found in California accessible to ordinary Bostonians.

Although Central Park and the Riverway were massive infrastructural projects requiring advanced technology, engineering, and design, Olmsted disguised their constructed character by employing a pastoral vocabulary that viewers assumed to be natural. Even today, this default identification between nature and the conventions of the picturesque has become integral to landscape perception. Of Olmsted's double-edged legacy, Anne Whiston Spirn writes: "Olmsted was so skillful at concealing the artifice that both the projects he had so brilliantly constructed and the profession he had worked so hard to establish became largely invisible. Today the works of the profession of landscape architecture are often not 'seen,' not understood as having been designed and deliberately constructed, even when the landscape has been radically reshaped."[13]

At the outset of the twentieth century, Olmsted was the acknowledged leader of a growing new profession with the potential to guide the design of America's burgeoning metropolitan regions. Only thirty years later, however, a new generation of landscape architects had lost its way. Struggling to invent a robust landscape vocabulary that would complement the achievements of their architectural peers, this group found its efforts stymied by the supposed incompatibility of nature and design.

Many contemporary critics and architects bemoaned this professional vacuum. Fletcher Steele wrote, "What a modernistic garden may be is everybody's guess. The reason is that it does not yet exist as a type. We gardeners have always been behind other artists in adopting new ideas."[14] In *Gardens in the Modern Landscape,* one of the few books devoted to the subject, critic Christopher Tunnard confirmed this sentiment: "For the garden of today cannot be called contemporary in spirit, as can the modern movements in architecture, sculpture or painting. It is not of our time, but of the sentimental past; a body with no head and very little heart. Imagination is dead, romance a mere excuse for extravagance in decoration."[15]

The catalog for "Contemporary Landscape Architecture and Its Sources," an exhibition curated by Henry-Russell Hitchcock at the San Francisco Museum of Art (today the San Francisco Museum of Modern Art) in 1937, underscored the crisis surrounding the profession's inability to devise a compelling new modernist landscape vocabulary, a concern that would be echoed by landscape critics and designers for the next twenty-five years. The objective of this exhibition was to do for landscape what the Museum of Modern Art's 1932 "Modern Architecture—International Exhibition" had done for American architecture: legitimate a new movement by bringing together a range of projects that exemplified the tenets of a new school. But unlike the International Style exhibit, with its treasure trove of groundbreaking projects, the San Francisco exhibition organizers acknowledged that their exhibition checklist offered little in the way of stylistic coherence: "Extensive preliminary inquiry before the exhibition had taken form indicated that few definite principles of a contemporary style in landscape architecture had emerged from the diverse opinion held by eminent landscape architects. The exhibition will have served its purpose, if by illustrating diverse accomplishments and experiments in modern gardens, it demonstrates certain tendencies that appear to be fundamental, and directs attention to the general problem."[16]

In contrast to MoMA's persuasive demonstration of the capacity of modern architecture to shape a broad range of building types, from single-family residences to factories, the San Francisco curators narrowly defined the problem of the modern landscape as belonging to residential garden design. In the process, Hitchcock grafted principles from architecture to landscape architecture. Transferring modern architecture's famed prohibition against ornament to its sister discipline, he advocated that landscape designers renounce their propensity for decorative ornamental planting: "The most successful contemporary technique is neither embellishment nor 'improvement.'"[17] Conflating two design professionals—the interior decorator and the gardener—who he saw as threatening the

integrity of buildings by adorning them with applied ephemeral materials, Hitchcock cautioned against the use of flowers, writing that flower beds "serve primarily a decorative purpose, like curtains or upholstery indoors, subordinate to the useful general purpose of the terrace."[18] Hitchcock's prescriptive guidelines betray a deep-seated disciplinary prejudice that bifurcated nature and design. The exhibition itself perpetuated two mutually reinforcing perceptions: landscape professionals concerned themselves with trivial pursuits, like the decoration of residential properties for the idle rich; architects instead concerned themselves with essential human problems.

This identification of garden design with decoration tapped into deep-rooted disciplinary assumptions tinged by gender prejudices. Unlike architecture, a cerebral enterprise apprehended intellectually, gardens elicited visceral pleasures stimulated by the textures, colors, and scents of material Mother Nature. If in a strict modernist view all of landscape, whether cultivated or untamed, was considered an accessory to architecture, then gardens were even more inconsequential. As modernists repudiated ornament based on its association with feminine adornment, they also condemned decorative plantings, which they equated with womanly decoration, artifice, and masquerade.[19] While International Style architects focused on pressing social issues, landscape designers devoted their attention to the inconsequential and devalued domain of the female homemaker. In short, the discipline of landscape could redeem itself only by transcending its own tainted history as a superficial pastime affiliated with women. These prejudices were not exclusive to Hitchcock, but they would soon be reiterated by subsequent generations of landscape professionals, and though often unconscious, they are still pervasive today.

Ironically, while intended to elevate the low profile of the landscape profession, Hitchcock's exhibition upheld the preeminence of architecture by arguing that landscape designers extend architectural principles from indoors to outdoors: "Gardening on roof terraces and in close

conjunction with houses is not so much a separate art as a sort of outdoor architecture."[20] Imposing another key tenet of modern architecture on landscape—functionalism—he contends that designers must treat garden terraces as literal extensions of the interior, as "rooms that promote exterior functional activities." This passage outlines an approach to marrying modern buildings and landscapes that still dominates the profession today. He maintained that outdoor spaces immediately adjacent to the house should be treated architecturally, but those farther away from the building should be left intact: "The house with its living terraces forms a single formal unit, controlled by geometrical principles of design, set down on a well chosen site, otherwise almost completely untouched."[21]

This statement evokes the modernist paradigm of the "machine in the garden," a conception exemplified in such modern domestic masterpieces as the Villa Savoye and the Farnsworth House. These pre- and postwar icons conjure the image of the isolated building set in a pastoral setting, as found in seventeenth-century landscape paintings, as well as eighteenth- and nineteenth-century naturalistic gardens reconceived for the twentieth century. Le Corbusier described a version of this vision in "Precision": "I shall place this house on columns in a beautiful corner of the countryside … Grass will border the roads: nothing will be disturbed—neither the trees, the flowers, nor the flocks and herds. The dweller in these houses, drawn hence through love of the life of the countryside, will be able to see it maintained from their hanging gardens or from their ample windows. Their domestic lives will be set within a Virgilian dream."[22]

Le Corbusier's passage captures mainstream modernism's Romantic, hands-off vision of the landscape as well as its understanding of the key role that technology plays in negotiating the interplay between man-made and natural. The Savoye and the Farnsworth were conceived as suspended objects that through new technologies—the curtain wall and the steel frame—leave nature deceptively unspoiled. Architecture has appropriated a responsibility once shared with landscape design—the framed view.

Divorced from the ground plane, the elevated house allows detached spectators to observe carefully composed views of an ostensibly pristine landscape.[23] The technology that made possible this conception of nature as a spectacle for visual contemplation was deemed the domain of the architect, not the landscape architect. In this way, two unequally matched disciplines—modern architecture and modern landscape—together reinforced the nature/culture, mind/body dualisms, effectively confirming nature and architecture as fundamentally opposed entities.

But in a remarkable passage written just one year after the San Francisco exhibition, Christopher Tunnard unmasked the artistry behind the conceit of the modernist "utilitarian building in the garden": "One strives to create a contrast between the disciplined outlines of terrace walls, paved spaces, pools, etc. and luxuriant vegetation designed to produce a happy decorative effect and to give the impression that it is a work of nature or of chance."[24] He cautioned architects to resist the fiction of "the wild and beautiful countryside," which, he argued, led even trailblazing architects like Le Corbusier to disavow the inevitable and inextricable relationship between nature and art.

It was the responsibility of a next generation of American landscape architects—Garrett Eckbo and James Rose, classmates in the landscape architecture program at the Harvard Graduate School of Design when Gropius arrived in the 1930s—to find a way to reconcile the designed landscape with the nature/culture mentality underpinning modern architecture. Preoccupied with the burden of generating a viable direction for modernist landscape, they seemed stymied by a professional inferiority complex. Their writings in journals recount self-deprecating themes justified by the same ideological and gender prejudices espoused by Hitchcock, Fletcher Steele, and Tunnard. They share the conviction that their discipline's legacy of creating "pretty pictures" composed with ornamental plantings must be overturned by embracing modern architecture's core values. But formulating an approach grounded in science, technology, and human use

was easier said than done: the primordial nature of landscape seemed to
resist the application of new technologies and materials. In 1948, Brenda
Colvin wrote, "Architecture is dealing with completely new materials as
well as new needs, whereas the natural materials of landscape (land and
vegetation) and the *basic* human needs which landscape fulfills are age-
less. In garden design and in the wilder landscape, any conscious effort to
create a 'new style' will be sterile."[25] Borrowing terminology from modern
architecture, Eckbo and Rose attempted to prove the naysayers wrong
by espousing a structural or scientific approach that was muddled and
vague at best. Pragmatic design guidelines—the use of honest materials,
trees that were isolated rather than planted in traditional clumps, and plant
species suitable to local climates—never matched their lofty rhetoric of
marrying science and design.

These two landscape architects practiced in California. Allying them-
selves with a loosely defined California school of modernist landscape
designers like Thomas Church and Lawrence Halprin, they took advantage
of the West Coast's gentle climate and relaxed lifestyle to marry architec-
ture and landscape in a way that facilitated indoor/outdoor living. But these
practitioners had few role models in their own field. Instead the works of
architects like Frank Lloyd Wright, Rudolph Schindler, and Richard Neutra,
as well as the Case Study architects, represented a departure from the
prevailing conception of architecture as a self-contained object building
with nature as a foil. These architects instigated indoor/outdoor continuity
via architectural means, extending materials and built elements—patios
and roof overhangs—from inside to outside. But what contribution could
landscape architects make to this initiative without resorting to a familiar
picturesque vocabulary?

Absorbing the influence of early modernist designers, including
Gabriel Guevrekian and Pierre-Emile Legrain, these resourceful designers
looked outside their discipline to fine art, particularly to landscape and to
Cubism and Surrealism. The outcome was a series of modest residential

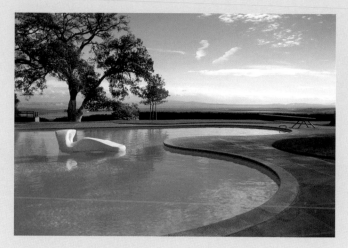

**Thomas Church, Donnell Garden,
Sonoma, California, 1948**

designs, widely published in popular regional periodicals like *Sunset* in
the late 1940s and the 1950s, that borrowed bold abstract forms and motifs
from a variety of modern art sources, including Theo van Doesburg, Joan
Miró, and Jean Arp. In projects like the Martin Garden (1948) and the Zwell
Garden (1950), Garrett Eckbo juxtaposed two signature modernist motifs,
the cubist zigzag and the biomorphic amoeba. Perhaps the most resolved
example of this approach is Thomas Church's Donnell Garden (1948),
whose dynamic composition combines zigzag stone walls, curved biomor-
phic planting beds, and a kidney-shaped pool.[26]

 But this fertile period of small-scale experimentation was short-lived.
Eckbo and Rose, like many of their postwar peers, gradually withdrew from
taking on the residential commissions that were the bread and butter of
many noted American landscape designers: Charles Platt, Warren Man-
ning, and Ruth Dean at the turn of the century and Thomas Church in the
1950s. Small-scale residential projects came to be regarded as the domain
of the amateur female homemaker, not the trained professional, due in
part to the emergence of mass-market publications like *House Beautiful*.[27]
Instead, taking advantage of a burgeoning postwar economy, Eckbo and
Rose shifted their focus to large-scale commissions like university cam-
puses, corporate office parks, and suburban subdivisions. Modeling their
practices on such architectural entities as HOK and SOM, Eckbo and his
colleagues joined the ranks of a generation of corporate landscape firms
that would dominate the profession for years to come. By the 1970s, the
ASLA awards reflected this shift: only five of two hundred awards went to
residences. But professional success came at a price. Eckbo acknowledged
the tensions between corporate practice and design: "When does such
an expansion divorce the professional more or less completely from the
design process and leave him as primarily an organizer, promoter, adminis-
trator, director, critic and contact man?"[28]

 For the most part, the early experiments of postwar Californians in
attempting to bridge functionalism and abstraction in residential work are

largely overlooked today. And when they are studied, critics tend to dismiss them as superficial appropriations of Cubist and Surrealist clichés that are graphic, not spatial. Although at times awkward and unresolved, these works nevertheless stand out as exceptional and noteworthy examples of the ongoing struggle to invent a viable alternative to naturalism, a compelling form language that can reconcile nature, humans, technology, and design.

Another postwar practitioner, Ian McHarg, also preferred to think big. Like Olmsted, he worked at a scale even larger than that of his corporate peers. He often partnered with state and federal agencies as he tackled the infrastructural challenges of formulating ecologically minded master plans that could transform entire metropolitan regions. A charismatic professor and self-promoting public intellectual who disseminated his ideas through print and television, McHarg outlined his ecological approach in *Design with Nature,* a book that grappled with an Olmstedian ambivalence about the role design plays in reshaping urban environments. For McHarg, writing in 1969, Olmsted's worst predictions had been realized—rapacious capitalism aided by remarkable technological advances had tipped the precarious balance between nature and civilization, resulting in environmental casualties in America's polluted, slum-ridden cities. McHarg compared city dwellers to "patients in mental hospitals" consigned to live in "God's Junkyard."[29]

McHarg's diagnosis of the problem extended beyond the confines of the design disciplines, encompassing history, philosophy, and ideology. Using sweeping rhetoric that in many ways anticipated the anthropocentric critique launched by contemporary ecofeminists and deep ecologists, McHarg located the roots of the environmental crisis in misplaced Western values that he traced back to the Bible's "raucous anthropocentrism which insists upon the exclusive divinity of man, his role of domination and subjugation."[30] According to McHarg, greedy, profit-driven capitalists aided by new technologies reinforced centuries-old Judeo-Christian values by treating nature as a mere commodity.

Like Olmsted, McHarg aspired to redeem what had become America's sprawling and decaying metropolitan regions. But how? For McHarg, landscape architecture had little to teach. He attacked his profession along the lines advanced by Steele, Tunnard, and Rose. In a chapter titled "On Values," he restated a recurring disciplinary debate that pitted the French Formal school against the English Naturalist approach. McHarg dismissed the achievements of André Le Nôtre by enlisting a familiar argument tinged with gender prejudices: he deplores the "ornamental quality of plants" used to impose order on a "submissive," "flat and docile landscape." Instead, McHarg praised the English tradition as a precursor of his own ecological approach: "Nature itself produced the aesthetic," and the English practice "applied ecology as the basis for function and aesthetics in landscape."[31]

As the title *Design with Nature* attests, McHarg also wrestled with the issue of reconciling nature and design. But McHarg pursued a different course from Olmsted, who smoothed over the paradox of constructing nature by concealing art, engineering, and infrastructure with a design vocabulary that appears to be natural. Likewise, he departed from modernists like Tunnard, Steele, Church, Eckbo, and Rose, who strived to wed functionalist precepts to abstract form-making derived from the fine arts. Instead, McHarg turned to the natural sciences. Not really interested in new materials or technologies, he nevertheless shared the preoccupations of contemporaries like Buckminster Fuller and Frei Otto who, following in the footsteps of nineteenth-century designers like Viollet-le-Duc, Ernst Haeckel, and René Binet, were interested in the underlying laws of form generation in nature. Natural scientists were for McHarg what engineers were for Le Corbusier. "Consequently the astronomer and geologist, the plant and animal morphologist are just as concerned and competent in the business of meaningful form as the painter," he wrote.[32] In a quasi-functionalist argument reminiscent of Corbusier's *Towards a New Architecture,* he advises designers to study and emulate the morphology

of plants and animals, not human works of engineering.[33] By identifying the natural sciences as a bridge between the constructed and the natural, McHarg made a more convincing claim for the integration of science and design than his functionalism-inspired predecessors. No longer specific to architecture, science became the legitimate purview of the landscape architect who, guided by ecological principles, was now capable of generating seemingly inevitable designs grounded in the logic of science that integrated the built and the natural without resorting to art. He wrote, "I conceive of non-ecological design as either capricious, arbitrary, or idiosyncratic, and it is certainly irrelevant. Non-ecological design and planning disdains reason and emphasizes intuition. It is anti-scientific by assertion."[34]

McHarg pioneered an ecological methodology that encouraged designers to consider a range of interconnected environmental factors—climate, water, flora, and fauna; this system is still immensely influential today. Nevertheless, his comprehensive regional proposals, generated through a process-oriented approach grounded in the supposedly objective logic of the natural sciences, largely evaded design. His master plans were too large, conceptual, and abstract to engage issues of form, space, materials, and the human body in the way traditional garden designs once did.

While McHarg's design approach coincided with and reflected the process-oriented, ecological values that dominated the late 1960s and the 1970s, his philosophy nevertheless betrays the same struggle to come to terms with the supposed incompatibility of nature and design that preoccupied two generations of American landscape designers before him. McHarg revisited many wilderness-inflected themes inherited from his predecessors: a dualist way of thinking that views nature as a passive, vulnerable entity that must be protected from the predatory interests of humans, including architects; a professional bias against designed nature, which he dismisses as a frivolous pursuit affiliated with residential gardening, decoration, and

feminine artifice; a preference for large-scale problem solving based on a deterministic design approach justified by science.

One of the consequences of this way of thinking is a mistrust of the designed environment, a legacy that continues to haunt professionals. Aspects of this mentality can be detected in the work of some of today's most progressive practitioners, many of them students of McHarg. Setting their sights on large-scale infrastructure rather than medium- or small-scale commissions, they are apt to generate ambitious abstract proposals that map a methodology largely indifferent to formal factors.

The core values associated with wilderness thinking—in particular, its dualistic disciplinary worldview and its preference of science over aesthetics—also inform mainstream professional design practice, strongly shaping the parameters of green design today. In the first decade of the twenty-first century, two types of design professionals—architects and landscape architects—and two sectors of the construction industry—builders and landscapers—have developed parallel strategies for making buildings and landscapes more sustainable. For the most part, style alone differentiates high-design approaches from market-driven directions. Products and materials are generally designed to replicate the environmentally irresponsible ones they replace: solar panels are attached to sloped or flat roofs, renewable materials clad the interior and exterior of conventional buildings, and organic fertilizers and indigenous plantings are eco-friendlier ways to make the acres of traditional lawn and shrubs that adorn buildings conceived as isolated objects. When innovation in green design takes place, it is generally architects, not landscape architects, who take the lead, employing such formally expressive solutions as rain screens and double-layered louvered skins; landscape designers tend to favor more understated solutions. This bifurcated approach mirrors and perpetuates the design professions' ambivalence about the relationship between technology and nature since the nineteenth century: the former is embraced as long as it leaves no visible trace upon the latter.

In short, green design fosters a product-oriented mentality that generally evaluates materials and techniques on the basis of performance and efficiency, rarely taking into consideration issues of form and program. Moreover, by taking disciplinary divisions for granted, sustainable design unwittingly reinforces one root of the problem: the dualistic paradigm of the building as a discrete object spatially, socially, and ecologically divorced from its site. As a consequence, this American ideal—itself derived from wilderness thinking—inhibits designers and manufacturers from treating buildings and landscapes holistically as reciprocal systems that together impact the environment.

Might it be possible to jettison this outmoded and environmentally detrimental paradigm and instead reimagine buildings and landscapes as mutually interactive entities that effortlessly incorporate sustainable materials and techniques? What would it take to foster a new, formally progressive, integrated approach to sustainable landscape and architecture, one mandated not only to conserve resources but also to sponsor new forms of interaction among people in social space?

Designers must radically readjust their ways of thinking and working. First, wilderness values, the unexamined foundation that still shapes the perception of what it means for people to live with nature, must be called into question. The polarizing mentality that pits humans against nature continues to pervade mainstream environmentalist thinking, at least as it is transmitted by the media. Consider the Hollywood blockbuster *Avatar:* this ecological parable depicts greedy capitalists who threaten to exploit the natural resources of Pandora, an Eden-like planet occupied by gentle natives capable of spiritual communion with plants and animals.

Relinquishing wilderness values will allow designers to adopt the more complicated viewpoint advanced by progressive scholars and scientists: a recognition that nature and civilization, although not the same, have always been intertwined and are becoming more so. Climate change reveals that there is not a square inch of the planet that does not in some way bear the

imprint of humans. Landscape and culture intermix in various combinations; while constructed elements are more common in urban areas and natural elements predominate in rural zones, organic and synthetic operate as a gradient of differing intensities that forms a continuum across the surface of the earth.

It is important to adopt a more complex understanding of the relationship between nature, science, and technology. Designers need not demonize technology as an agent of destruction deployed by avaricious commercial interests, as many ecofeminists and deep ecologists are prone to do. Nor should they uncritically embrace science as a solution to pressing environmental problems. Cultural critics like Donna Haraway and Katherine Hayles have demonstrated that nature is not an a priori fact but a historical fiction that reflects changing social values and ideologies; science has played a central role in inventing and perpetuating narratives about nature that are taken as objective truths.[35] Common ground must be sought between technophobia and technophilia. Environmental problems can be resolved only by considering nature as both a scientific and a cultural phenomenon. Realigning deep-rooted preconceptions and conceiving of culture and nature, and as a consequence buildings and landscapes, as deeply interconnected entities will allow designers to transcend the architecture/landscape divide and usher in a new model of integrated practice, a way of working that reunites two fields of inquiry that should never have been divided.

Since 2000, a new way of thinking and working has been gaining momentum. A wide range of international architects and landscape architects—many of them included in this volume—are creating provocative projects that register this more nuanced understanding of the complex interplay between humans, nature, and technology. As these practitioners call into question the contested boundary between buildings and landscapes, they remain open to yet critical of technology. On one hand, they mine the formal and programmatic potential of sustainability. In the

same way that a first generation of modern architects harnessed newly invented materials like plate glass and the steel frame to generate a building language adapted to modern life, these designers recognize the potential of advances in green materials and techniques to instigate the development of a truly innovative design vocabulary. But on the other hand, these contemporary designers part ways with their modernist forbears: rejecting modernism's often unqualified faith in technology and its general indifference to the designed landscape, they have spurned the paradigm of buildings as constructed artifacts floating in a predictably naturalistic landscape and instead freely invent hybrid landscape/architecture solutions that effectively mingle natural and synthetic. *Groundwork* champions this new breed of cross-disciplinary pioneer that recognizes that combining technological, formal, and programmatic innovation will lead to the creation of high-performance environments suited to twenty-first-century life.

1. For a classic study of the origin of the American wilderness concept, see Roderick Frazier Nash, *Wilderness and the American Mind* (New Haven: Yale University Press, 1967).

2. William Cronon, "The Trouble with Wilderness; or Getting Back to the Wrong Nature," *Uncommon Ground: Toward Reinventing Nature* (New York: W. W. Norton, 1995), 70–71.

3. Ralph Waldo Emerson, "The Young American," *Dial* 4 (1844): 489, 491, as cited in Carolyn Merchant, "Reinventing Eden: Western Culture as a Recovery Narrative," in Cronon, *Uncommon Ground,* 142.

4. For two influential feminist accounts of the intertwined relationship between nature, science, capitalism, and gender, see Carolyn Merchant, *The Death of Nature: Women, Ecology and the Scientific Revolution* (New York: Harper Collins, 1980) and Val Plumwood, *Feminism and the Mastery of Nature* (London: Routledge, 1993).

5. Henry David Thoreau, "Walking," *The Works of Thoreau,* ed. Henry S. Canby (Boston: Houghton Mifflin, 1937), 672, as cited in Cronon, "Trouble with Wilderness," 69.

6. Theodore Roosevelt, "The Strenuous Life," in *The Winning of the West, The Works of Theodore Roosevelt*, as cited in Roderick Frazier Nash, *Wilderness*, 150.

7. For both William Cronon and Donna Haraway, wilderness—represented as the American frontier or the African jungle—served as an antidote to the emasculating effects of American industrialism for an elite class of industrial capitalists who paradoxically believed they needed to escape its debilitating effects. For an account relating the meticulously crafted taxidermy of the African dioramas at the American Museum of Natural History to a spectacle of nature designed to compensate for a threatened white privileged masculinity, see Donna Haraway, "Teddy Bear Patriarchy," in *Primate Visions: Gender, Race, and Nature in the World*

of Modern Science (New York: Routledge, 1989). For a discussion of how America's wealthy citizens sought refuge in the first wilderness tourist retreats, see William Cronon, "Trouble With Wilderness," 78.

8. For a discussion of the way media disseminates images of rural masculinity, see Hugh Campbell, Michael Mayerfeld Bell, and Margaret Finney, "Masculinity and Rural Life: An Introduction," in *Country Boys: Masculinity and Rural Life* (University Park: Pennsylvania State University Press, 2006).

9. Cronon, "Trouble With Wilderness," 80–81.

10. Frederick Law Olmsted to Mrs. William Dwight Whitney, December 16, 1890, as cited in Laura Wood Roper, *FLO: A Biography of Frederick Law Olmsted* (Baltimore: Johns Hopkins University Press, 1973), 447, as cited in Catherine Howett, "Modernism and American Landscape Architecture," in Marc Treib, *Modern Landscape Architecture: A Critical Review* (Cambridge, Mass.: MIT Press, 1993), 19.

11. Frederick Law Olmsted "A Review of Recent Changes, and Changes which Have Been Projected, in the Plans of Central Park," reprinted in *American Earth: Environmental Writing Since Thoreau*, ed. Bill McKibben (New York: Library of America, 2008), 125.

12. Olmsted, "Review of Recent Changes," 124.

13. Anne Whiston Spirn, "Constructing Nature: The Legacy of Frederick Law Olmsted," in Cronon, *Uncommon Ground,* 91.

14. Fletcher Steele, "New Pioneering in Garden Design," *Landscape Architecture* 20, no. 3; reprinted in Treib, *Modern Landscape Architecture,* 110.

15. Christopher Tunnard, *Gardens in the Modern Landscape* (London: Architectural Press, 1938), 126.

16. Henry-Russell Hitchcock, *Contemporary Landscape Architecture and Its Sources* (exhibition catalog, San Francisco: San Francisco Museum of Art, 1937), 13.

17. Hitchcock, *Contemporary Landscape Architecture,* 15.

18. Hitchcock, *Contemporary Landscape Architecture,* 19.

19. For a discussion of the way modern architects justified a prohibition against the decorated interior by comparing it to the presumed artifice of the adorned female, see my essay "Curtain Wars: Architects, Decorators, and the 20th Century Interior," in *Harvard Design Magazine* 16 (winter/spring 2002), reprinted in *Joel Sanders: Writings and Projects* (New York: The Monacelli Press, 2004).

20. Hitchcock, *Contemporary Landscape Architecture,* 15.

21. Hitchcock, *Contemporary Landscape Architecture*, 17.

22. Tunnard, *Gardens in the Modern Landscape,* 78.

23. In his exhibition catalog, Hitchcock repeatedly describes buildings as viewing apparatuses that transform the landscape into "pictorial" compositions. He advocates thinning out existing trees that obscure distant views so that the trees can function "like a window in a wall, a means of providing a view of what lies beyond" and using screen walls with "glazed or unglazed openings through which the landscape appears like a framed picture." See *Contemporary Landscape Architecture,* 15, 18.

24. Tunnard, *Gardens in the Modern Landscape,* 77.

25. Brenda Colvin, *Land and Landscape* (London: John Murray, 1948), 62, as cited in Treib, *Modern Landscape Architecture,* 55.

26. For a discussion of the influences of modernist fine arts on landscape designers see Marc Treib, "Axioms for a Modern Landscape Architecture," in Treib, *Modern Landscape Architecture.*

27. Dianne Harris, "Making Your Private World: Modern Landscape Architecture and *The House Beautiful*, 1945–1965," in *The Architecture of Landscape 1940–1960*, ed. Marc Treib (Philadelphia: University of Pennsylvania Press, 2002).

28. Melanie Simo, *100 Years of Landscape Architecture: Some Patterns of a Century* (Washington, D.C.: Spacemaker Press, 1999).

29. Ian McHarg, *Design with Nature* (1969; reprint ed., New York: John Wiley, 1991, 1995), 20, 23.

30. McHarg, *Design with Nature,* 29.

31. McHarg, *Design with Nature,* 71, 73.

32. McHarg, *Design with Nature,* 165.

33. McHarg, *Design with Nature,* 170.

34. Ian McHarg, "Ecology and Design," in *Ecological Design and Planning,* ed. George S. Thompson and Frederick R. Steiner (New York: John Wiley & Sons, 1997), 321, as cited in Anne Whiston Spirn, "The Authority of Nature: Conflict and Confusion in Landscape Architecture," in *Nature and Ideology,* ed. Joachim Wolschke-Bulmahn (Washington, D.C.: Dumbarton Oaks, 1997).

35. For discussions of how science crafts cultural narratives about nature, see Donna Haraway, "A Manifesto for Cyborgs: Science, Technology, and Socialist Feminism in the 1980s," *Socialist Review* 15 (March–April 1985), and N. Katherine Hayles, "Toward Embodied Virtuality," in *How We Became Posthuman: Virtual Bodies in Cybernetics, Literature and Informatics* (Chicago: University of Chicago Press, 1999).

Across the Divide: Between Nature and Culture

Diana Balmori

I have often used a thick line to represent the interface between architecture and landscape: a tangible spatial unit between a building and its surroundings, a line that is wide and varied and that changes in thickness and intensity, vanishing at times, densifying at others. This thickened irregular juncture between landscape and architecture comes from erasing the clearly defined, continuous line of separation drawn by the modern movement. It entails considering the site and the building as a continuum, each modifying and being modified by the other to different degrees.

Groundwork looks at the ways in which design strategies in between landscape and architecture are shaping their respective fields. Joel Sanders and I were drawn to this topic by our own interest in designing across the two fields. But our exploration reflects design currents now at work in both disciplines. The grouping of these strategies into categories—Topography, Ecology, and Biocomputation—is one way of ordering the direction they have taken. Yet the strategies do not always fit neatly into a single category: some belong in more than one category, and others occupy a blurry area in between. In such cases, that is precisely where the significance lies.

What is perhaps most important about the connections between landscape and architecture is that they inspire optimism about the general direction of design today, for two reasons. First, an examination of these connections focuses on a view of nature that is inclusive: everything on the planet exists within it. Second, the renewed search (renewed, that is, since

Diana Balmori, *Thick Line*

the collapse of the modern movement's credo) for something on which to
base form focuses on life and the behavior of living things. Why wouldn't
this inspire optimism?[1]

Interface

The connections between landscape and architecture, and by extension,
between nature and culture, respond to what has happened in the design
disciplines in the twentieth century. The early twentieth century was a
heroic moment in which architecture tore itself away from everything.
Sculpture, painting, landscape—all were cut off from architecture's tectonic
self. An abstracted, clearer, objectified discipline emerged. Of the other
arts, only painting truly entered the modern movement. (Sculpture did so
to some extent, much later, veering away from representation.) Landscape
went into a long sleep, with occasional attempts to become "modern," aping
architecture. This reinvention of architecture was a colossal and brutal
disconnection. Landscape architects today work in the opposite direction,
seeking reconnection, and therefore giving rise to a concentration on an
aesthetic interface.

The concept of interface between landscape and architecture extends
also to landscape and urban design. In the nineteenth century, parks
were inserted into crowded, dirty, dangerous cities as palliatives. Though
regarded as pinnacles of design, parks sent an anti-urban message: this
landscape is here to help inhabitants survive the city. Contemporary urban
design has given landscape a new role. It is no longer about making parks,
or greening cities, or embedding nature in the city; it is about embedding
the city in nature. Above all, urban landscape architecture is about creating
a different relationship between landscape and its elements (water, earth,
air) and the city. This effort entails viewing cities in a new way, a way that
is not addressed by the typical master plan, an urban design of street lay-
outs and building clusters, or a program mix that maximizes the return per
square foot (though these can all be included).

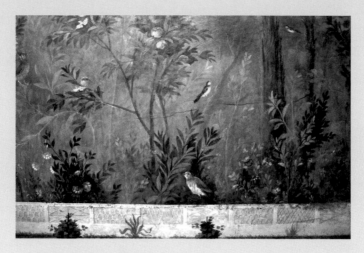

Second-style wall painting from the Villa of Livia, Prima Porta, c. 30–20 BCE

To embed the city in nature means paying attention to its specific parts (such as roads and roofs) and using engineered systems that work like natural systems to balance human needs with the city's geology and its water, its air, its flora and fauna. The interface between landscape and urban design is thus forged by putting the city in nature. Landscape has become the discipline best prepared to transform the city into a life-giving environment. And landscape combined with architecture can help people develop a new compact with nature. A vital component of this new blend is education: people must learn to be actively engaged with their transformed space.

The idea of interface extends to the juncture between nature and culture. Since the eighteenth century, cultural traditions have ignored the effect of humankind on nature or, more precisely, on the rest of the environment. A dramatic change in that relationship needs to be fostered, and the connection between landscape and architecture needs to make the new relationship between society and the complex nature of the ecosystem clearly visible. This means inventing an aesthetic language for that connection.

Pioneers of Connectivity

Connections between landscape and architecture have existed at various moments in the past. Yet the linearity of time brings about an intellectual quandary: a historical outlook on the moments when landscape and architecture were linked can imply a false continuity. Instead, markedly different approaches at various times attempted radically dissimilar types of connection. Each requires an exploration of cultural meanings and intentions and decodes a word considered the most complex in the English language: nature.

The courtyards of urban Roman houses of the second century CE were closed on all four sides. Roman country villas of the time were open on one side to the surrounding landscape; the three walls of the courtyard

Marc-Antoine Laugier, frontispiece to *Essai sur l'Architecture*, 1753

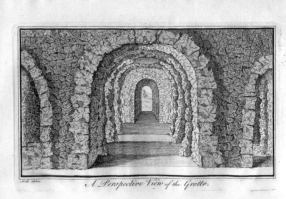

Alexander Pope's grotto, engraving

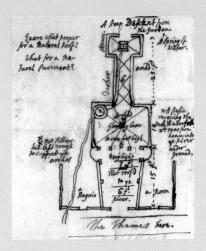

Alexander Pope's grotto, plan, 1740

were painted with frescoes depicting landscapes, plants, and animal life.[2] The seventeenth-century landscape paintings of Lorrain and Poussin were copied by landscape designers and then executed as three-dimensional landscapes: at that time, the word *landscape* meant a landscape painting rather than landscape itself. These paintings played a role in deformalizing the landscape, making it more "natural" in the terms of its era. Buildings were "naturalized"—presented as ruins covered with vegetation, subjected to the effects of time so that they fused with living things.

In the eighteenth century, Laugier's powerful image of columns emerging from the trunks of trees to form a primitive dwelling shows yet another understanding of this connection. And Alexander Pope's eighteenth-century villa was one of the first experiments in connecting a classical building to a landscape that was not organized on classical principles. Pope, poet and garden designer, dealt with the disjunction by building a grotto in a tunnel that led to his garden. The many-roomed grotto presented itself not as an architectural object but as a cave submerged in the earth—a location that highlighted its position between architecture and nature. Furthermore, he shaped the grotto to represent a naturally occurring geological formation. Advised by William Borlase, a Cornwall geologist, Pope made a point of using minerals common to the lead mines of that area. His grotto is not pure artifice; rather, he said, its purpose was to expose the riches of nature, whose formation is independent of human art.[3]

Nature

The most definitive discontinuity between present efforts to create connections between landscape and architecture and any of these past attempts lies in the concept of nature itself. The challenge in addressing present-day associations of nature is that this complex word keeps changing its meaning. The "nature" of the current moment is not that of the first half of the twentieth century, nor that of the nineteenth, nor that of the seventeenth.

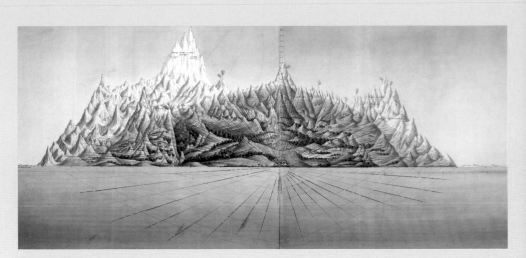

Joseph Paringer, *Worldwide Distribution of Organic Nature,* lithograph after Ferdinand August von Ritgen and Johann Bernhard Willbrand, 1821

In the nineteenth century, there was a search for a single source in nature from which all other forms were generated. Artists, architects, and scientists such as Haeckel, Goethe, Schinkel, Semper, von Humboldt, Viollet-le-Duc, and Ruskin participated in that search. Haeckel, the German marine biologist who in 1879 was the first to speak of an ecosystem, also produced the myriad of images of radiolarians that awed the aesthetic establishment; for a short time, they were considered the key to discovering that single natural source.

Beginning in the 1960s, however, nature ceased to be viewed as monistic, and the idea that there is a single source for all its forms and parts was abandoned. Instead of Haeckel's belief in a fundamental unity is an understanding of nature as basically heterogeneous and constantly changing. This contemporary view has been expressed by French biologist François Jacob. He presents a picture of biological evolution as a sort of molecular *bricolage*, which "transforms an ancient system to give it a new function ... Living things are in fact historic structures, they are literally the creation of history."[4]

Thus, if the eighteenth century tried to imitate nature in its physical aspect, by painting a landscape (or constructing a landscape imitating a painted one), the twenty-first century is moving toward imitating the functions that have given rise to nature's forms rather than the forms themselves. A critical factor in this engagement is the realization that categories such as "artificial" and "natural," or "virtual" and "real," are fluid. Architecture and technology no longer occupy realms distinct from nature but now interact with nature; as a result, the distinctions between the organic and the technological have begun to dissolve.[5] New strategies include deploying technology to interface directly with natural processes and introducing natural processes into architecture. Thus, landscape accepts technology while architecture emulates natural processes.[6]

Haeckel's concept of ecosystem was more complex than one in which human beings were totally separate from nature. But that was not a commonly held view in 1879; indeed, until as recently as the 1960s, people

were seen as standing apart, outside of nature. Today, however, all are considered part of a single ecosystem; this view is no longer limited to intellectuals, artists, or scientists. And it will continue to change. The word *nature* is today being redefined in increasingly biological terms, focusing on living things and living systems. As a result of that shift, two fields are becoming crucial to a new alignment between humanity and a transformed nature: ecology and computation.

Ecology

One fallacy of contemporary notions of ecology—and indeed of nature and the natural—is that green or sustainable design atones for the alienation of human beings from the natural environment. On the contrary, sustainable design at its most conventional limits itself to a distinct set of quantifiable parameters and does not address the experiential relationship of its users to the natural world. Certain contemporary designs employ strategies that are far more effective at reconciling people to their natural surroundings. Such undertakings as R&Sie(n)'s Dust Project, which relies on experimental technologies, merge landscape, architecture, technology, and art to engage users with their environment in new ways.[7]

Nonetheless, a debt is owed to the pioneers of the green movement, which can be said to have begun in earnest in the 1960s with what was then termed the ecological movement. The publication of Rachel Carson's *Silent Spring*, in 1962, is often credited as the beginning of contemporary environmentalism. Seven years later, Ian McHarg published *Design with Nature*, a volume that would prove influential within the landscape and urban design professions.[8] Later, nascent Earth Day celebrations and the advent of the oil crisis of the early 1970s established a platform for the expansion of a movement that over the course of forty years would result in the mainstream, consumer-oriented interest in environmental sustainability seen today.[9] One consequence of this popular interest is the seeking out of both forms and organizing principles of living things as sources for design.

Computation

A legacy of the Industrial Revolution is a skepticism toward technological fixes and a lack of faith in being able to solve any major world problem through them. Nothing shows this more than the lack of any agreement on how to deal with climate change; this is a major failure on all levels that cannot be overcome by technology since sociopolitical issues dominate. But on a smaller scale the present era represents a moment in which technology—and in particular, bioengineering—is a critical tool that can emulate nature's functions in a way that is less damaging to its parts. By establishing parameters that imitate natural functions, which in the process can give rise to new forms, biocomputation is one of the ways that architecture and landscape, nature and culture, are interfacing.

The public reaction to the introduction of computer-generated forms in unfamiliar materials has been negative (though this is beginning to change) much like Viollet-le-Duc's response to Boileau's experiments with iron construction (although there are also significant differences between the two). Viollet-le-Duc saw Boileau as a *bricoleur,* with no serious investment in the discipline of architecture, and viewed iron and its engineering as crude.[10] Similarly, the Great Exhibition Hall, formulated by Sir Joseph Paxton—who was not an architect—was seen as a form of surrender to engineering and modern efficiency.

The entry of computers into the design profession to generate form owes much to the architect Frank Gehry. His office adapted the three-dimensional program CATIA, which had been used to design French warplanes. But the program (which, further developed, was eventually patented under Gehry's name) did not specifically relate to or work on forms from nature. Since the 1990s, however, computation has become a way to explore the forms and processes of nature; over time, there has been a fundamental shift away from imitating nature's forms to imitating its functions, or natural mechanisms—which may in turn provoke new forms. These processes can be approximated using various new

technologies, which similarly allow designers to express the processes as physical forms. Particularly compelling are models initiated to reveal and express the underlying patterns that emerge from natural phenomena, rather than simply to imitate their physical appearance.[11] It is in this sense that an unconventional design approach to mediating the relationship between humans and the natural environment can be more powerful and cogent than a conventionally direct, "green" approach.

The shift from a style-oriented to a process-driven paradigm is dependent on computer-aided design, which allows designers to perform intricate analyses of complex systems. The most valuable contributions of such digital simulations are not necessarily formal—the mimesis of natural forms—but are instead in their use as quantitative tools in the service of achieving original design solutions.[12] Indeed, digital design technology has arrived at a point where it will be possible to create artificial ecologies that simultaneously emulate and deviate from natural models.[13]

Designers such as ecoLogicStudio have taken the principle of process-driven design and, though they have abandoned the pretense of devising a quantitatively efficient "system," have nonetheless created projects that are formally strong. These designers are dedicated to exploring how relationships between the user and the environment are set up, with the intention of producing subtle patterns with compelling forms that still respond to their natural context.[14]

A commitment to conceptual cogency leads to a new set of criteria for the effectiveness of design that depends on emotional engagement with the user rather than on the achievement of an iconic image. And this is the nexus where design interfaces with interactive media. The possibilities inherent in digital technology—which already routinely deconstructs the dialectic between the real and the virtual—designate a moment in which occupiable space is conceived as a forum for multisensory experience and myriad interactions between people, so that design begins to favor the demonumentalization of space to a degree that suggests its dematerialization.[15]

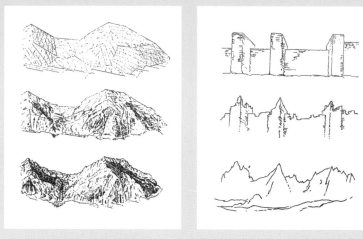

Eugène-Emmanuel Viollet-le-Duc, crystalline protoforms of the Alpine mountains and their disintegration

John Ruskin, studies of the Aiguilles-de-Chamonix showing the erosion of the rampart form of the Alps

Scale

On the surface, the three strategies of forging connections between landscape and architecture presented in *Groundwork*—Topography, Ecology, and Biocomputation—are generally distinct, although they do overlap. Less noticeable, perhaps, is that each tends to tackle landscape and architecture on a different scale. Topography emerges from geomorphology and in most cases addresses both landscape and architecture on a large scale, appearing mainly as a tool in master planning, as in the work of Zaha Hadid and Peter Eisenman. Biocomputation, on the other hand, tends to work on a smaller scale—for example, at that of a particular building, a particular site, or a particular room, as in the work of Philippe Rahm.

Ecologic projects are particularly sensitive to scale and can cover a wide range of them. To be successful, the ecological route chosen must be able to function in relation to the size of the project; the chosen spatial dimension is therefore critical. Ecology is a system of interconnections, and each system is capable of functioning on one scale better than another.[16]

McHarg's *Design with Nature* looked at large systems such as coastal dunes and made design recommendations with regard to their vital role. He drew attention to the need to allow for their movement and for having them stack up in rows of two or three, which is an issue of scale. The specificity of the dune system was what made these recommendations work. When applied to complex systems, where social and political agendas play a critical role, ecological strategies become generic unless they involve a particular element of those systems, such as a green roof, green wall, linear park, or specific building on a specific site. These, like a coastline of dunes, are better suited to the ecological approach than a city as a whole would be. Though it was a study at a very large scale, *Silent Spring* was effective because it had a specific focus: bird life.

Bruno Taut, *Alpine Architektur,* **1919**

Precedents

Just as the definition of nature has changed from the nineteenth century to the twenty-first, with at least three dramatic transformations by the 1960s—when it came to be conceived as a heterogeneous ecosystem inclusive of humans—the precedents to the three paths show that notions about topography, ecology, and biocomputation as formal sources for design have evolved over time. In general, the topographic path represents an earlier step in that evolution, followed by the ecologic, and later still by biocomputation. All three contain ideas that continue to sponsor new work, and each in its own way was a breakthrough into a new way of doing things.

Topography, on the surface, may recall some of the topographical work of the nineteenth century or the mountain projects of Bruno Taut, Viollet-le-Duc, and others.[17] Although each of these efforts emerged from a different set of concepts, all sought a single structure in nature (for example, in crystallography). They also developed from the belief in a clear-cut division between nature and artifice (for instance, things built by human effort). Then again, new topographical work takes as a direct precedent the Land Art of the 1960s.[18] Harvey Fite, Robert Morris, Herbert Bayer, Robert Smithson, James Turrell, and Ian Hamilton Finlay were important models in the search for the connection between landscape and architecture.

Among the precedents for Ecology is, of course, *Design with Nature,* which opened the doors through which ecological ideas entered design. McHarg's system of examining many layers of a site was a precursor of the GIS computational programs that analyze multiple tiers of geographical information: geology below the site, water table, underground streams, surficial geology, soils, cultural and historical traces on the ground, vegetation, and so on. Reyner Banham's *Architecture of the Well-Tempered Environment* of 1969 pioneered the consideration of exterior forces, such as climate and site, as directives for architectural design.[19] The period of the 1960s and 1970s is marked by a rearguard battle of ecologists and naturalists who claimed that design had no role in landscape work, asserting that

all that was needed was to follow nature. It would take two more decades to change this attitude, which occurred partly because of the shift in the meaning of nature and partly because ecologists began to understand that a design that was beautiful could become more sustainable.

Ecologic designers, like Topographic ones, were strongly influenced by Robert Smithson. His well-known works—such as *Broken Circle* (1971), *Partially Buried Woodshed* (1970), or the most famous, *Spiral Jetty* (1970)—and also his writings had a major impact. He transformed remediation and ecological projects so that they acquired the status of art. In fact, ecological precedents as a whole contain a fair share of remediation projects—a reflection of the early stages of ecological work.

Early precedents for Biocomputation sought a monistic answer: a universal structure that could describe all. Curiously, the system that emerged to undo this vision—Darwin's—did so by showing a framework under constant change. Later, sometimes much later, precedents reflect this view. Lars Spuybroek's water pavilion, HtwoOexpo (1997), is a fully interactive building in which the geometry is digitally generated by the body of the visitor. Greg Lynn's Embryological House series (2000) worked toward a model for "mass customization."

The computer itself may be considered a precedent for the work of the Biocomputation designers. But this is partly a mark of its relatively recent arrival. Its role is beginning to be more transparent; in the next years it will move toward becoming invisible. Photography offers an interesting analogy. In photography, the computer has gradually increased in importance, and not just because images are recorded digitally. Photographers such as Floris Neusüss, Garry Fabian Miller, and Susan Derges are making photographs without cameras. Derges placed sensitized paper in an aluminum frame at the bottom of a stream to show the water patterns in the streambed; this type of work is able to transmit nature directly. Though technology remains, the camera is no longer the intermediary. This may be the course for computers in design.

Work in all three categories—Topography, Ecology, Biocomputation—
aspires toward integration across the divide. But the formal aspect of each
is not adequately summarized by any single aesthetic. Their most signifi-
cant direction is heterogeneity, a basic tenet of what has come to be
called nature.

1. Antoine Picon, "What Has Happened to Territory?" *Architectural Design,* May–June 2010, 98, 99.

2. Pierre Grimal, *Les jardins romains à la fin de la République et aux deux premiers siècles de l'Empire* (Paris: E. de Boccard, 1943), 48.

3. Diana Balmori, "Architecture, Landscape, and the Intermediate Structure: Eighteenth-Century Experiments in Mediation," *Journal of the Society of Architectural Historians,* March 1991, 38–56.

4. François Jacob, "Le Bricolage de l'Evolution," *Le Jeu des Possibles* (Paris: Fayard, 1981), 70, 86.

5. Picon, "What Has Happened to Territory?" 98.

6. "Brooklyn Pigeon Project: Terraswarm," in *Verb Natures,* ed. Irene Hwang et al. (Barcelona: ACTAR, 2006), 207.

7. Javier Arbona, "It's in Your Nature: I'm Lost in Paris," *Architectural Design,* May–June 2010, 48, 53.

8. Ian L. McHarg, *Design with Nature* (1969; reprint ed., New York, John Wiley & Sons, 1991, 1995).

9. Angeli Sachs, "Paradise Lost? Contemporary Strategies of Nature Design," *Nature Design: From Inspiration to Innovation* (Zurich: Lars Muller, 2007), 266–67.

10. Martin Bresani, "Viollet-le-Duc's Optic," in *Architecture and the Sciences: Exchanging Metaphors,* ed. Antoine Picon and Alessandra Ponte (New York: Princeton Architectural Press, 2003), 119.

11. Jason Kelly Johnson and Nataly Gattegno, "The Aurora Project," *Architectural Design,* May–June 2010, 76.

12. "What Is Grotto?: From Classic Grotto to Contemporary Grotto," in Hwang, *Verb Natures,* 7.

13. "Wave Garden," in Hwang, *Verb Natures,* 144.

14. Terri Peters, "Practice Profile: ecoLogicStudio," *Architectural Design,* May–June 2010, 112.

15. Valentina Croci, "Relational Interactive Architecture," *Architectural Design,* May–June 2010, 122, 125.

16. My colleague Herb Borman, an ecologist at Yale's School of Forestry, has said that when he was trying to determine whether there was such a thing as acid rain he failed many times until he came up with the unit by which it could be measured—a watershed.

17. Luis Fernandez-Galiano, *Fire and Memory: On Architecture and Energy* (Cambridge, Mass.: MIT Press, 2000), 89–90.

18. As John Beardsley has described in *Earthworks and Beyond* (New York: Cross River Press, 1984), there was an explosion of land forms and work on the earth in remote places rather than in museums.

19. Reyner Banham, *Architecture of the Well-Tempered Environment* (Chicago: University of Chicago Press, 1969).

Topography

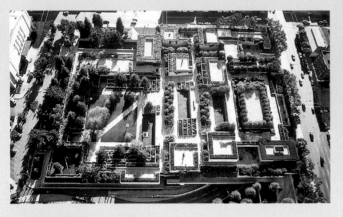

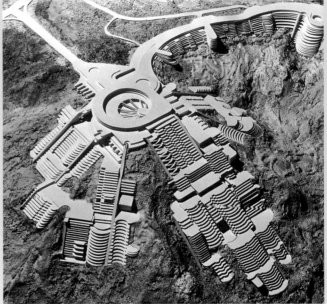

1961–68

Kevin Roche John Dinkeloo and
Associates, Oakland Museum of
California, Oakland, California

1966

Cesar Pelli with Tony Lumsden,
Urban Nucleus at Sunset Mountain
Park, Los Angeles, California

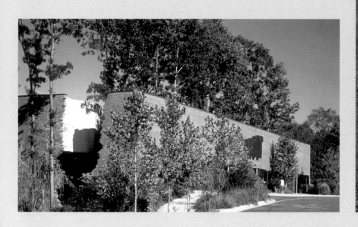

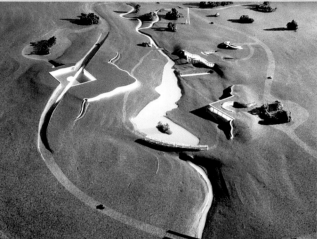

1980
SITE, BEST Forest Showroom,
Richmond, Virginia

1982
Emilio Ambasz, Schlumberger
Research Laboratories, Austin,
Texas

Topographic designers reject the paradigm of an object building that sits
discretely on the land. Their projects manipulate the ground to blend
building and landscape, treating built form as inhabitable landform. Light
years away from a generation of technophobic structures created by
ecologically minded architects of the 1960s and 1970s—inconspicuous
buried buildings made of rough-hewn natural materials—these ambi-
tious projects are unapologetic human interventions. In this way they are
close in spirit to such pioneering works as Bruno Taut's *Alpine Architektur*,
Cesar Pelli and Tony Lumsden's Urban Nucleus at Sunset Mountain Park,
Enric Miralles and Carme Pinós's Igualada Cemetery, and SITE's BEST
showrooms. More recent digitally generated projects—Zaha Hadid's One
North Masterplan and Foreign Office Architects' influential Yokohama
Port Terminal—likewise weave together natural and synthetic materials to
elide conventional distinctions between building and site.

Topographic designers develop their schemes in response to an age-old
dilemma: how to create designed environments that are respectful of con-
text while accepting that human settlements inevitably alter the landscape.
Five projects tackle the challenge of building within hillsides in different
ways. Three deploy eye-catching strategies: Duncan Lewis Scape with OFF
recontours the profile of a French hillside with an arresting striated pattern
of overlapping green roofs. Snøhetta carves a notch into a sloping mound
in Alstahaug and replaces it with a wedge-shaped museum building that
abstracts the hill's profile. Weiss/Manfredi models ramped, faceted ground

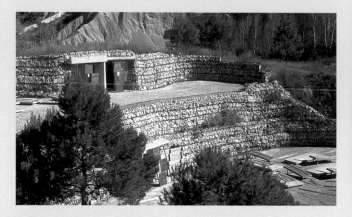

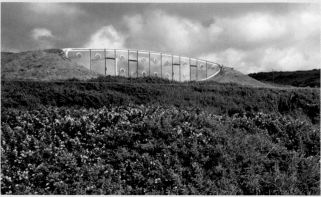

1986–90
Enric Miralles and Carme Pinós,
Igualada Cemetery, Igualada,
Barcelona, Spain

1994–96
Future Systems, House in Wales

planes to navigate the descent from city to waterfront in urban Seattle. The other two projects adopt a more low-key approach: Atelier Girot regrades an entire mountainside in Lugano using displaced earth from a railway tunnel excavation, subtly blending the transplanted soil with its surrounding terrain. R&Sie(n)'s mixed-use gallery/residence surreptitiously insinuates itself into a sloping site located near the Korean Demilitarized Zone. In their blending of organic and inorganic materials to fabricate new hillside terrains, these projects are indebted to the Oakland Museum of California by Kevin Roche and John Dinkeloo, Schlumberger Research Laboratories by Emilio Ambasz, and the House in Wales by Future Systems.

SLA, Eisenman Architects, Toyo Ito, and Zaha Hadid address an increasingly common but opposite challenge—designing a flat, marginal site on the outskirts of a city. They respond similarly: all transform feature-less property into constructed landforms with striking silhouettes that confuse traditional distinctions between man-made and natural. Both Ito and Hadid adopt curvilinear geometries, inviting pedestrians to occupy immense undulating roofs that mix hardscape and softscape. Eisenman Architects' undulating forms at Santiago de Compostela are derived from overlapping maps that reference the city's urban and natural contexts. In contrast to these sculptural landforms, SLA's urban garden in Nørresundby emulates its flat harborside setting by employing graphic topographic patterns made of materials—water, crushed iridescent mussel shells, and asphalt—indigenous to the site.

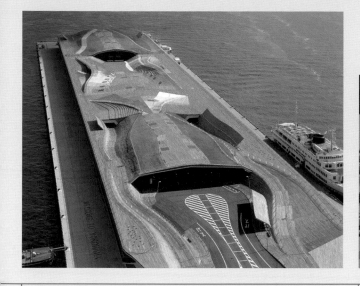

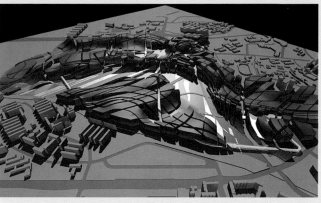

1995–2002
Foreign Office Architects,
Yokohama International Port
Terminal, Yokohama, Japan

2001–21
Zaha Hadid, One North
Masterplan, Singapore

It is important to note that Topographic projects share affinities with those of Biocomputation and Ecology: some employ complex forms that could have been generated and even fabricated only with advanced digital tools; others incorporate sustainable strategies, including green roofs. What sets these designs apart is that they are first and foremost driven by formal concerns: instead of resorting to a naturalistic vocabulary, they invent a shared landscape/architecture expression that makes a bold imprint on the land.

Cairo Expo City

**Zaha Hadid Architects
Cairo, Egypt
2009–ongoing**

Zaha Hadid's master plan for Cairo Expo City resembles a landform carved by water flows—a concept inspired by the Nile delta. The project was devised as a business and entertainment complex between downtown Cairo and the city's airport. An international exhibition and conference center along with two office towers and a shopping mall ensures a stream of visitors at all hours of the day. Clusters of torqued architectural masses are shaped by pedestrian circulation paths. A floating walkway serves as the main pedestrian artery, funneling visitors into a fluid landscape of open plazas and lawns connecting Hadid's buildings and Cairo's streetscape. Eliding distinctions between building and ground, the patterned skin of each building splits and dilates to accommodate daylighting and visitor entrances. By envisioning this urban master plan as a vortex of interconnected rather than fixed programs, Hadid creates a pedestrian landscape in constant flux.

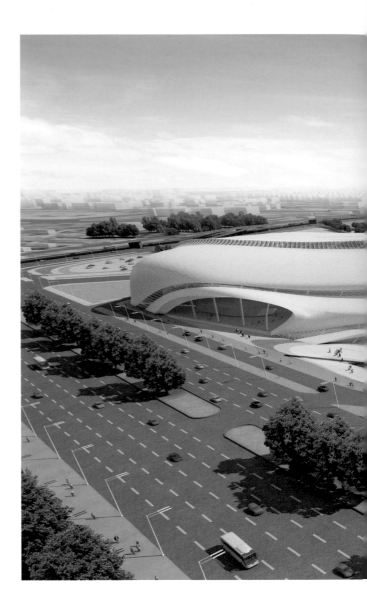

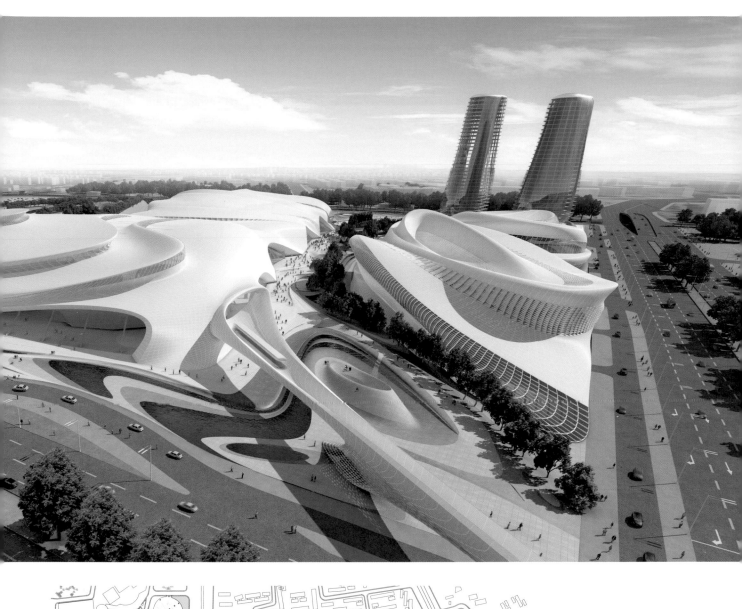

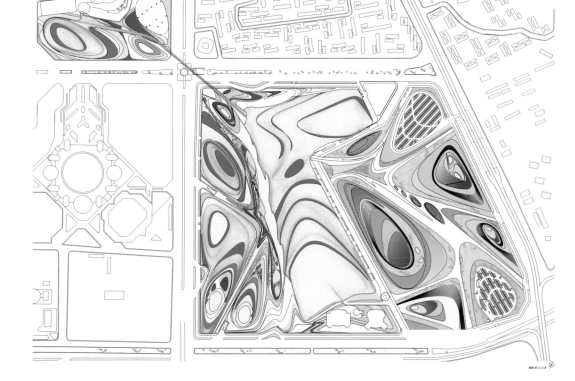

GROUNDWORK | TOPOGRAPHY

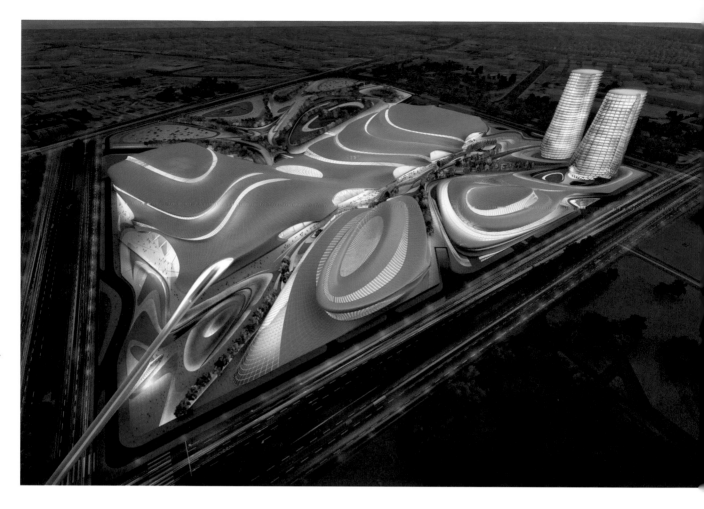

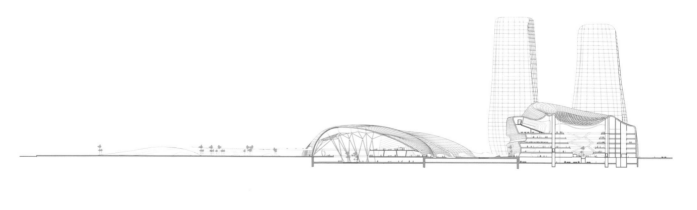

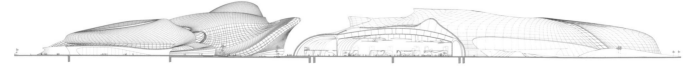

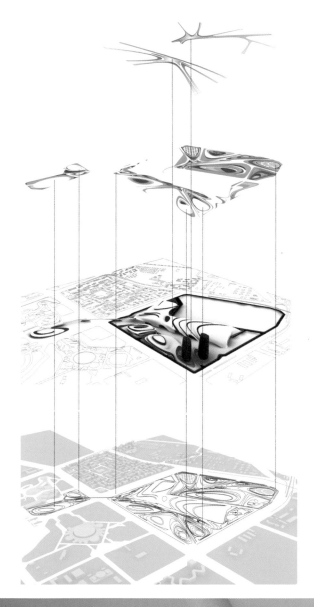

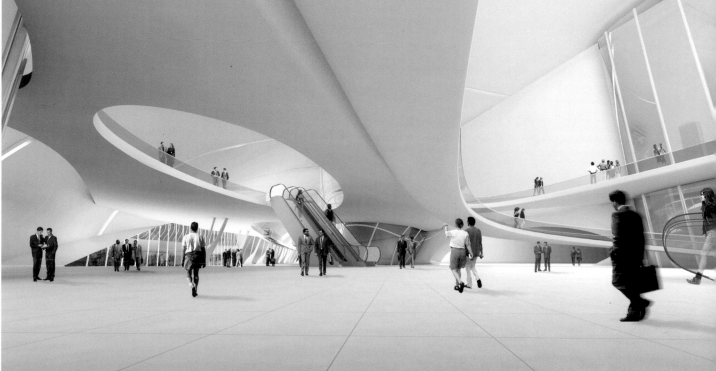

GROUNDWORK | TOPOGRAPHY

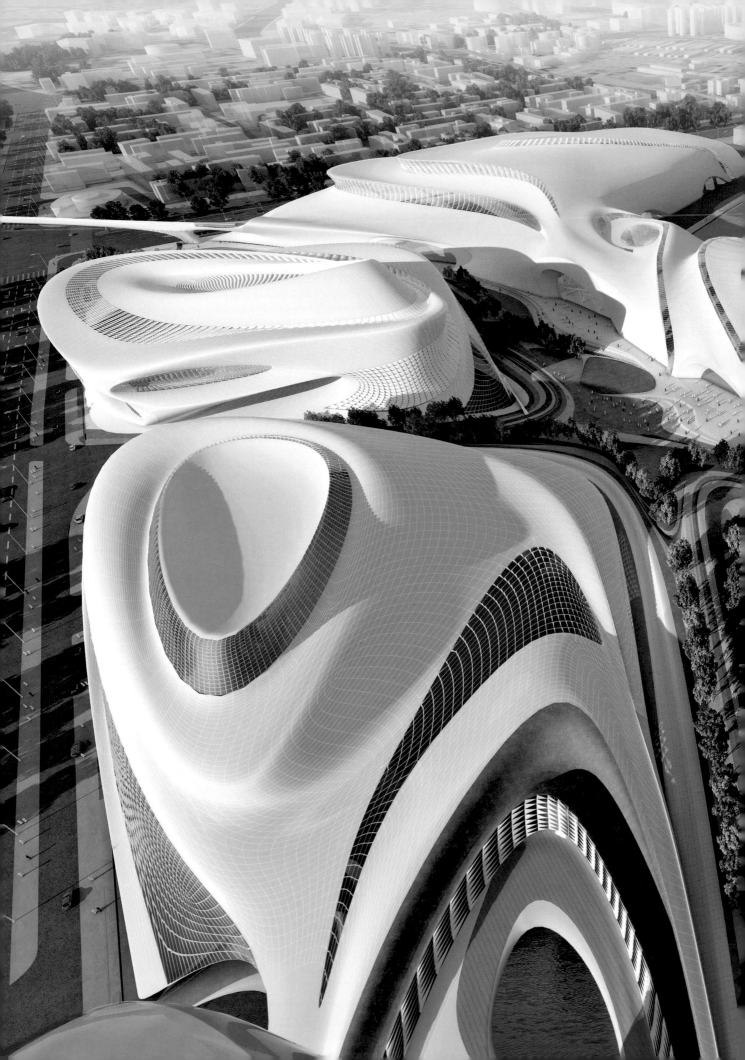

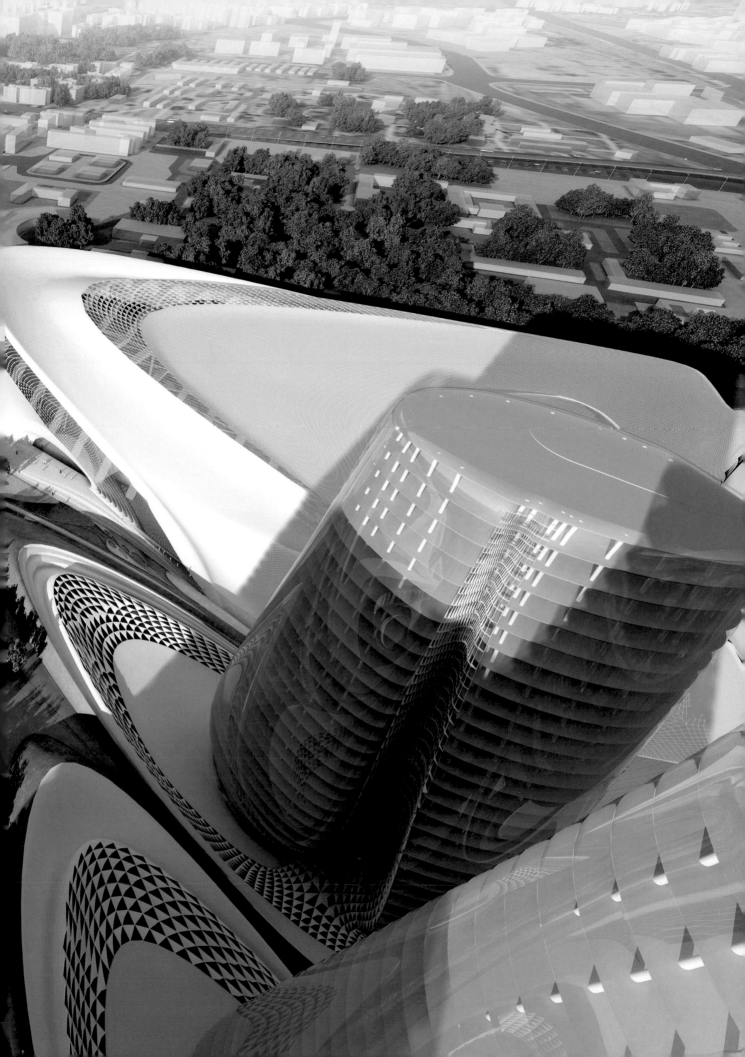

Island City Central Park Grin Grin

**Toyo Ito & Associates
Fukuoka, Japan
2002–2005**

Island City is a large artificial island of shipping ports, private industry, education facilities, and residences, all meant to serve as a hub of global commerce for Fukuoka, Japan. The island's Central Park injects leisure and environmental awareness into an enterprise otherwise shaped by economic interests. Ito's Grin Grin building, a series of lakeside pavilions joined by a rippling roof structure, breaks from the island's rectilinear zoning. Its topography of undulating ellipses houses three interior greenhouses, each between nine hundred and one thousand square meters, as well as covered spaces for casual enjoyment. The complex geometries were realized via a design method that utilizes bending stress values to create unique curvatures that minimize structural deformation. The roofs are carpeted with grass so that they appear to be continuous with the park's lawns; concrete pedestrian walkways that snake above and below the roof structure contribute to the illusion. Inlaid glazed panels dematerialize the mass of the roof shells while illuminating the flowing spaces below.

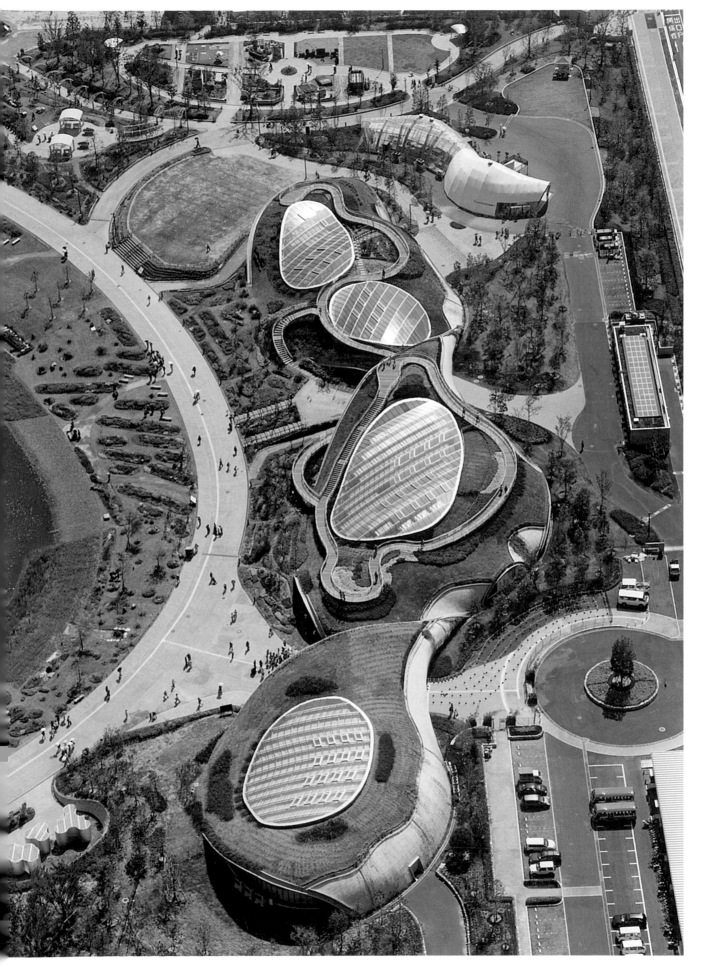

59

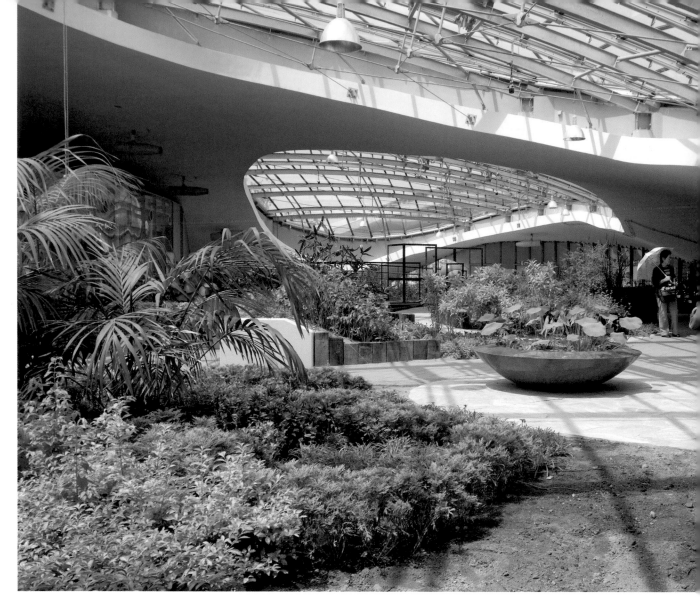

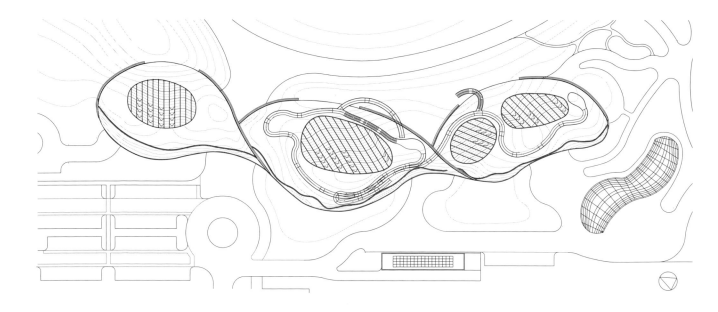

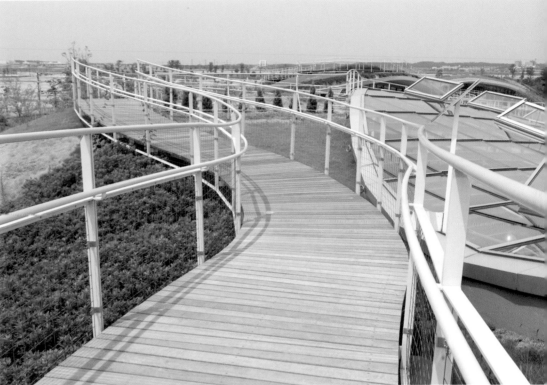

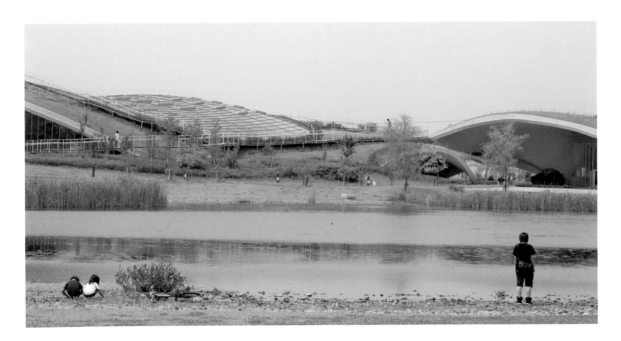

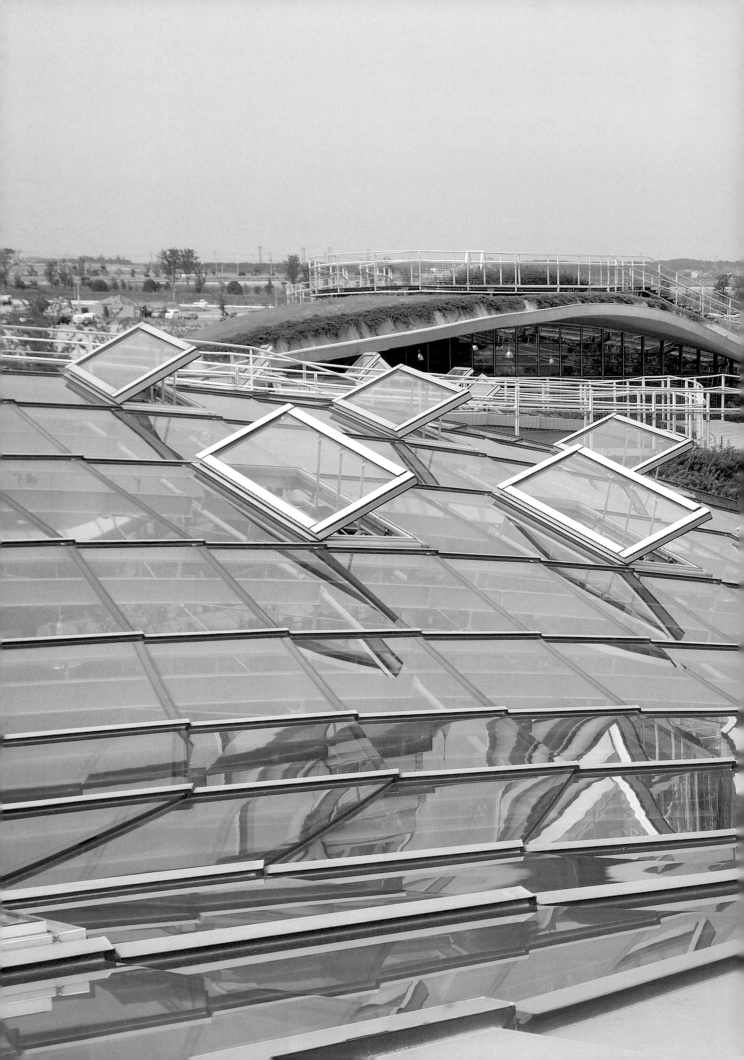

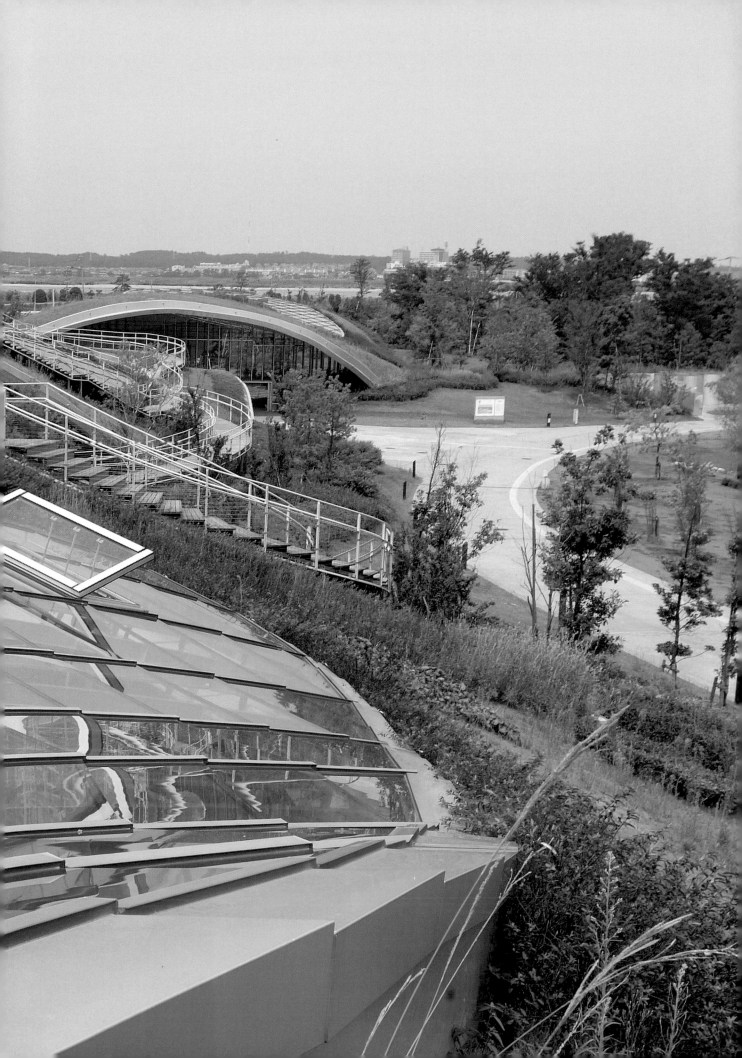

Urban Garden
in Nørresundby

SLA
Nørresundby, Denmark
2002–2005

This thousand-square-meter urban garden
bordering Nørresundby's harbor features
an original and arresting synthetic design
vocabulary that blends materials and motifs
derived from the gritty quayside setting. In
the tradition of modernist landscape pioneers
Isamu Noguchi and Roberto Burle Marx, the
design employs striking biomorphic shapes
borrowed from abstract painting or even the
work of Alvar Aalto rather than the romantic
curvilinear forms associated with more con-
ventional naturalistic park schemes.

A steel-mesh fence creates a permeable
perimeter that veils the graphic landscape
within, where a rippling ground surface
of asphalt and crushed iridescent mussel
shells creates a topography of organic and
inorganic materials indigenous to the site.
Water animates, reflects, and dematerial-
izes the surroundings, injecting a sense of
unpredictability into the garden: it collects
in amorphously shaped ponds or erupts from
the ground in skyward plumes that create a
glassy surface mirroring cloud formations
onto the black asphalt below. Water vaporiz-
ers interspersed with willow trees, brackens,
and mosses further soften the site's hard-
edged industrial qualities. The garden opens
toward the harbor with ramps and a blue,
rubber-coated stairway. Atmospheric lighting
illuminates the quay and nearby industrial
buildings, creating a flickering effect that
conflates sea, sky, and architecture.

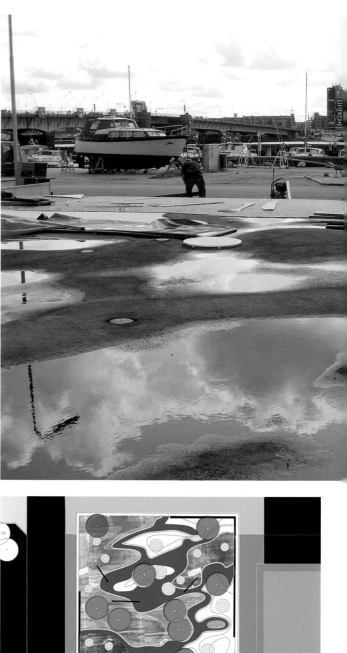

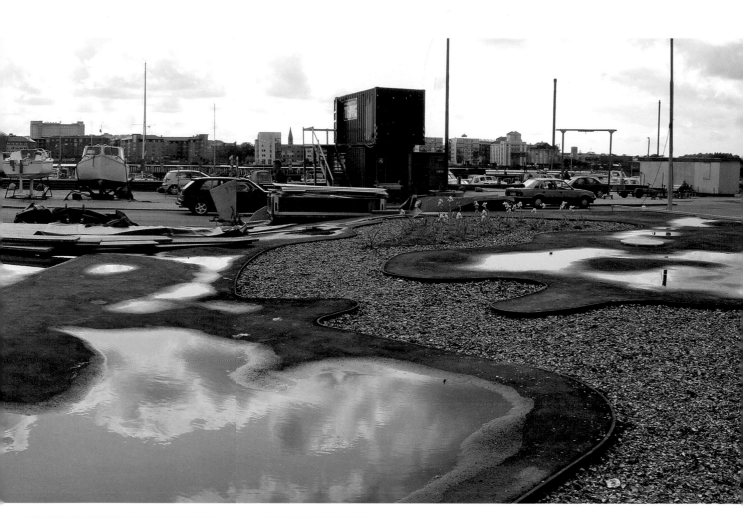

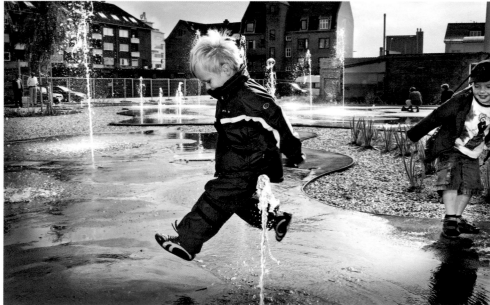

City of Culture
of Galicia

**Eisenman Architects
Santiago de Compostela, Spain
1999-ongoing**

The City of Culture of Galicia, located in the northwestern Spanish province of Galicia, rises from the hilltops ringing Santiago de Compostela, a site of medieval pilgrimage said to house the remains of Saint James the Apostle. Eisenman Architects synthesized six individual programmatic elements within an undulating artificial terrain of crests and troughs that blurs the traditional figure-ground relationship between building and land.

The dynamic formal language derives from the overlay of three maps: the street plan of Santiago's original medieval center, a modern Cartesian grid, and the topography of the existing hillside. The site's rugged contours distort the two flat geometries, generating an inflected surface that reposi-tions old and new in a matrix that calls into question hard and fast distinctions between history and modernity, city and nature. Through this mapping operation, Peter Eisenman writes, Santiago's medieval past "appears not as a form of representational nostalgia but as a new yet somehow familiar presence found in a new form."

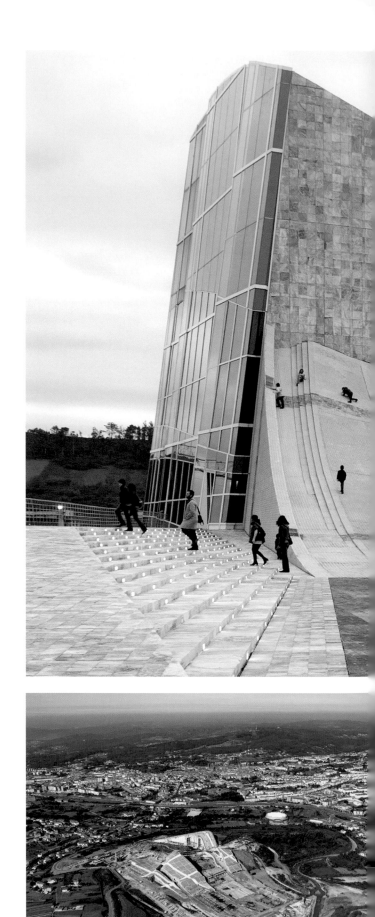

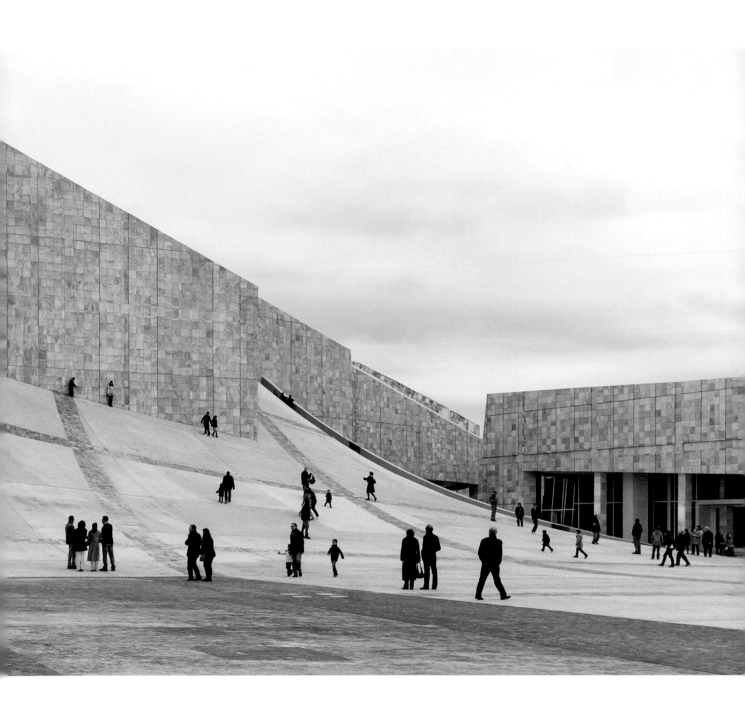

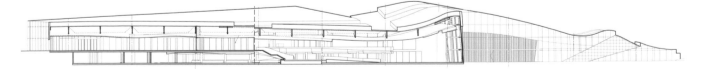

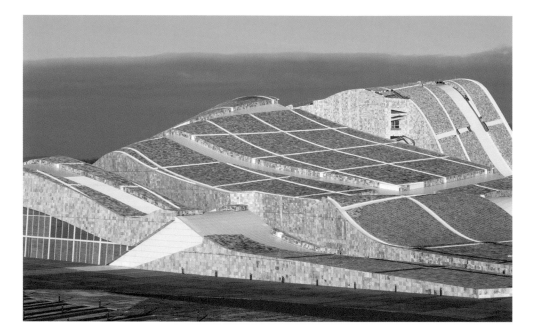

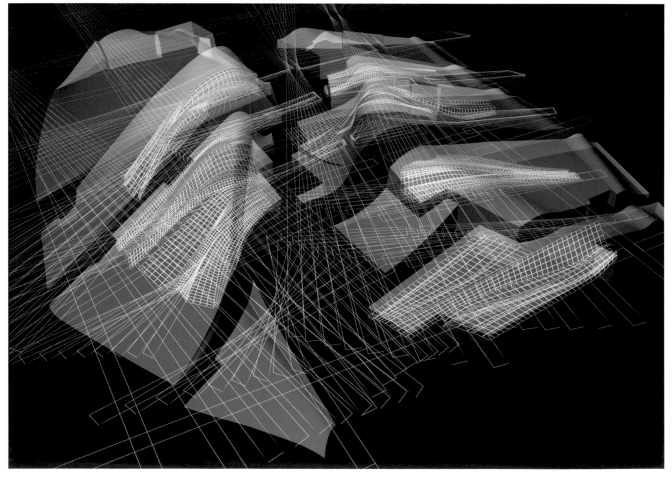

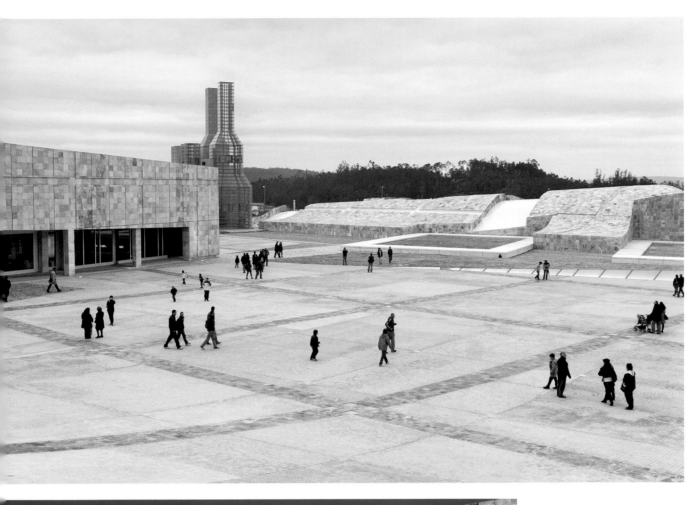

71

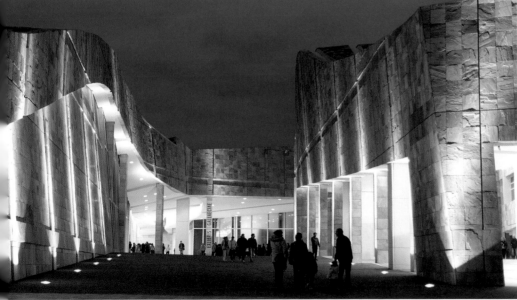

71

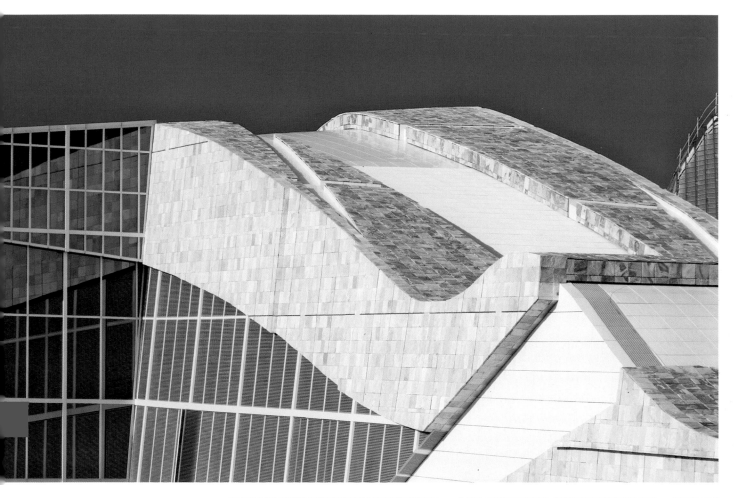

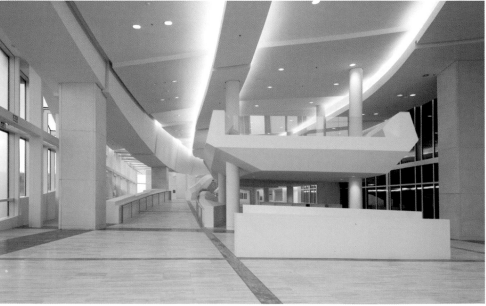

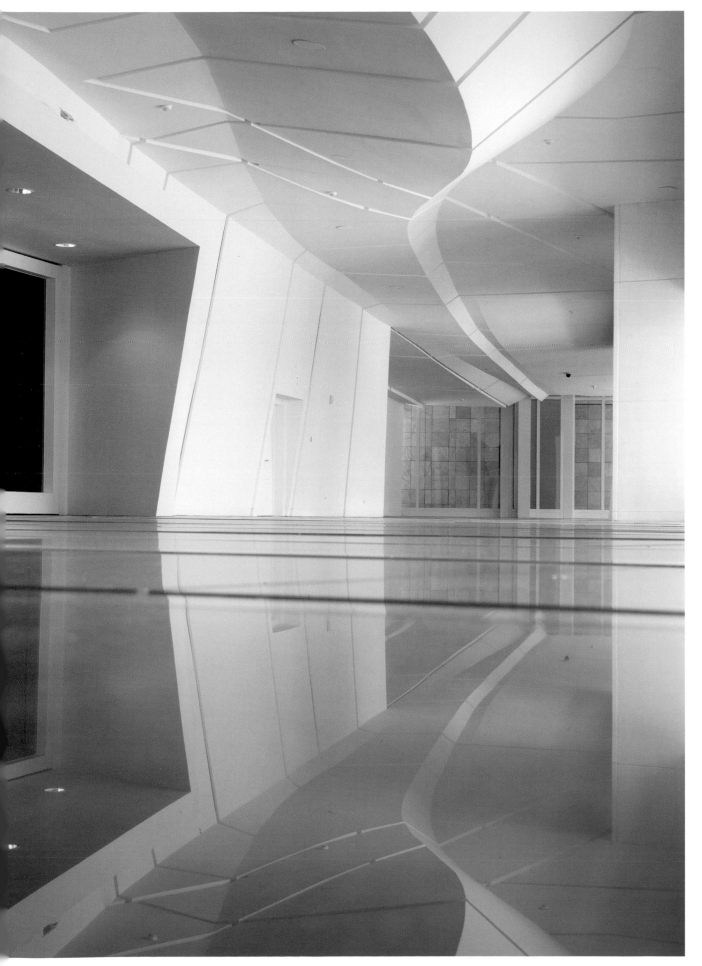

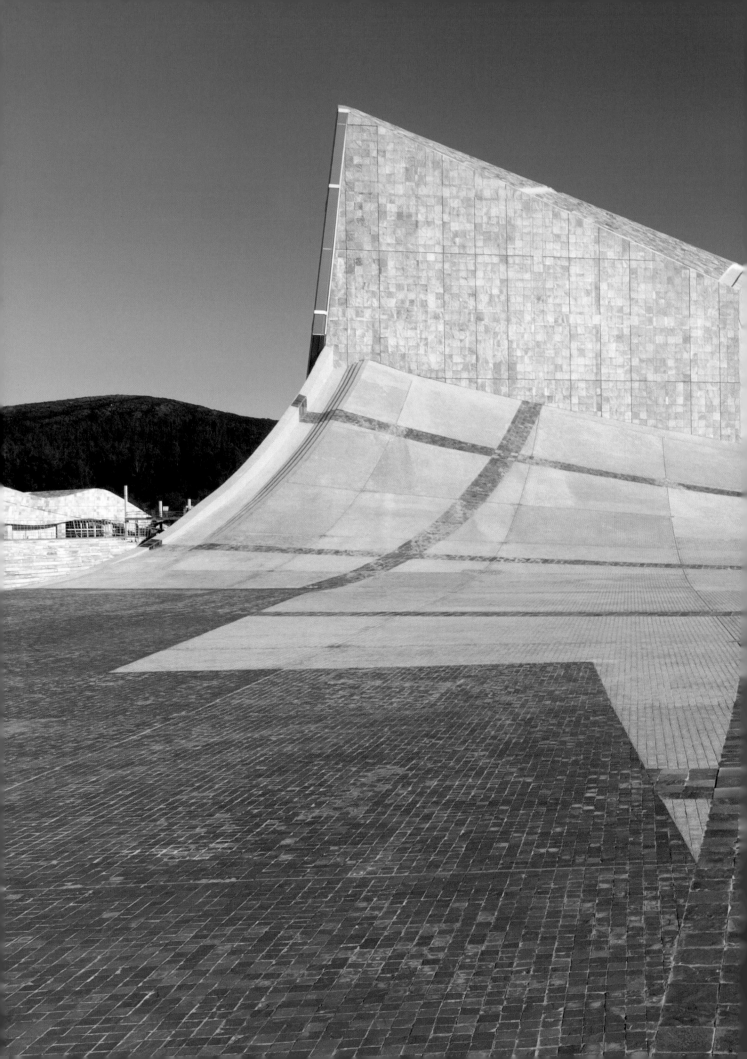

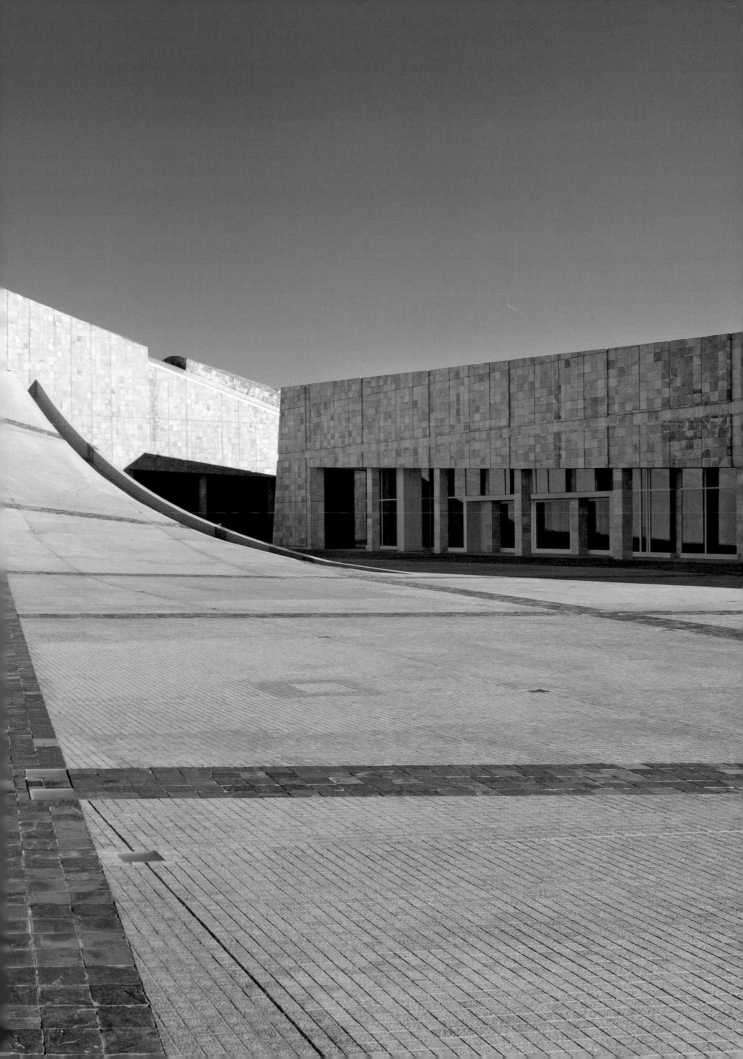

Seattle Art Museum Olympic Sculpture Park

Weiss/Manfredi
Seattle, Washington
2002–2007

The Olympic Sculpture Park is a hybrid complex that combines museum, park, and urban infrastructure into a sloping terrain between the city edge and the Seattle waterfront. The site was originally an industrial brownfield, gutted and capped with over two hundred thousand cubic yards of clean soil, largely from the Seattle Art Museum's expansion project. Beyond serving as satellite exhibition space for the museum, the sculpture park—described by Weiss/Manfredi as a "landscape for art"—acts as a pedestrian bridge between the city's urban core and its last undeveloped waterfront.

To overcome the forty-foot grade change between the city and Elliott Bay, the park unspools as a continuous Z-shaped ramp. The path starts at an eighteen-thousand-square-foot exhibition pavilion, then narrows and zigzags over an existing highway and train tracks before arriving at a newly created urban beach. The corresponding landscape design emphasizes the park's slope in its progression from temperate evergreen forest to deciduous forest to tidal terraces for salmon and saltwater vegetation, all while directing and cleansing stormwater. The planting scheme parallels the park's programmatic mixing by bridging ecologies of nature and urbanism.

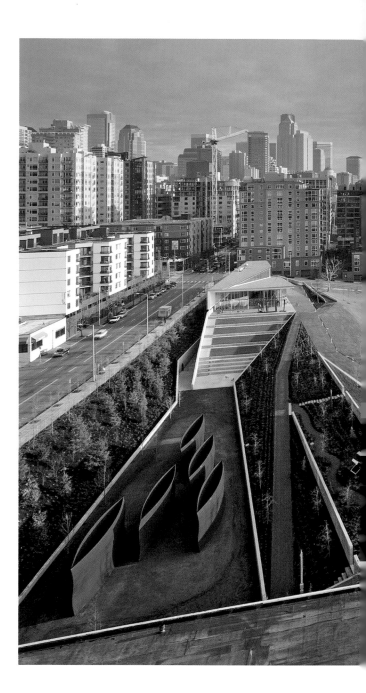

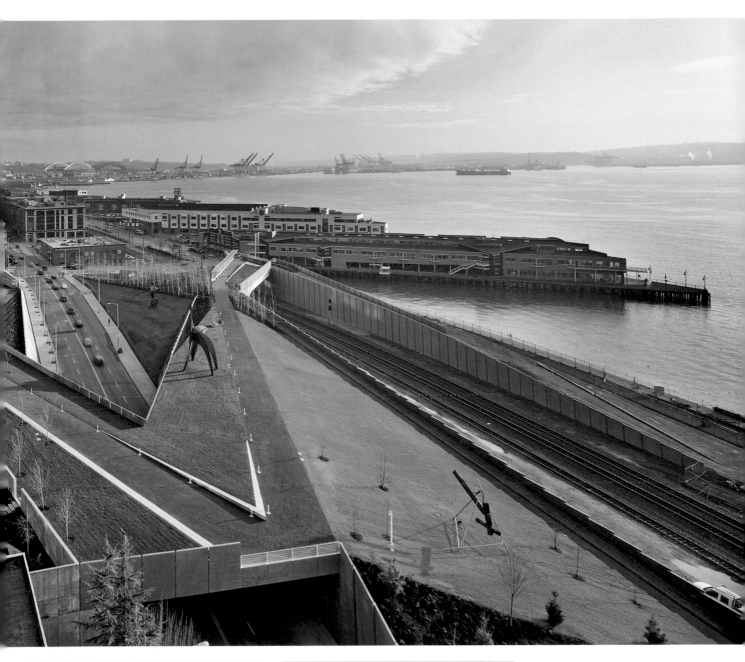

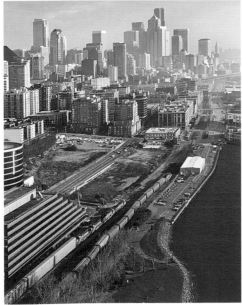
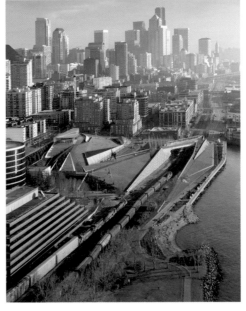

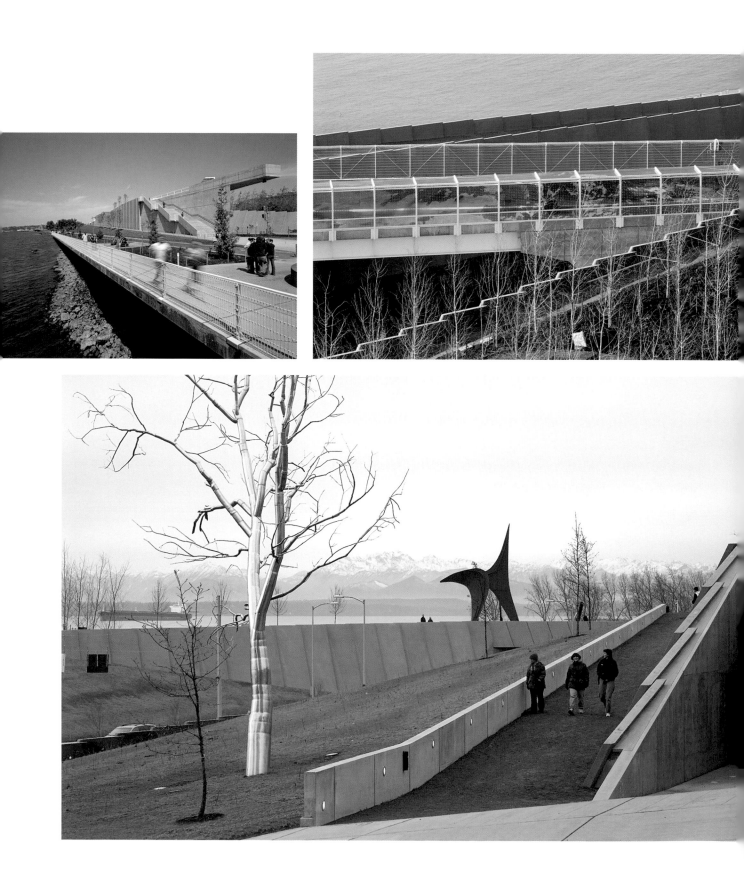

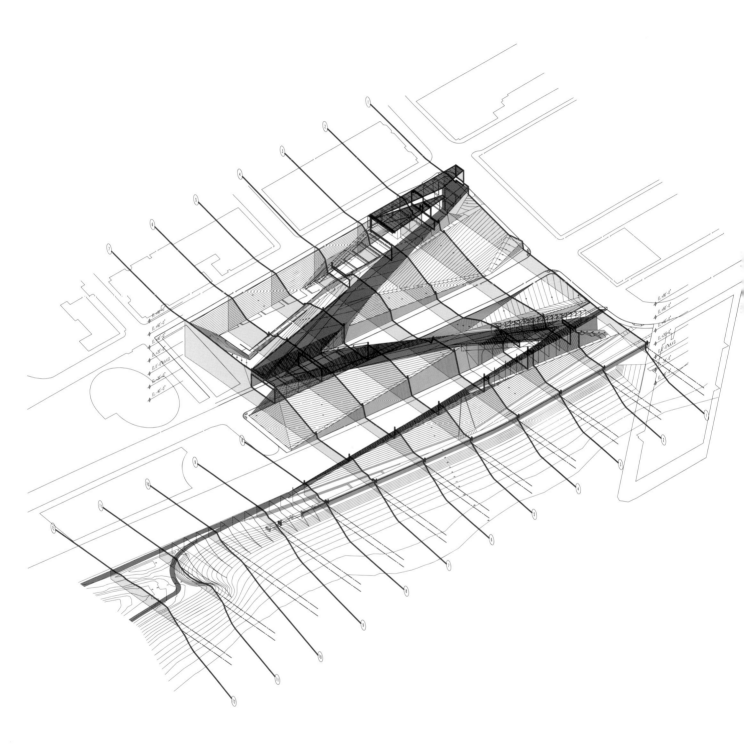

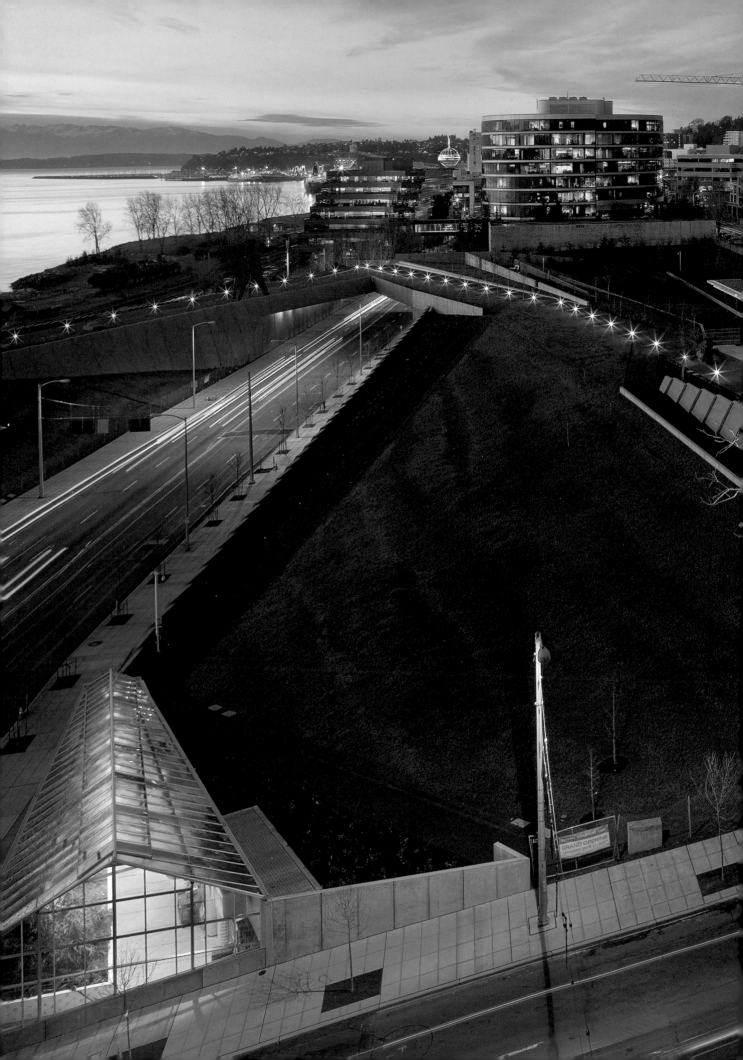

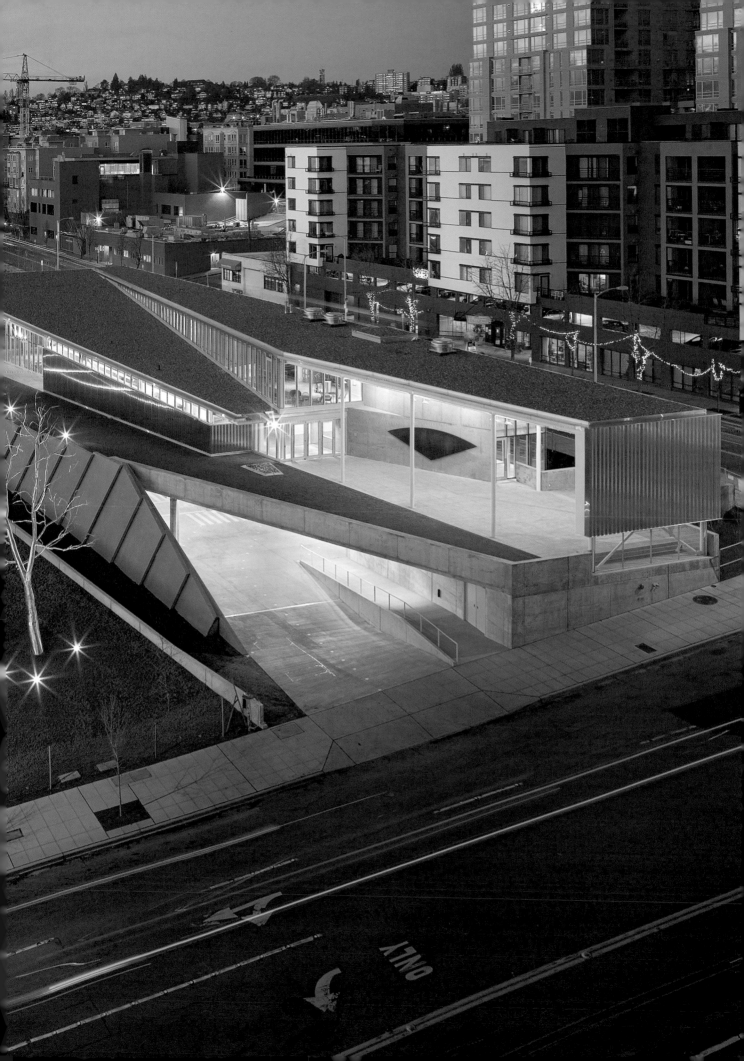

Sigirino Depot

**Atelier Girot
Lugano, Switzerland
2003–2020**

The planned fifty-seven-kilometer AlpTransit, a railway tunnel to be bored through the Alps to connect Italy and Switzerland, is slated to be the world's longest. The project poses pressing environmental concerns, particularly because the massive construction effort will yield more than 3.7 million cubic meters of displaced earth that will be deposited on a steep mountainside facing the village of Sigirino, Switzerland. The charge to Atelier Girot was to develop a comprehensive landscape design ensuring the integration of the excavated material into both the ecological and the cultural context. The proposal demonstrates that large-scale construction projects have the potential to mend rather than cause environmental trauma.

The design process began by mapping the deposit's topographic complexities with three-dimensional modeling and visualization technologies. In addition to topographical data, ecological tests of artificial substrates and vegetation activators yielded solutions for blending existing and displaced soil. While the imported soil's chemical properties denied the possibility of reproducing the site's previous plant species, Atelier Girot created a "new nature" of ground cover and, in later project phases, trees. A wide walking path descending the slope simplifies water collection and also establishes a pedestrian connection to nearby nature reserves.

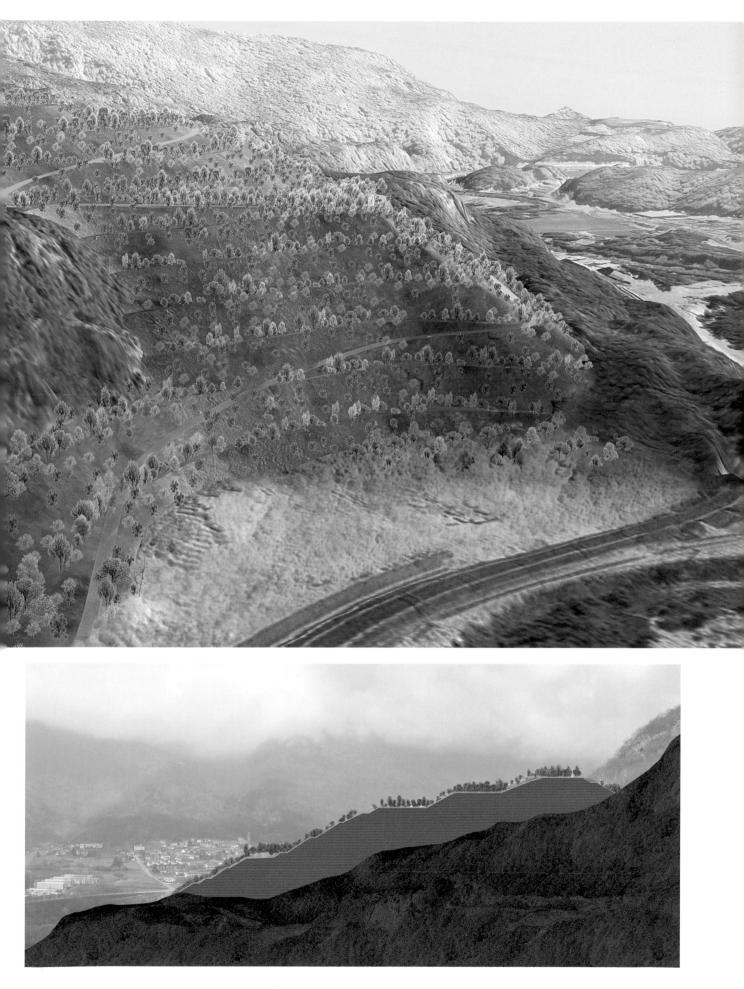

GROUNDWORK | TOPOGRAPHY

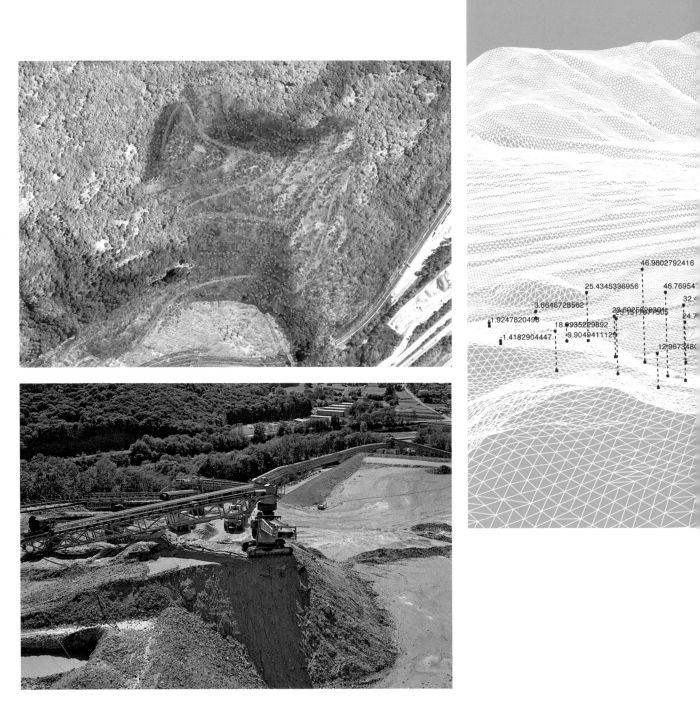

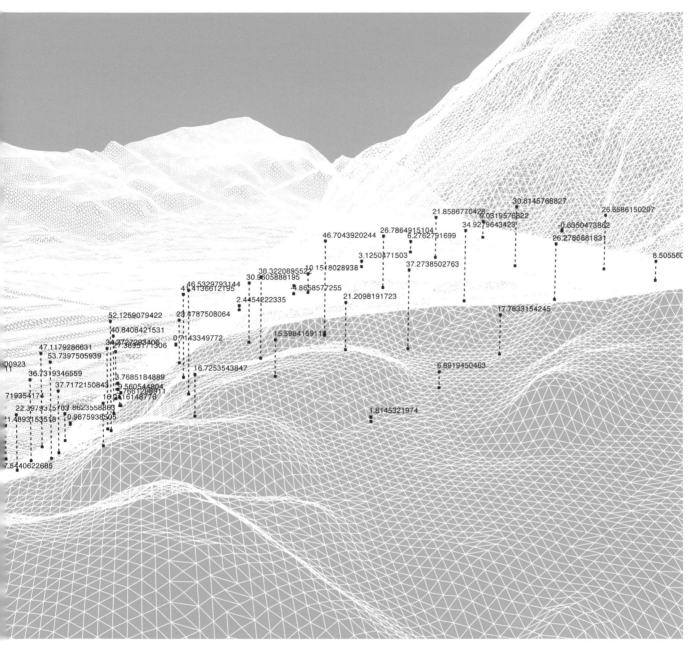

30.8145768827
21.8586770428
5.0319576822
26.6686150207
34.9279643423
46.7043920244
26.7864915104
0.6350473862
6.2762791699
26.2786681831
8.50556C
3.1250471503
37.2738502763
10.1518028938
21.2098191723
30.3220895527
30.9605888195
46.5329793144
4.8658577255
4.4136672195
17.7633154245
2.4454222335
23.3787508064
52.1259079422
16.5984159118
40.8408421531
34.2727293406
0.7143349772
47.1179286631
53.7397505939
16.7253543847
00923
36.7319346559
6.7685184889
11
37.7172150843
9.560544804
6.8919450463
719354174
10.9416148778
22.397937570
3.862355886
1.8145321974
2.489313531
0.9875938505
7.5440622685

85

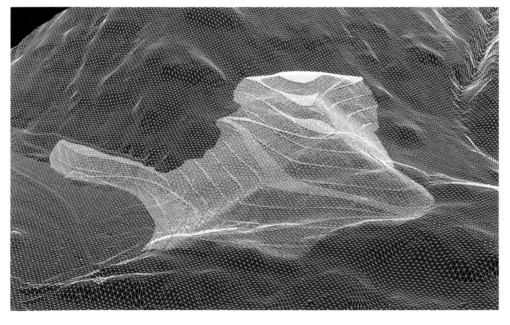

Lycée Jean Moulin

**Duncan Lewis Scape Architecture
with OFF Architecture
Revin, France
2008–2012**

The competition-winning design for a renovation and addition to Lycée Jean Moulin, set on a sloping hillside among the mountains and mists of France's Champagne region, sought to transpose the gentle topography into a comprehensive roofscape for the sprawling school campus. Classrooms as well as circulation and gathering spaces are combined under an immense canopy divided into a series of stepped ribbons. The ribbons are covered with topsoil roof plantings and connected by infill clerestory glazing, which admits daylight into spaces below. By inscribing an inhabitable structure within the terrain, the architect's site-specific topographic approach renders the project both visible and invisible, depending on the perspective: up close, the tiered green roofs transform the hillside into a striated abstract spectacle; from a distance, they camouflage the academic complex. To students inside the building, the alternating bands of glass offer expanded vistas.

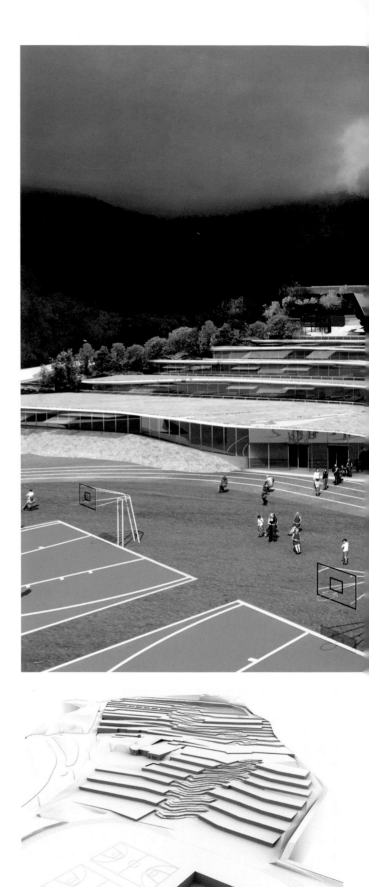

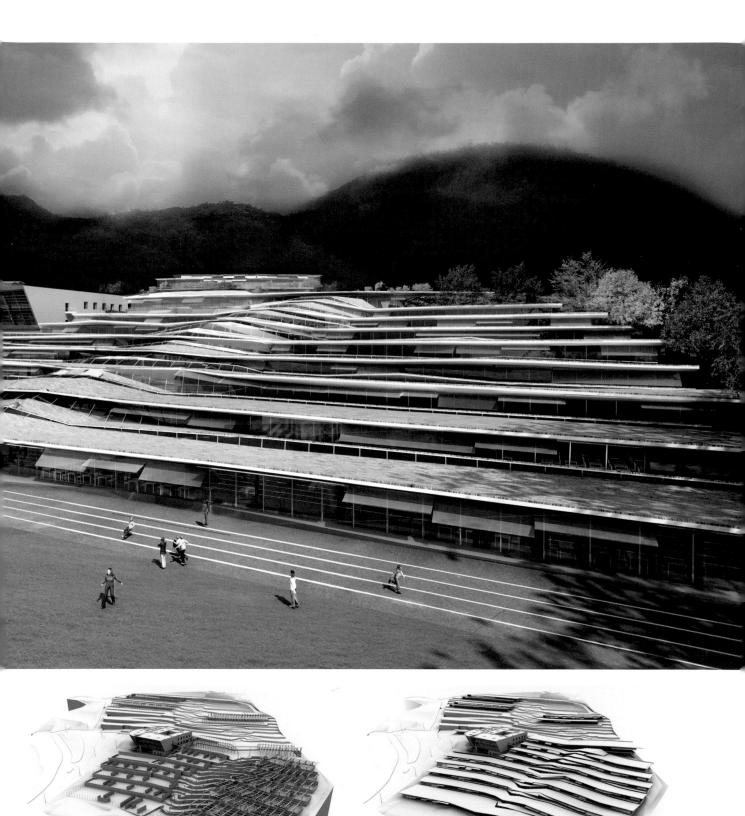

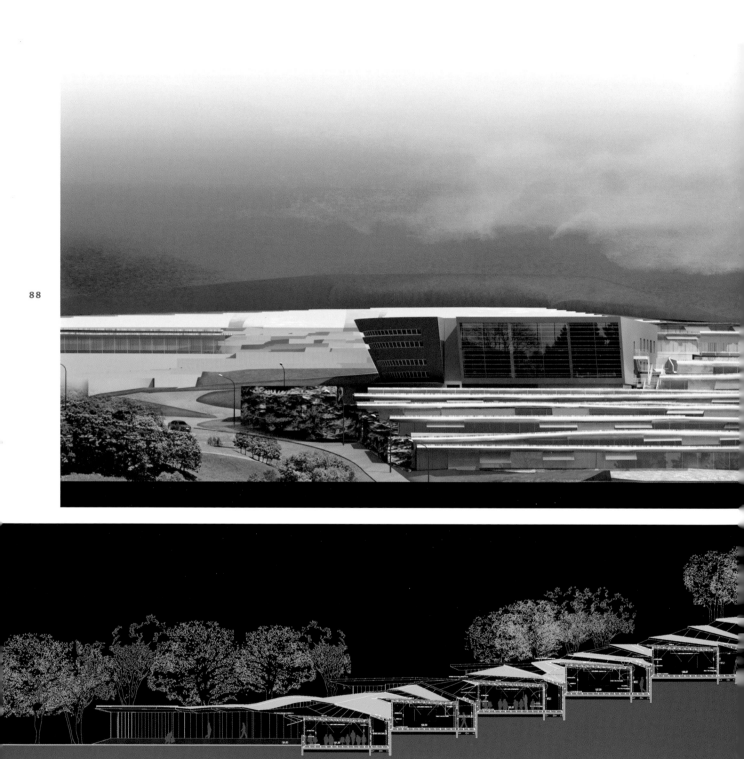

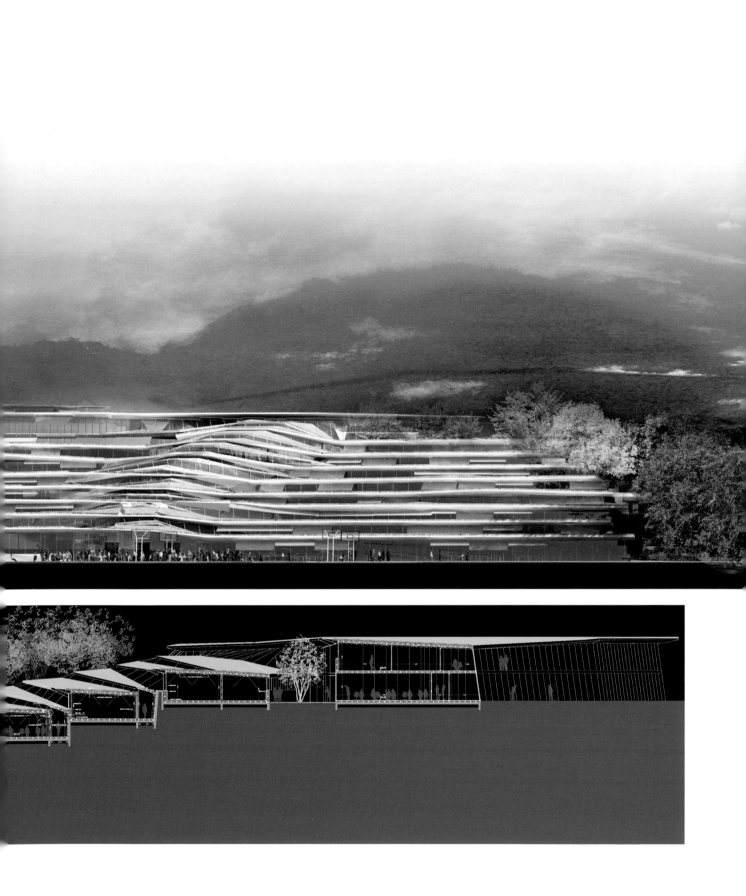

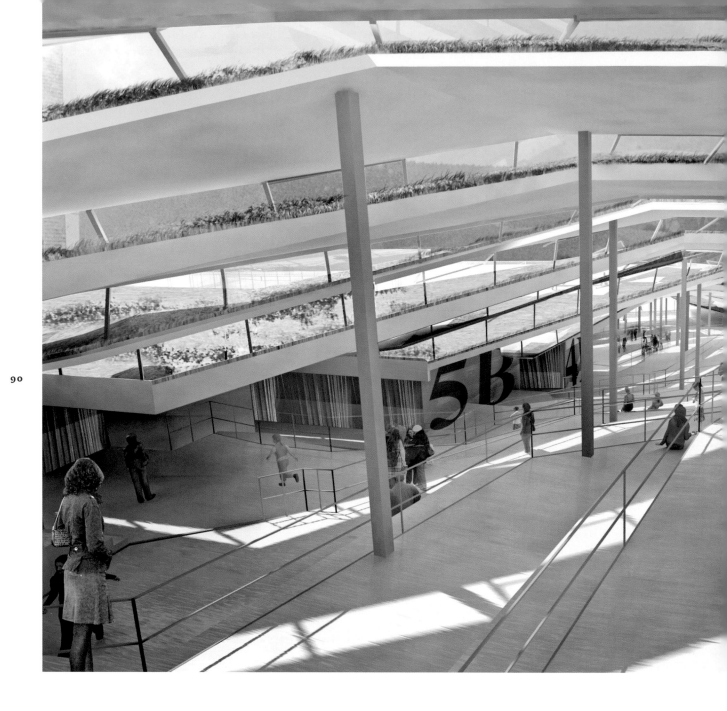

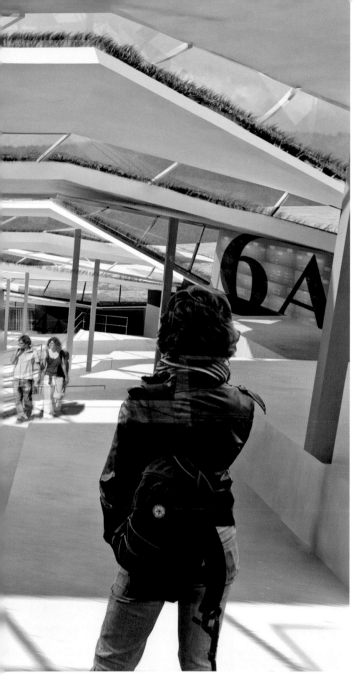

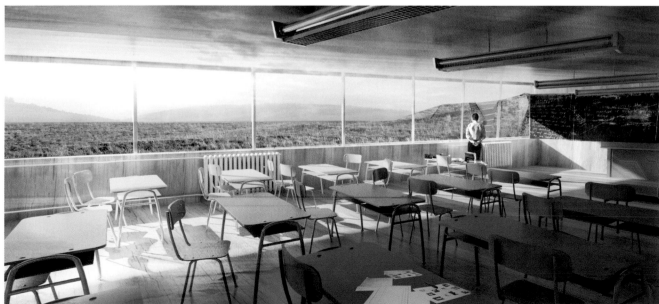

Symbiosis'hood

R&Sie(n)
Seoul, South Korea
2009

Symbiosis'hood blurs the spatial and material boundaries between a pair of private properties near the border of two contentious nations. The scheme is positioned at the edge of a forest near the Demilitarized Zone between North and South Korea, an abandoned landscape scarred by warfare and seeded with weaponry that in the hands of R&Sie(n) yields perverse new forms of botanical growth. Symbiosis'hood makes use of the fraught relationship between politics and ecology to design an entropic landscape, fusing spaces belonging to neighboring clients into a twisting, climbing mass of interlocked program. Public exhibition space is combined with one hundred square meters of private living space into a sprawling, 750-square-meter complex in which both owners share intertwined resources. The modular, tentacle-like components comprising the topography both enforce and confuse this duality: those of one owner are seeded with kudzu, which collects and cleanses waste water while subsuming the building beneath a blanket of uncontrolled growth; those of the other owner are transparent Plexiglas and transmit daylight into the building. These uncanny tectonic/botanic formations, which instigate interactions and negotiations between neighbors, shed light on how political and ecological concerns impact the seemingly hallowed and inviolable principles of property rights and domestic privacy.

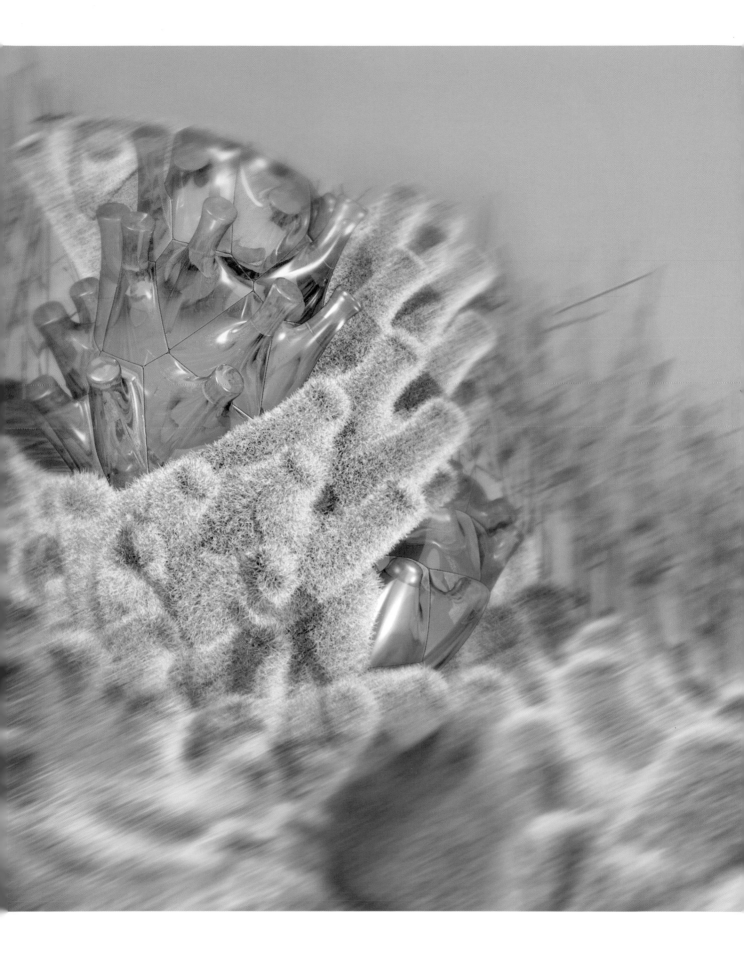

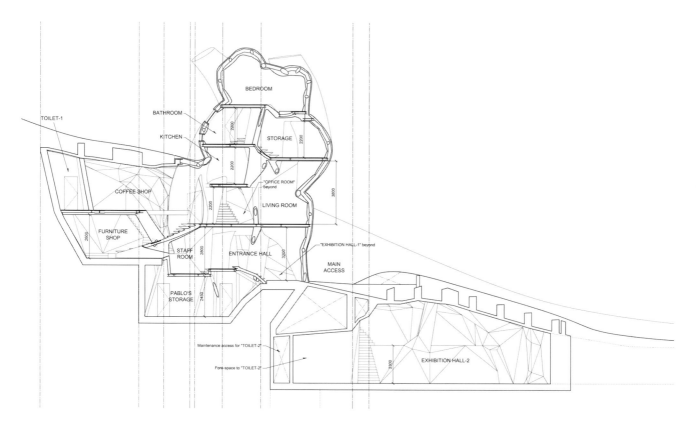

TOILET-1

BATHROOM

BEDROOM

KITCHEN

STORAGE

COFFEE SHOP

"OFFICE ROOM"
beyond

LIVING ROOM

FURNITURE
SHOP

STAFF
ROOM

ENTRANCE HALL

"EXHIBITION HALL-1" beyond

MAIN
ACCESS

PABLO'S
STORAGE

Maintenance access for "TOILET-2"

Fore-space to "TOILET-2"

EXHIBITION HALL-2

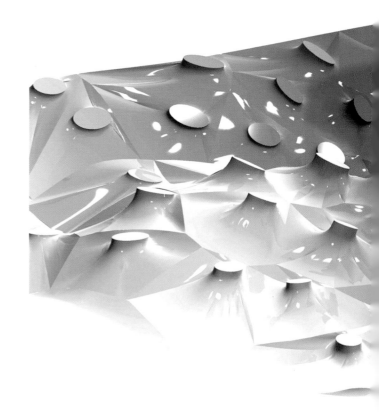

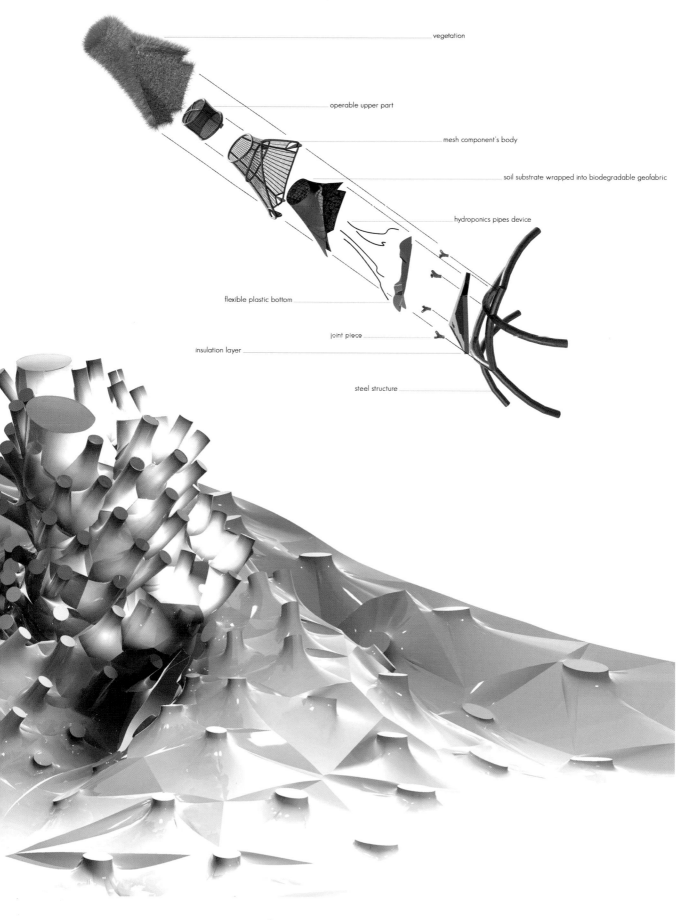

vegetation

operable upper part

mesh component's body

soil substrate wrapped into biodegradable geofabric

hydroponics pipes device

flexible plastic bottom

joint piece

insulation layer

steel structure

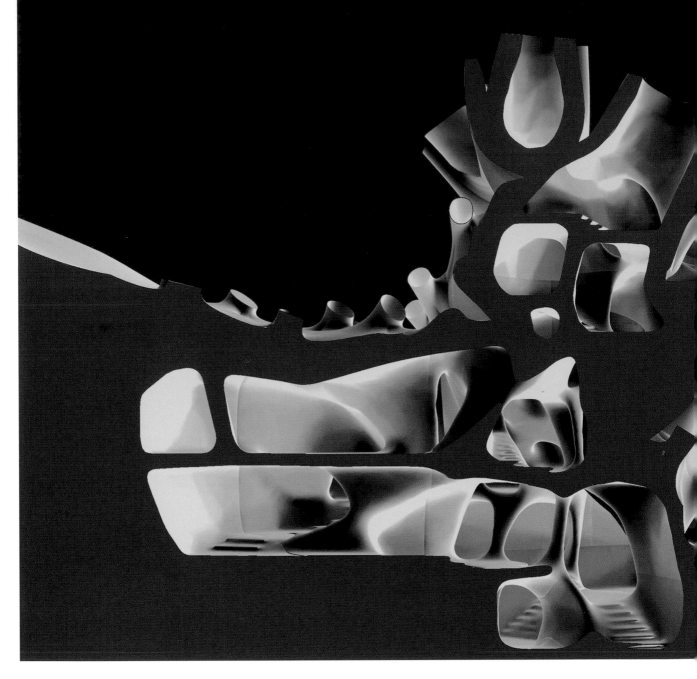

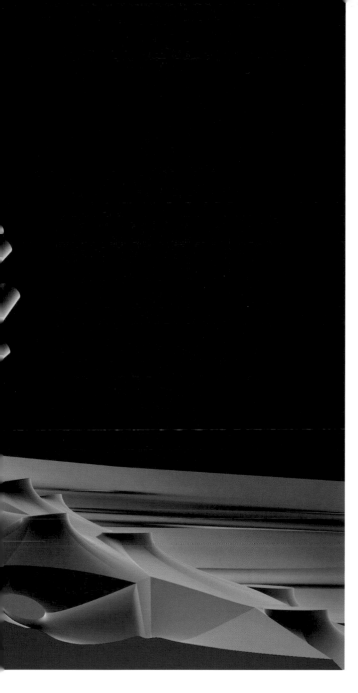

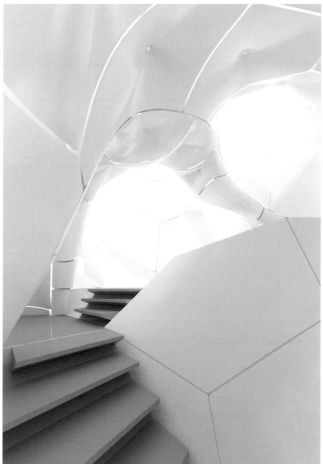

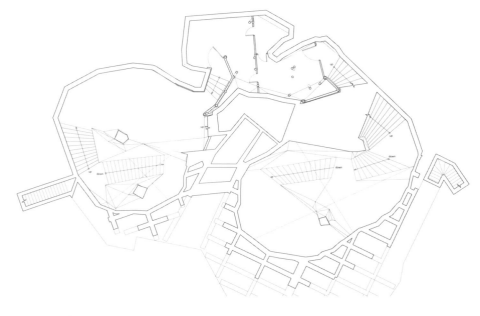

GROUNDWORK | TOPOGRAPHY

Petter Dass Museum

**Snøhetta
Alstahaug, Norway
2001–2007**

In the remote coastal town of Alstahaug, a towering church spire serves as a monument to the Norwegian National poet Petter Dass, who was the church's priest from 1689 until his death in 1707. Snøhetta's adjacent Petter Dass Museum treats the surrounding historic site as a treasured artifact, extending its curatorial program well beyond the museum's walls.

Snøhetta cut a deep, fifteen-meter-wide trench—reminiscent of Michael Heizer's earthwork *Double Negative*—into a raised mound sloping toward the sea and filled the void with 1,350 square meters of museum space. The building's slender form, capped by a gently arced roof, mirrors the contours of the surrounding topography. The seventy-meter wire-cut rock walls of the trench are offset from the sunken building by two meters; the resulting spatial compression expands at either end of the building, where floor-to-ceiling glazing offers framed views of the church at one end and the sea at the other. Neither emerging from nor receding into its terrain, the museum is contiguous with the physical and cultural landscape of its site. While Snøhetta's topological insertion clearly differentiates the boundaries between museum and terrain, it nevertheless invites viewers to consider the tensions between past and present, man-made and natural.

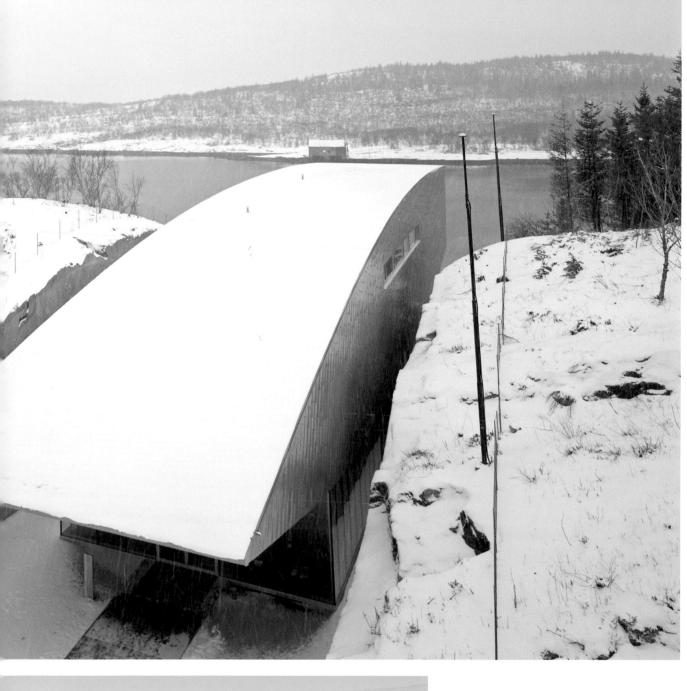

99

GROUNDWORK | TOPOGRAPHY

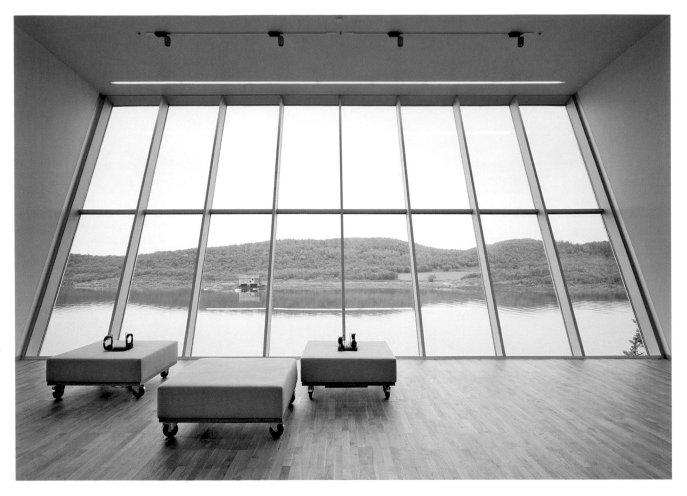

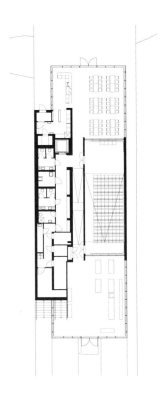
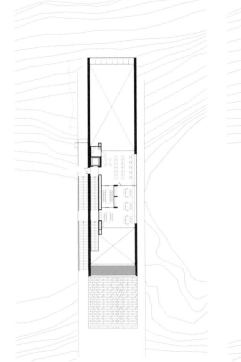
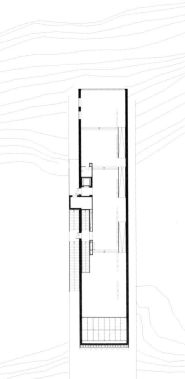

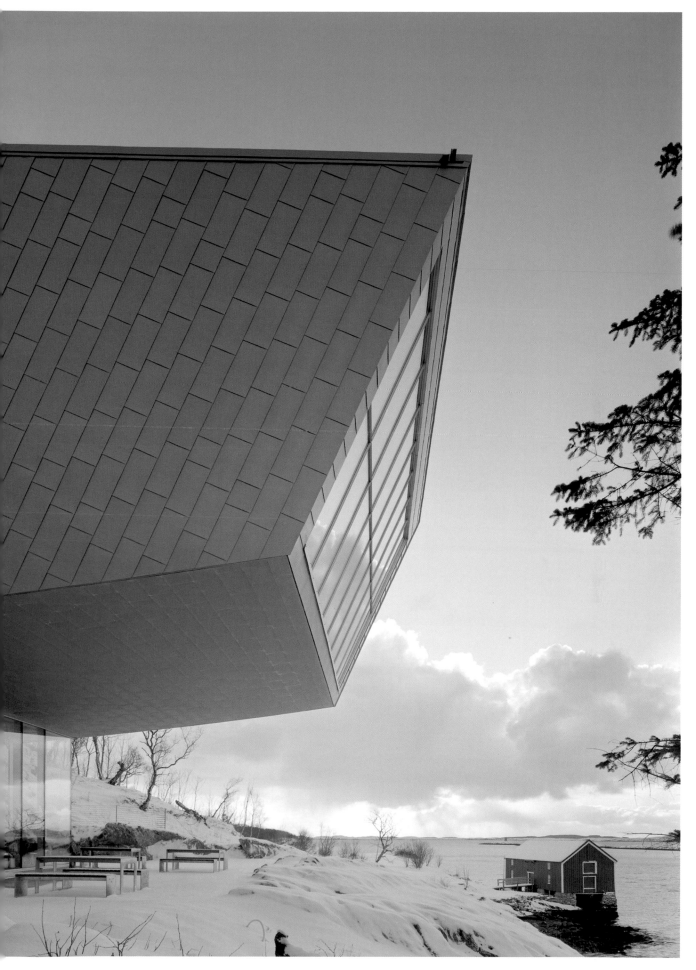

GROUNDWORK | TOPOGRAPHY

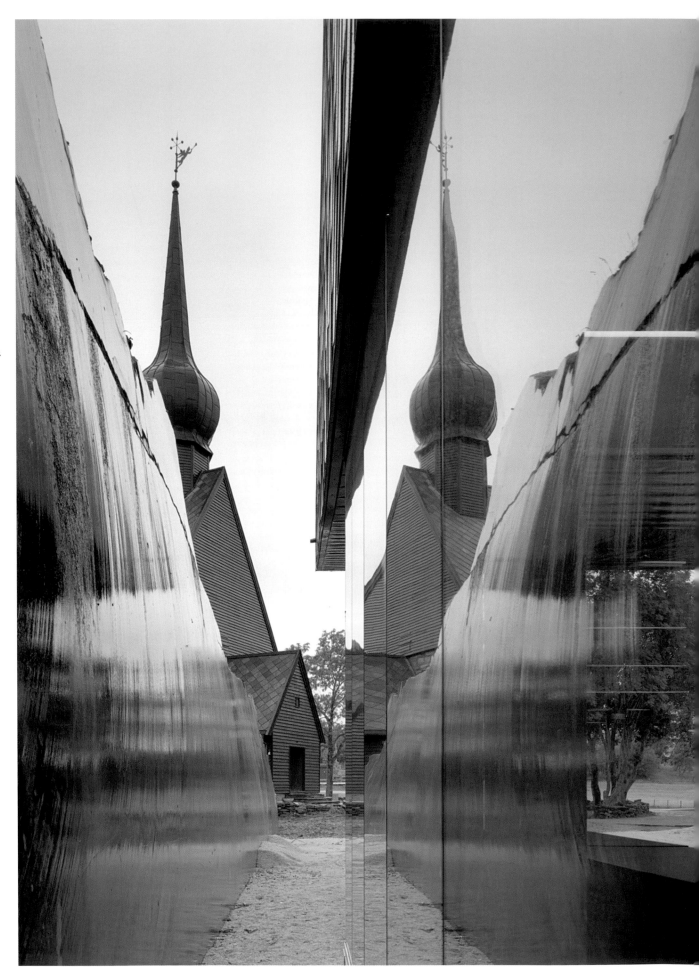

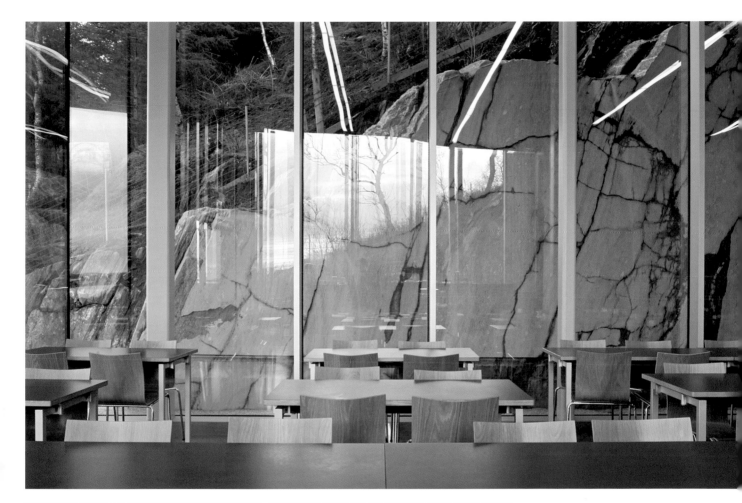

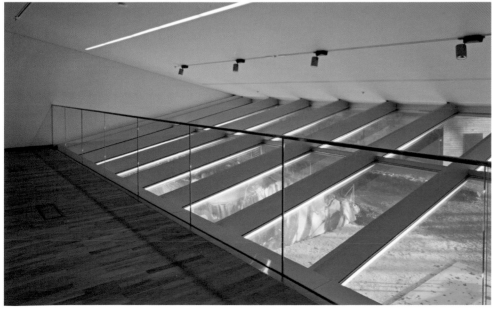

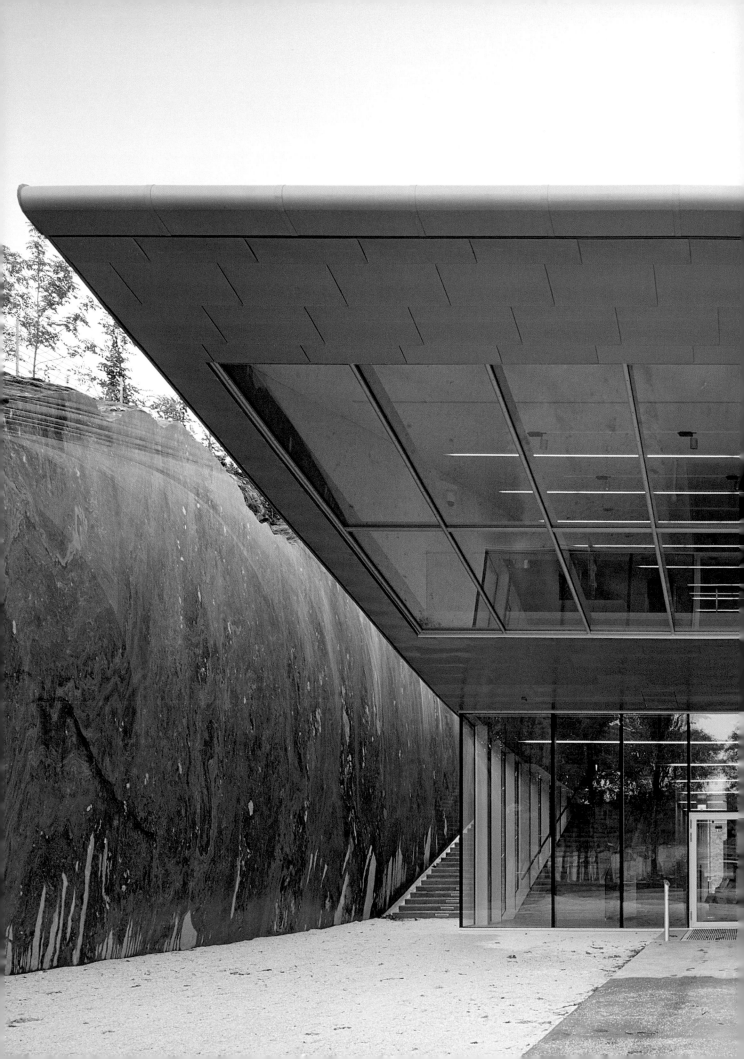

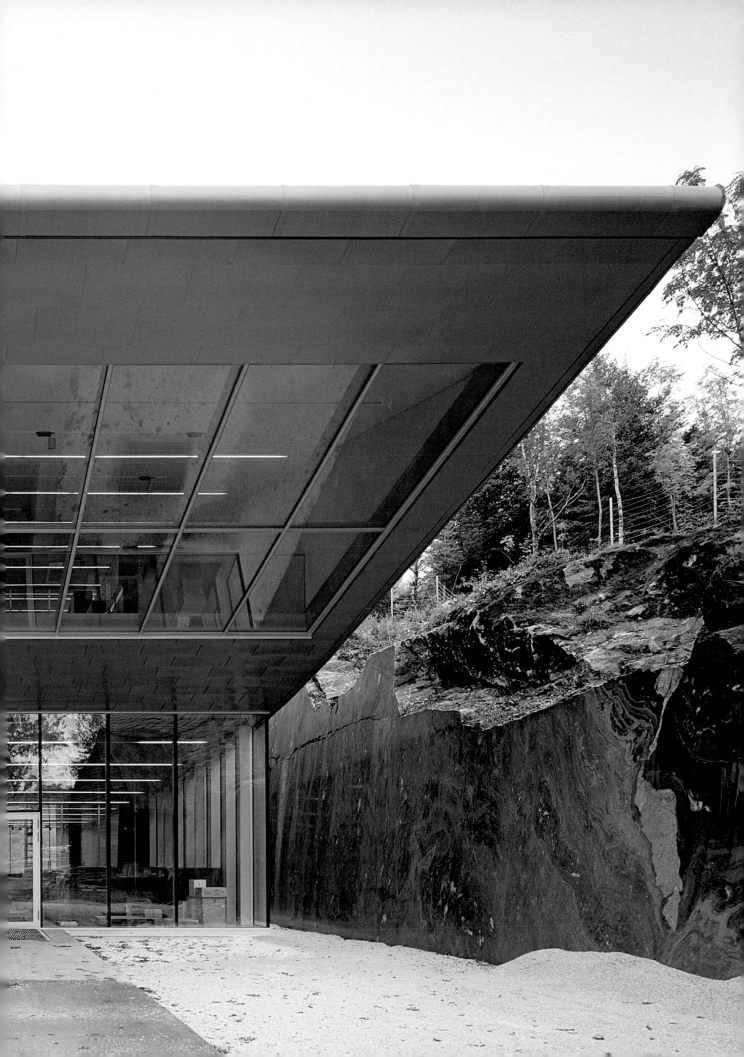

Ecology

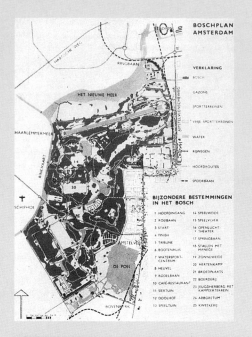

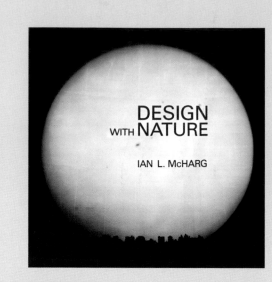

1934–67
Amsterdamse Bos, The Netherlands

1969
Ian McHarg, *Design With Nature*

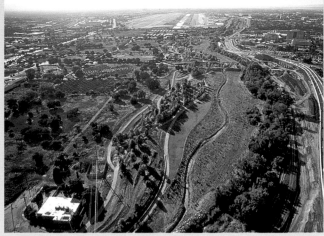

1971
Robert Smithson, *Broken Circle,*
Emmen, Holland

1988–98
Hargreaves Associates, Guadalupe
River Park, San Jose, California

Sustainable design evaluates materials and techniques on the basis of performance and efficiency, rarely taking into consideration issues of form and program. Ecologic designers are instead interested in unleashing the *creative* potential of sustainability, employing green principles at different scales—from the surfaces of buildings to entire master plans—to address issues of water retention, terrain remediation, and energy efficiency. Large and small, new and recycled, Ecologic projects push the parameters of sustainability beyond familiar checklists, raising both environmental and design standards.

Patrick Blanc's patterned vertical walls and Ken Yeang's memorable renderings of eco-skyscrapers paved the way for designers to transform the surfaces of buildings with aromatic and tactile living walls and green roofs that engage the senses and perform ecological functions; unlike their predecessors, these projects defamiliarize common building types by cross-pollinating organic and synthetic materials in unexpected ways. With its facades and roofs entirely covered with plants, VenhoevenCS's sports center merges with, yet stands out from, a surrounding park. Similarly, Höweler+Yoon's tower of stacked modular micro-algae incubators transforms an abandoned lot in downtown Boston into a surreal vertical farm for biofuels. And R&Sie(n)'s vaguely sinister living wall of hydroponic ferns threatens to engulf a Parisian courtyard. In all of these projects, nature is rendered not as a benign but as an ominous force, injecting a critical edge to the prevailing "feel good" sensibility of most green design.

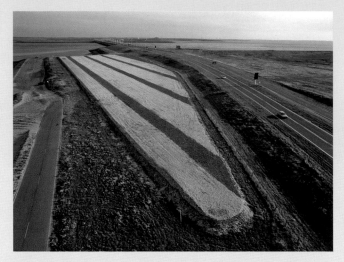

1990–92
West 8, Eastern Scheldt Storm
Surge Barrier, Zeeland, The
Netherlands

1990–2002
Latz + Partner, Duisburg-Nord
Landscape Park

Ecologic designers also test the parameters of green design by working with intangible substances—temperature and energy—in addition to solid materials. In Philippe Rahm's Convective Apartments, energy conservation provides a pretext for deforming the flat floor plate of a multi-family residential building, creating units with ceiling heights that produce varied thermal landscapes. Working at an urban scale, Habiter Autrement's energy pavilion abandons the paradigm of the contained building entirely, deploying ephemeral fields of clustered light poles that collect wind and solar energy and also form covered pathways and a central exhibition space between outlying communities.

Designers who work at a larger urban scale combine the influential process-oriented approach initiated by Ian McHarg in the 1960s with the formal bravura of 1960s and 1970s earthworks created by Robert Smithson and Herbert Bayer, artists unafraid to leave strong marks on the land. And like Smithson, Ecologic designers are not interested in the tabula rasa. In the tradition of Peter Latz, Mathur/da Cunha, and West 8, they work with found, often recycled materials and artifacts that serve as reminders of a site's former life. The abstract circular form of Snøhetta's Turistroute, a service area carved into a site along a scenic highway, is reminiscent of Smithson's *Broken Circle*: made of rocks excavated from the site and driftwood gathered from a nearby beach, it incorporates the ruins of a former radar station. Similarly, in a project indebted to Peter Latz's pioneering Duisburg-Nord Landscape Park, the reclamation of a derelict steel mill

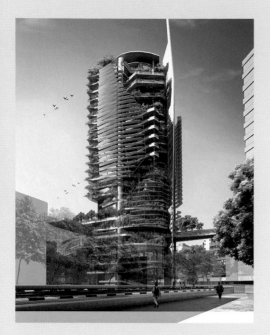

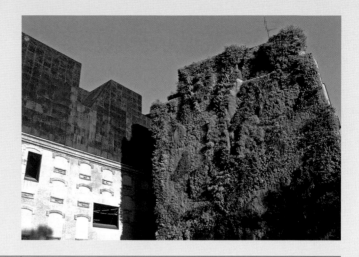

1998
Ken Yeang, EDITT Tower,
Singapore

2007
Patrick Blanc, vertical garden at
CaixaForum, Madrid, Spain

into a public park, D.I.R.T. Studio salvages pavement and unearths curving rail lines in the remediation of the former Philadelphia Navy Yard into a landscaped corporate headquarters for Urban Outfitters.

Like D.I.R.T., Batlle i Roig and Balmori Associates and Joel Sanders Architect focus on revitalizing marginal urban sites: they conserve marshlands adjacent to highways on the outskirts of, respectively, New York and Santander, transforming them into public amenities that foster collective gatherings as well as intimate strolling. These projects reject the tradition of the picturesque park, as do the Amsterdamse Bos by Cornelis van Eesteren and Jacopa Mulder and Guadalupe River Park by Hargreaves Associates, creating visually arresting, socially productive green spaces that manage threatened natural resources.

I'm Lost in Paris

R&Sie(n)
Paris, France
2008

A private residence hidden within a bourgeois Parisian neighborhood, I'm Lost in Paris exploits technological innovation to probe the underside of contemporary environmentalism. R&Sie(n) erected a 130-square-meter cabana to shelter a family of four within the shared interior courtyard of a typical Parisian block. The modest three-story pavilion is wrapped with wide-gauge steel netting to support a vertical garden of 1,200 hydroponic ferns that camouflages the uncanny new structure from its neighbors.

The ferns feed off collected rainwater and misting nozzles. In addition, they are sustained by a constellation of three hundred suspended blown-glass vases whose bio-morphic forms evoke insect nests. Referred to as "rear windows," the vases cultivate rhizobia, a bacterial soup used to nitrogenize the ferns without the assistance of soil. This site of botanical production doubles as urban spectacle, offering an ironic spin on the wholesome mentality of most green design: the project elicits ambivalent responses from its neighbors, who are unnerved by the creepy bacterial feeding process and the image of nature gone wild.

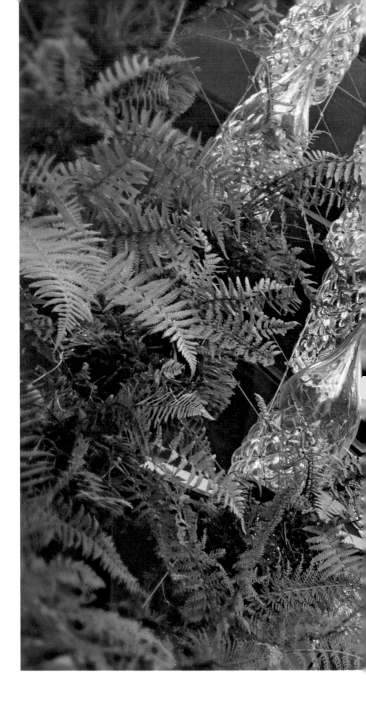

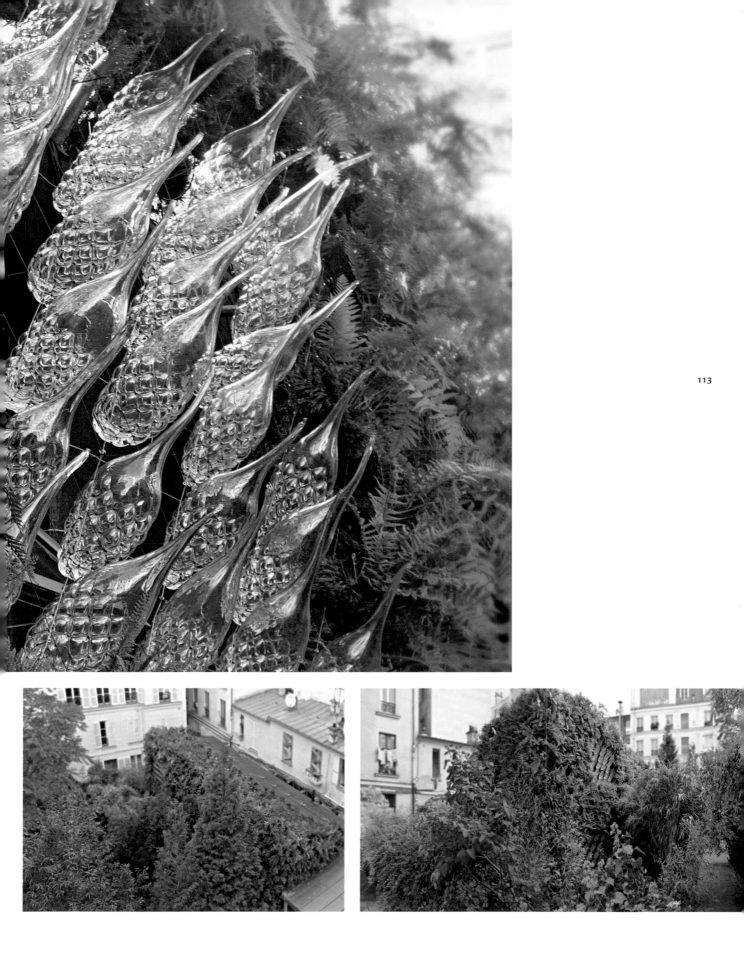

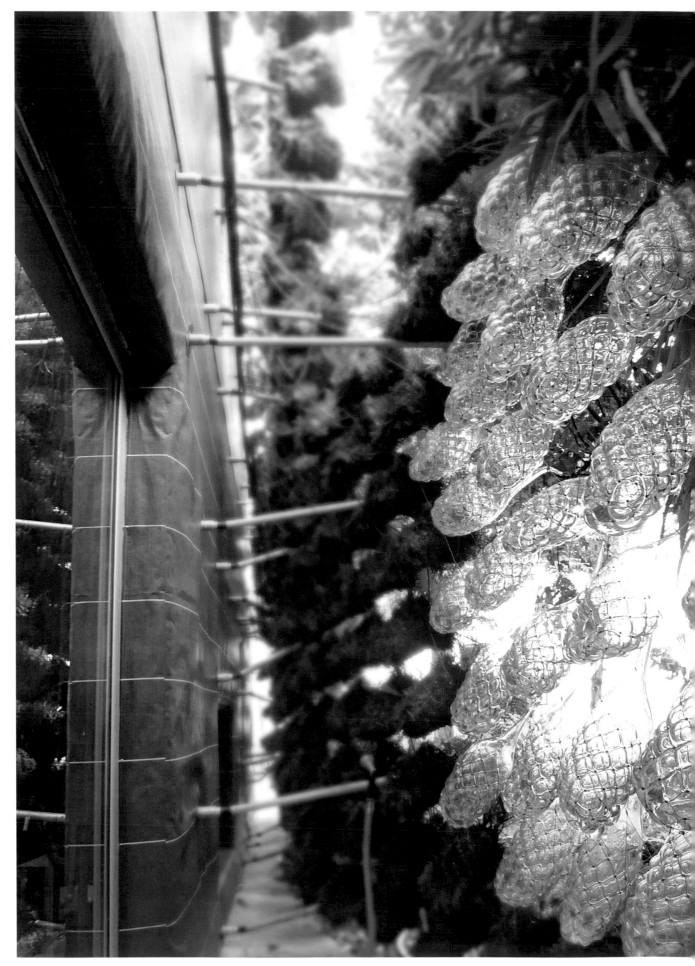

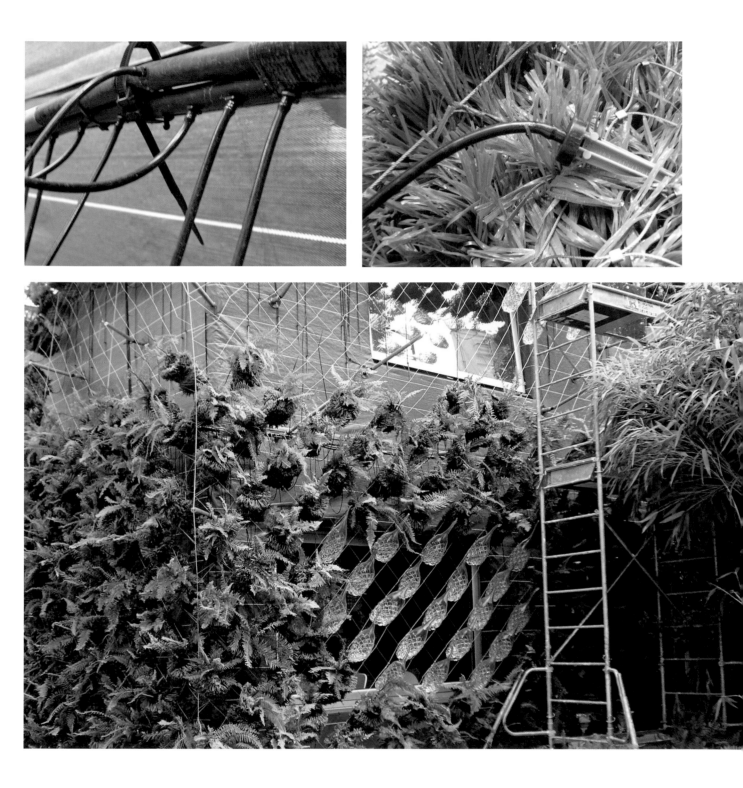

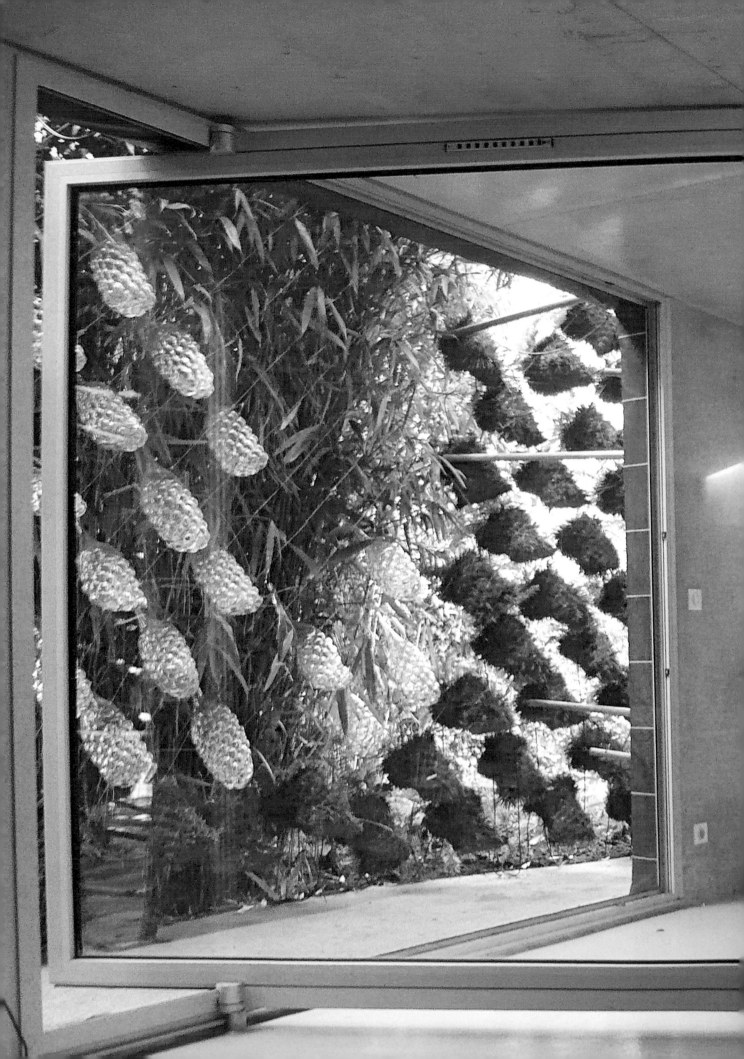

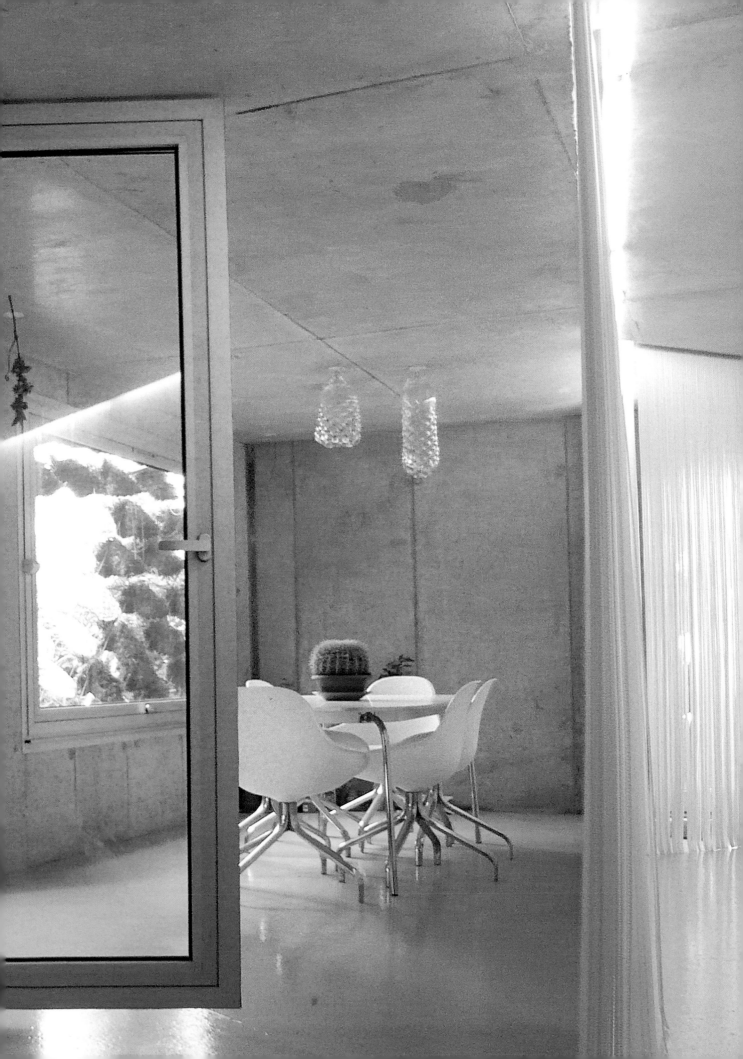

Sportplaza Mercator

VenhoevenCS
Amsterdam, The Netherlands
2001–2005

Located in a previously open park, the 7,100-square-meter athletic and leisure Sportplaza complex is a provocative social condenser entirely covered in plants. Inspired by philosopher Michel Foucault's concept of "heterotopia," VenhoevenCS conceived the project as a space with coexisting social, programmatic, and ecological spheres. Diverse amenities—swimming pool, therapeutic pool, fitness center, party hall, café, and even a branch of Kentucky Fried Chicken— attract local groups that, under normal circumstances, would rarely commingle.

The building's facades are treated as living landscapes that effectively camouflage the new structure, allowing it to blend into, yet stand apart from, the surrounding park. The exterior surface—nicknamed the "Wonderwall"—is an innovative botanical system housing over fifty plant species with integrated rain collection and a feeding system comprised of hoses and sensors. The formlessness of the lush plantings is accentuated by the tilting surfaces and irregular angles of the underlying building. Drawing from a vocabulary that comprises not only the Romantic grotto but also the aesthetic of science-fiction films and theme parks, Sportplaza redefines ecology as a nexus of forces beyond those of environment alone, synthesizing mass media, multiculturalism, and biodesign into a strange new vision of public space.

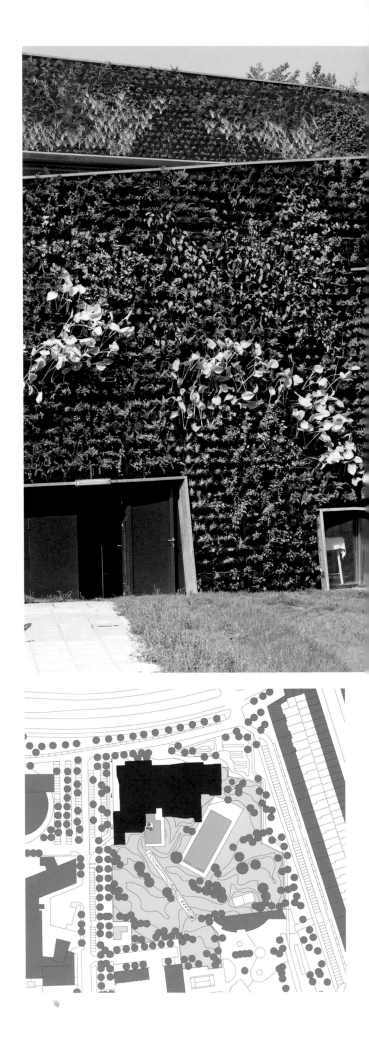

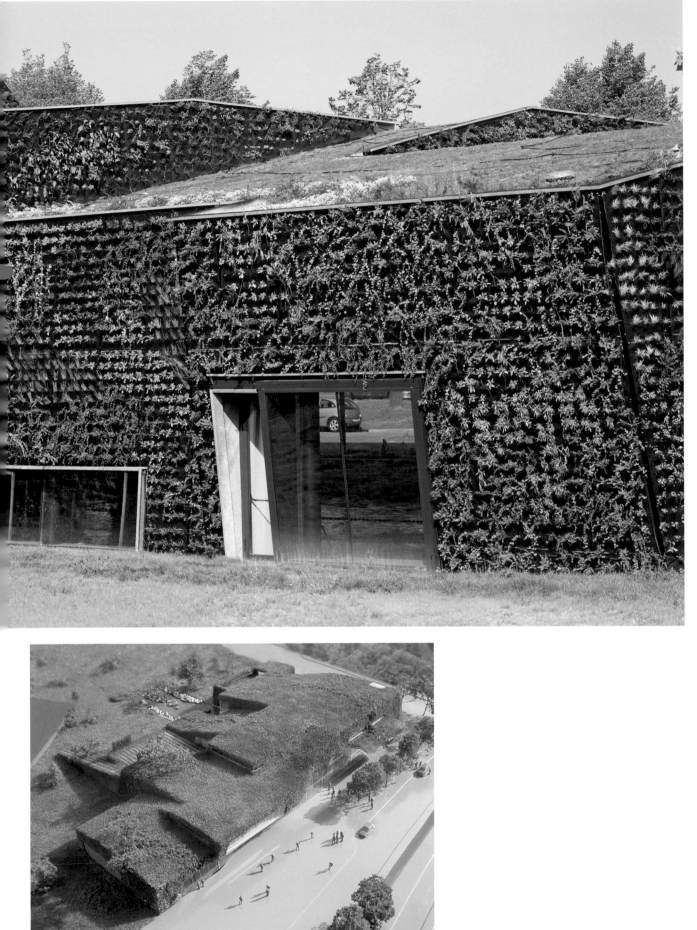

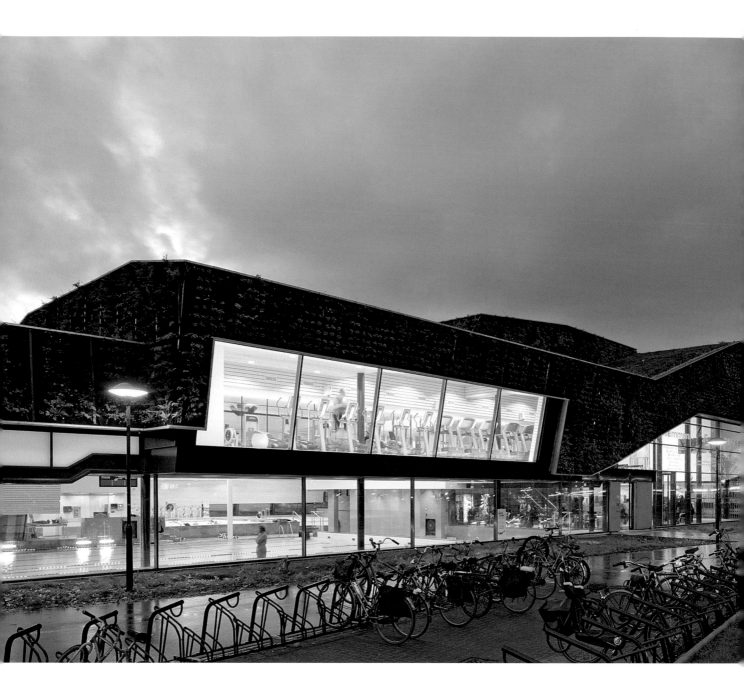

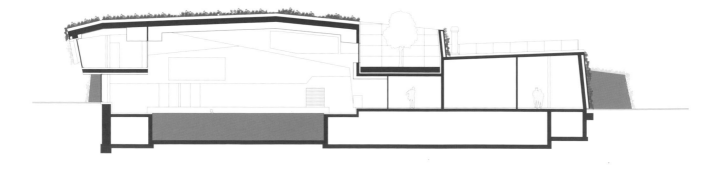

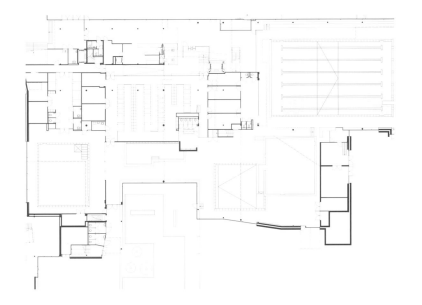

121

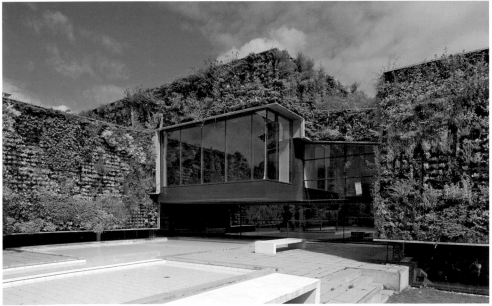

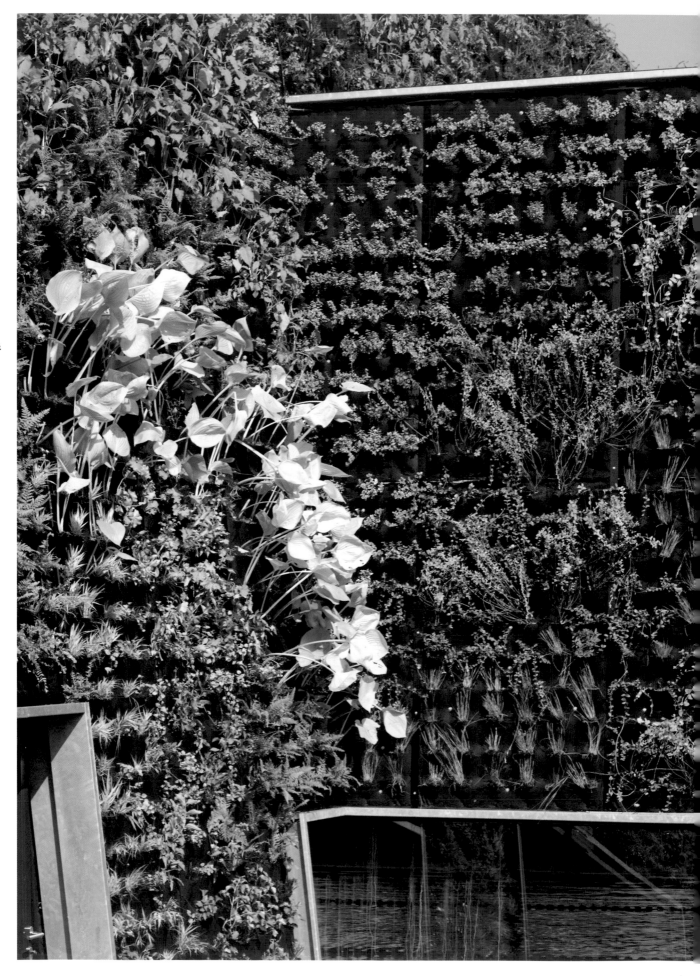

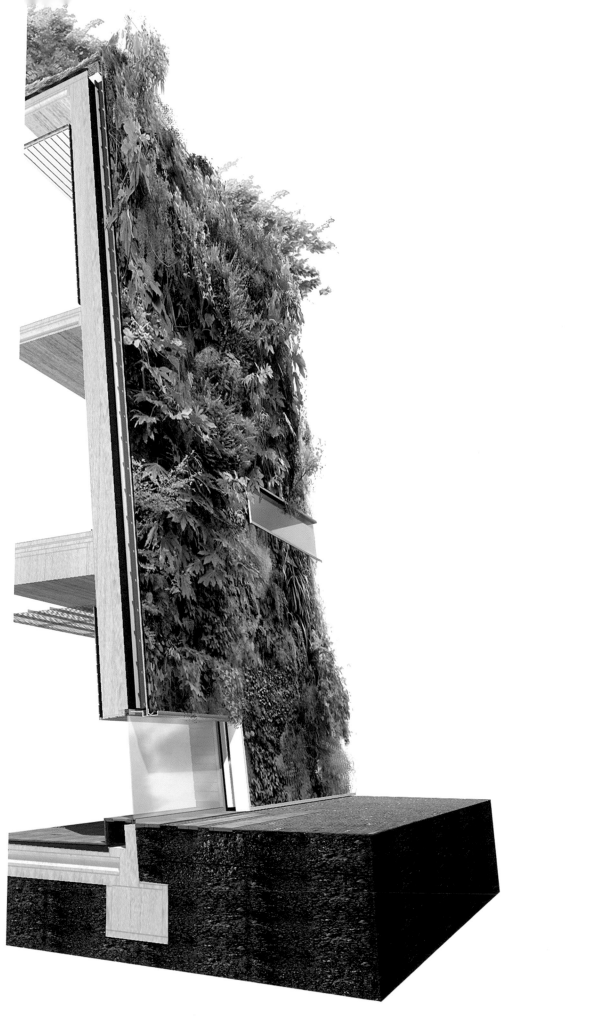

GROUNDWORK | ECOLOGY

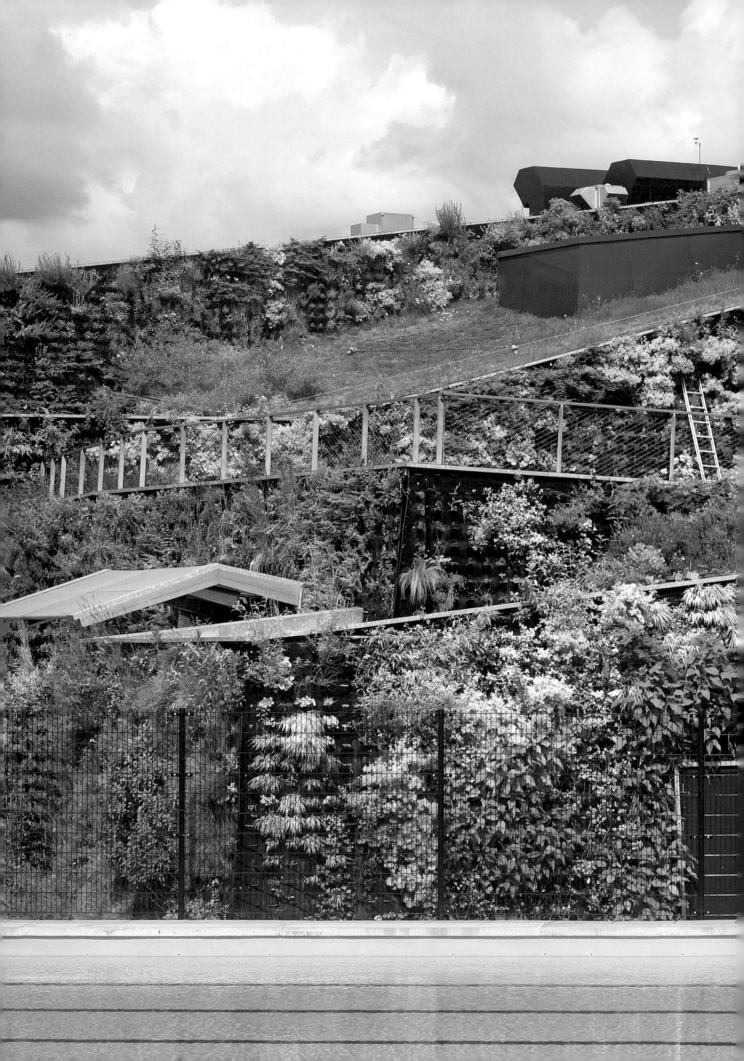

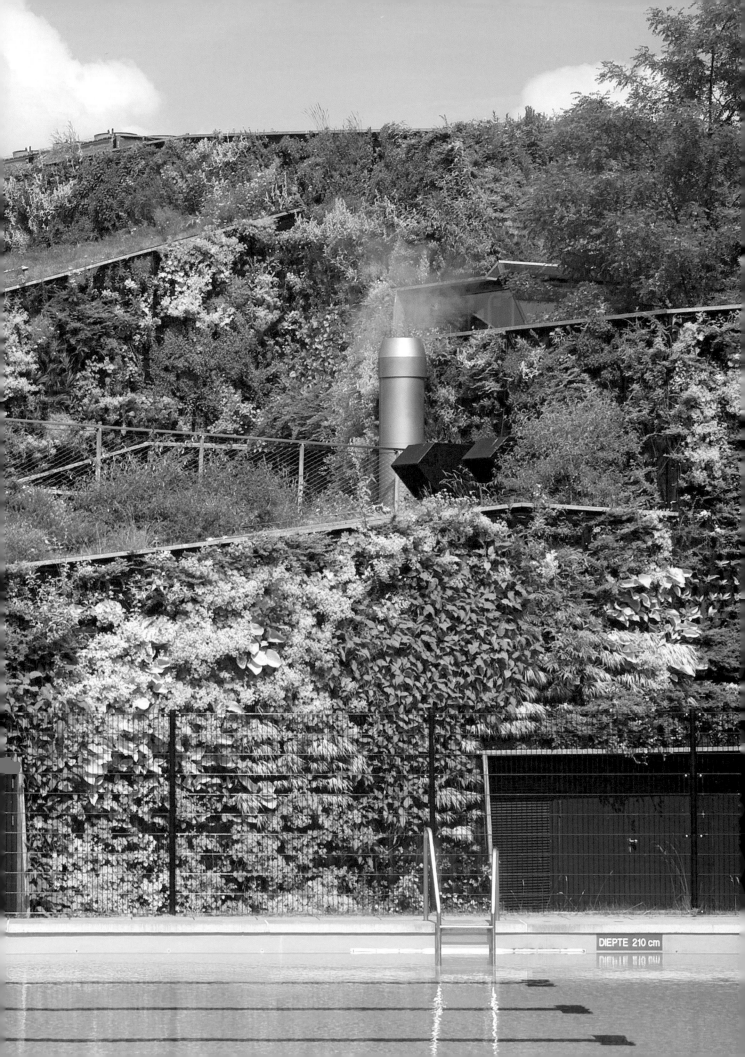

DIEPTE 210 cm

Eco-Pod: Pre-Cycled Modular Bioreactor

**Höweler+Yoon Architecture
and Squared Design Lab
Boston, Massachusetts
2009**

An architectural "stimulus package" with a joint economic and ecological agenda, the Eco-Pod is a temporary tower housing micro-algae farming. Micro-algae yields over thirty times more energy per acre than any other biofuel, providing a clean and renewable alternative to gasoline. The project has the capacity to grow vertically: the algae bioreactor is constructed from stacked prefabricated modules that can be quickly assembled, disassembled, and redistributed to almost any site. Most of the pods cultivate micro-algae; others serve as "research incubators" where new species and methods of extraction can be tested. The pods are installed using a robotic armature—an on-site apparatus that shuffles and stacks them. Although it recalls the modular prefabricated towers of Archigram and the Japanese Metabolists, the Eco-Pod is less a megastructure than a kind of grass-roots urban infill. At once vertical urban park and billboard to scientific progress, the Eco-Pod weds principles of mass production, economic development, and ecology to create a visually arresting building that heightens environmental awareness while literally growing the economy.

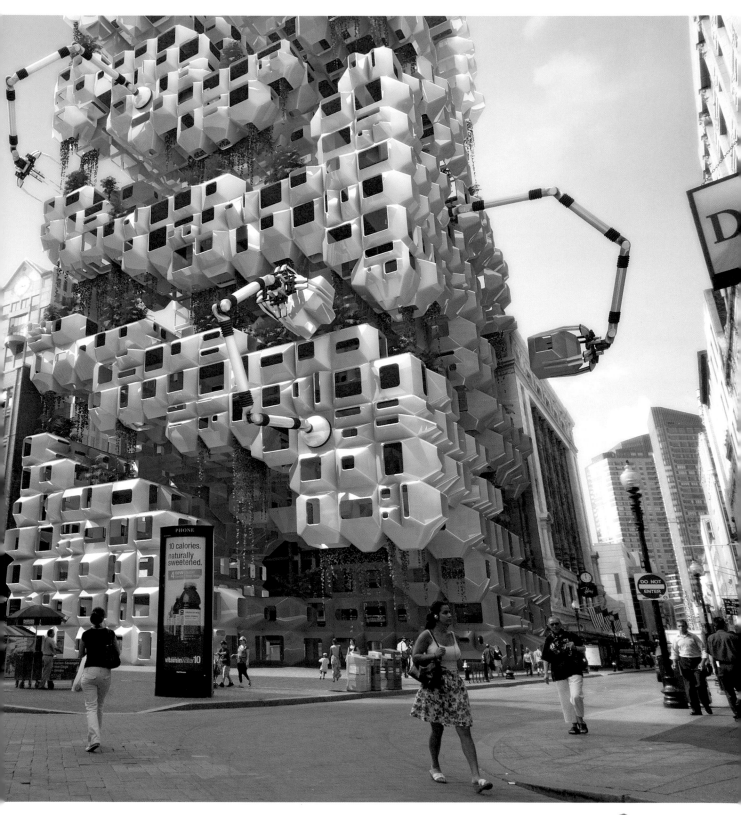

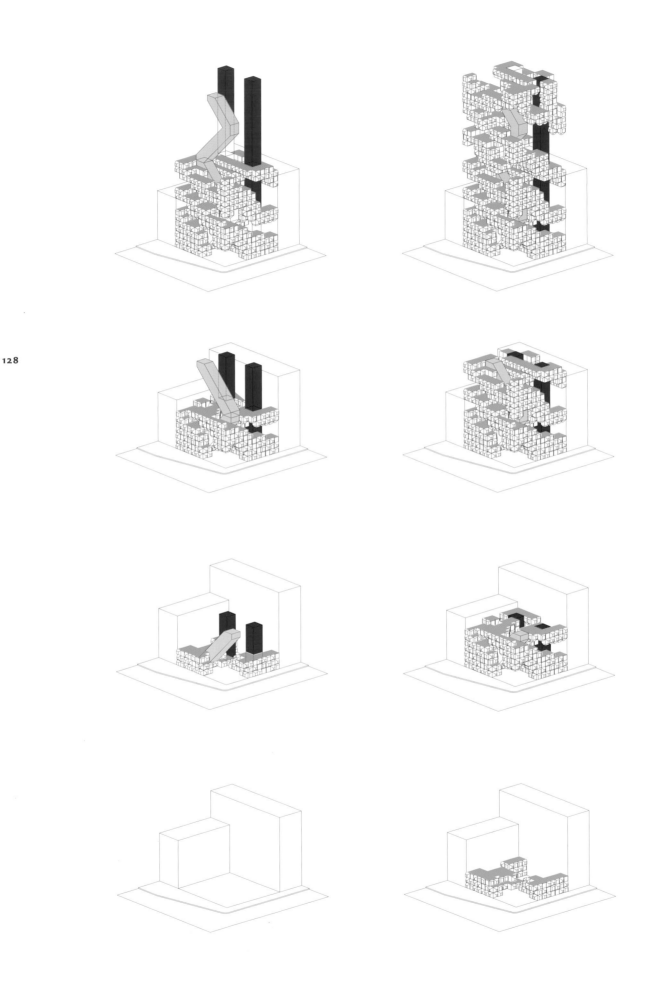

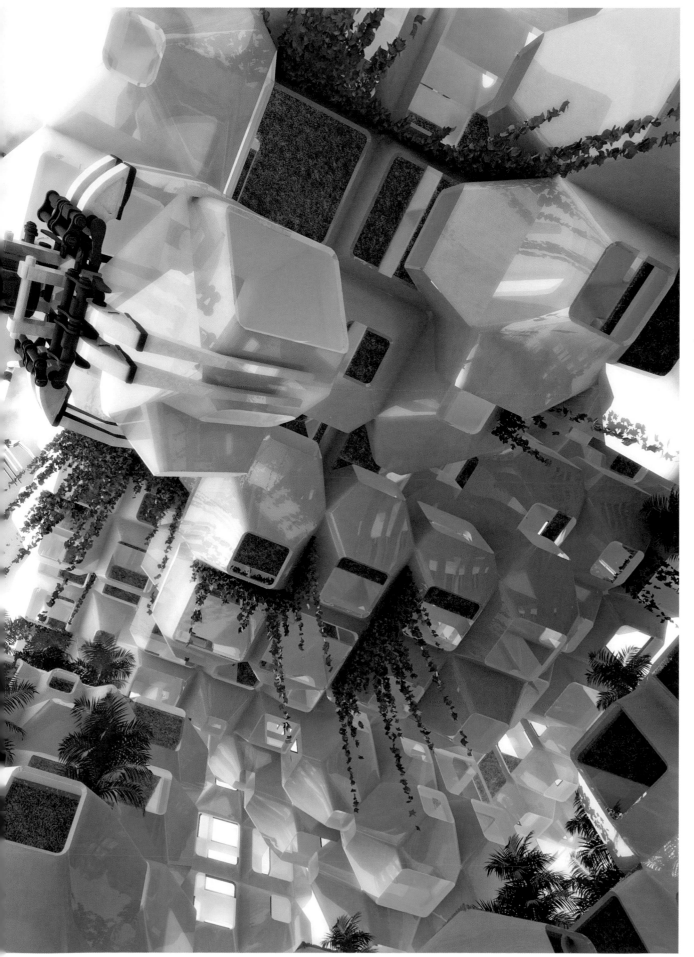

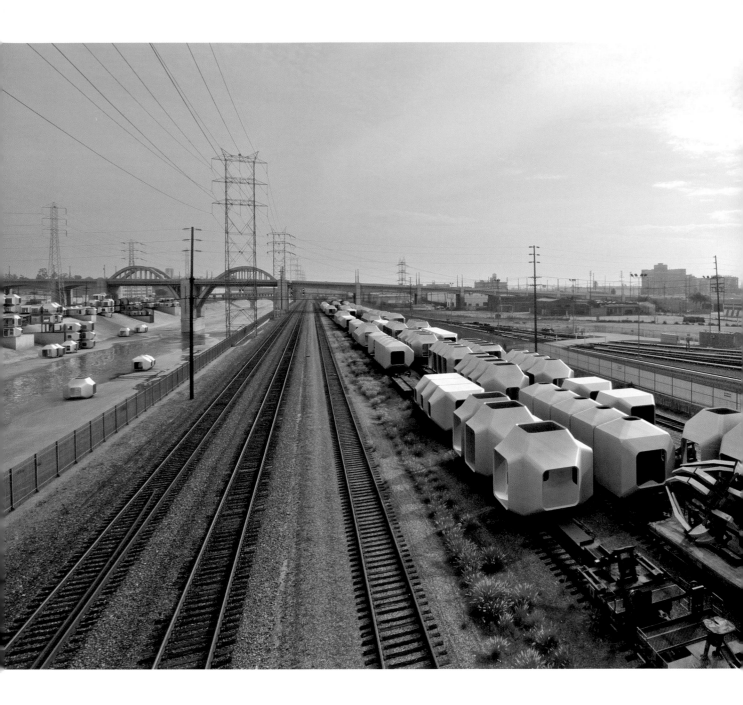

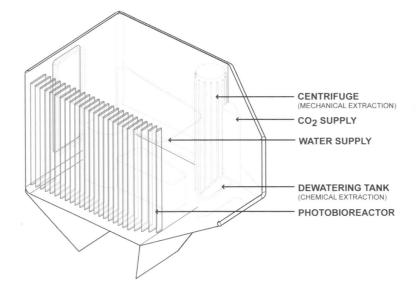

CENTRIFUGE
(MECHANICAL EXTRACTION)

CO₂ SUPPLY

WATER SUPPLY

DEWATERING TANK
(CHEMICAL EXTRACTION)

PHOTOBIOREACTOR

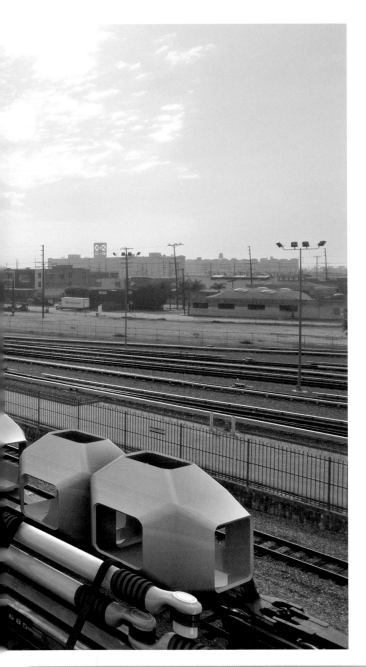

131

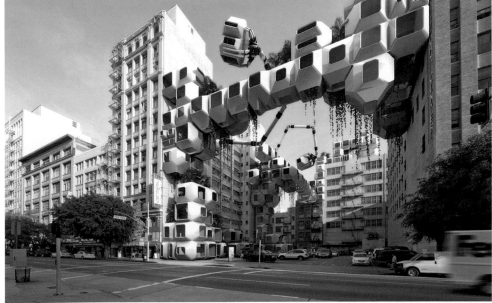

GROUNDWORK | ECOLOGY

Convective Apartments

Philippe Rahm Architectes
Hamburg, Germany
2010

The Convective Apartments offer a definition of ecology that bridges the material systems of architecture and the immaterial systems of thermodynamics to create a controlled environment for living. The project takes advantage of the fact that warm air rises and cool air falls, configuring the programmatic spaces of a typical house—bedroom, kitchen, bathroom—in a way that exploits the natural heat spectrum of the interior. Ground planes are modulated so that specific zones in the apartments vary in temperature depending on the inhabitant's level of activity and state of dress: warmer spaces like bathrooms are elevated to be closer to the ceiling; cooler areas like bedrooms and living spaces are placed on lower levels. The thermal landscape created by these stacked residences saves energy, both shaping and tracing invisible temperature flows. Rahm's scheme even extends into the landscape: the color and texture of specific plantings—darker grass to the north, near-white grasses interspersed with aromatic mint to the south—absorb or reflect light to heat or cool the ambient air and guide site winds.

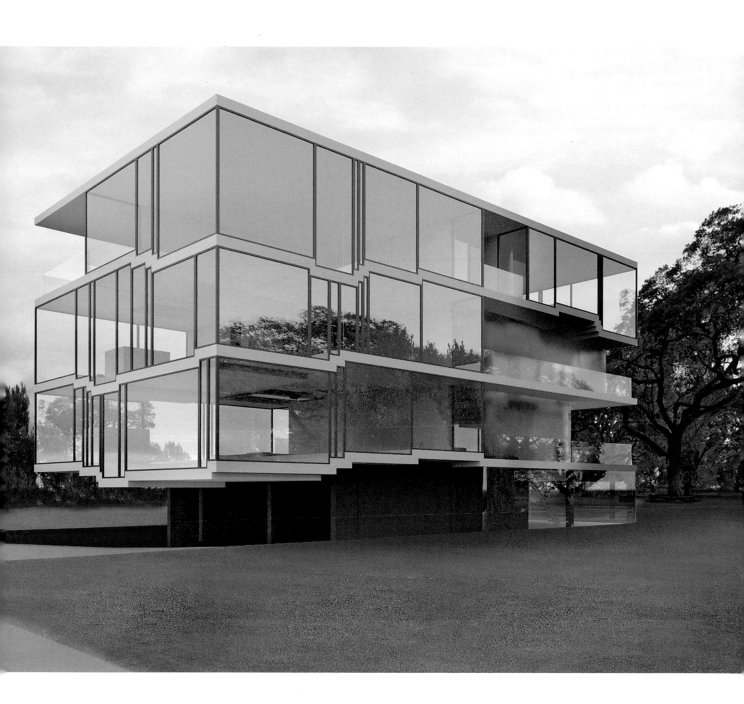

bed room kitchen living room bathroom

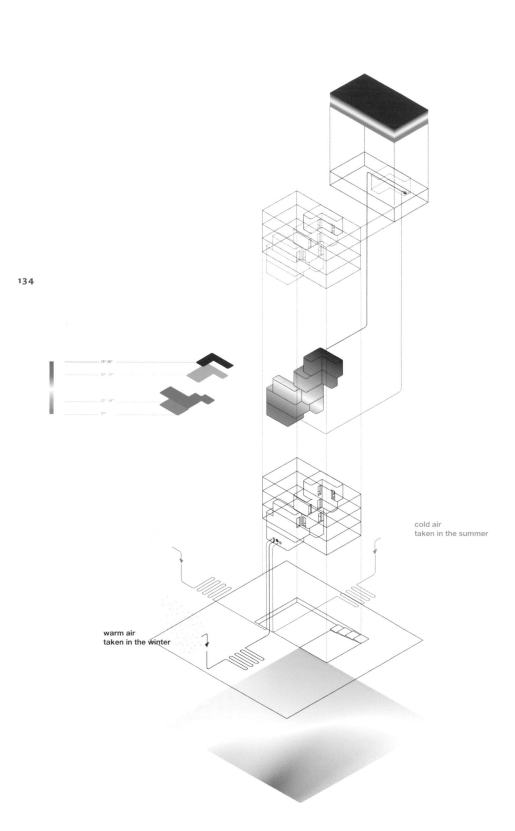

35°-50°
20°-25°
12°-18°
10°

cold air
taken in the summer

warm air
taken in the winter

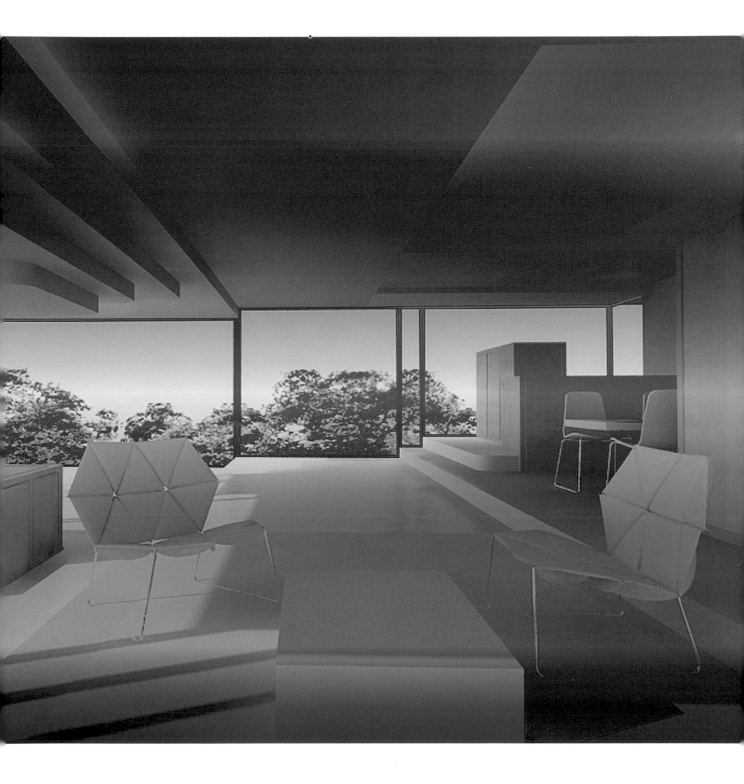

Stockholm Energy Pavilion

Habiter Autrement
Stockholm, Sweden
2010

To raise public awareness of energy technologies and usage, Habiter Autrement proposed a linked network of wind- and solar-power generators—a closed-circuit power grid—to be installed throughout northern Stockholm. The master plan, spanning three suburban communities and culminating with an exhibition pavilion in Järva Field, consists of hundreds of glass-fiber poles. Some are capped with leaf-shaped photovoltaic panels that feed captured energy to a central battery; others are designed to sway and bend with the wind to convert kinetic energy into electricity. The pole components, or "sprouts," are dispersed along undeveloped gravel and dirt roads to form covered pathways that light up at night using the energy they have generated.

The rambling paths intersect at the "grove" pavilion, where the poles cluster in greater density to create a thin canopy that encloses exhibition programming and provides a central meeting place for nearby residents. The translucent membrane roof collects rainwater and distributes it to an acrylic tank visible beneath the plinth's floor panels. Through the use of transparent materials and structural components that make visible the energy distribution system that fuels it, the pavilion informs visitors of its status as both pedestrian and energy infrastructure.

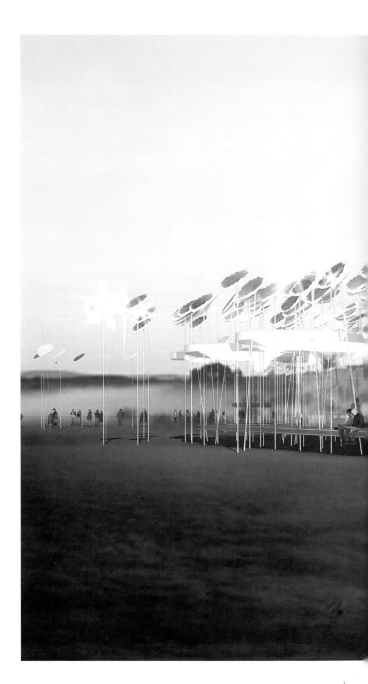

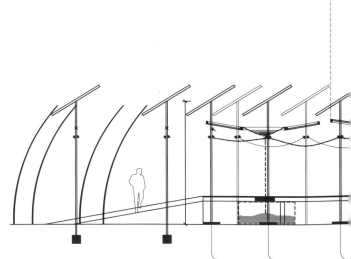

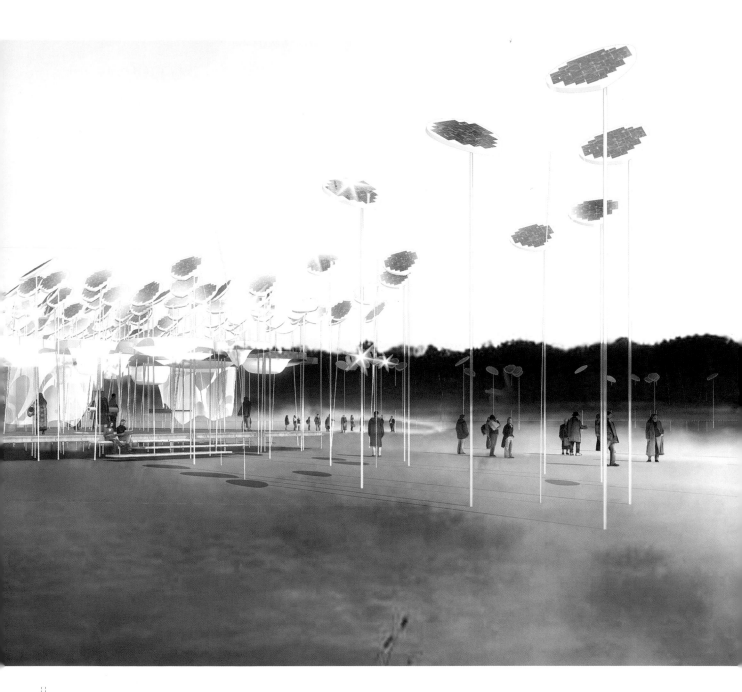

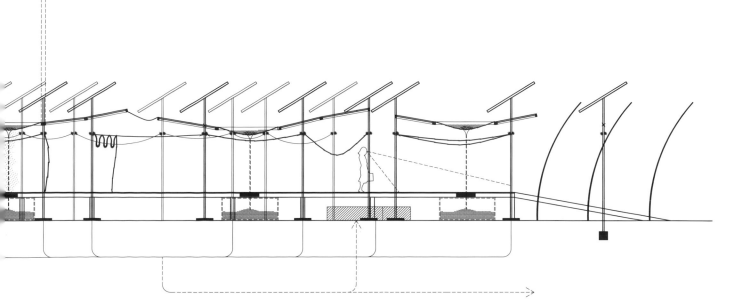

GROUNDWORK | ECOLOGY

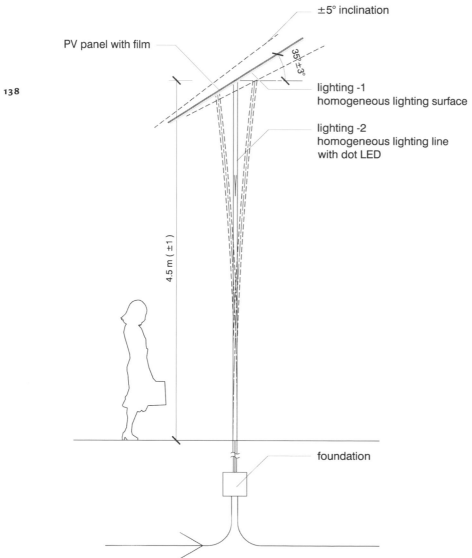

±5° inclination

PV panel with film

35°±3°

lighting -1
homogeneous lighting surface

lighting -2
homogeneous lighting line
with dot LED

4.5 m (±1)

foundation

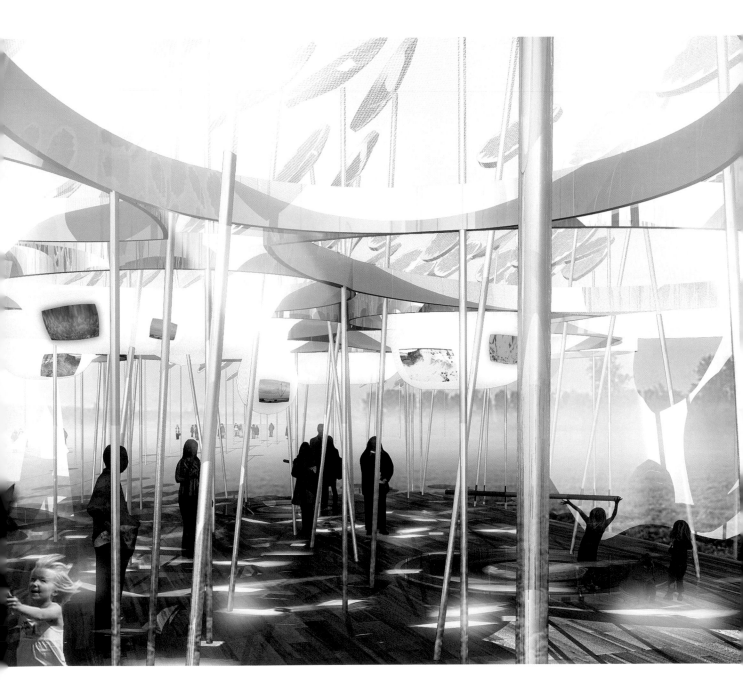

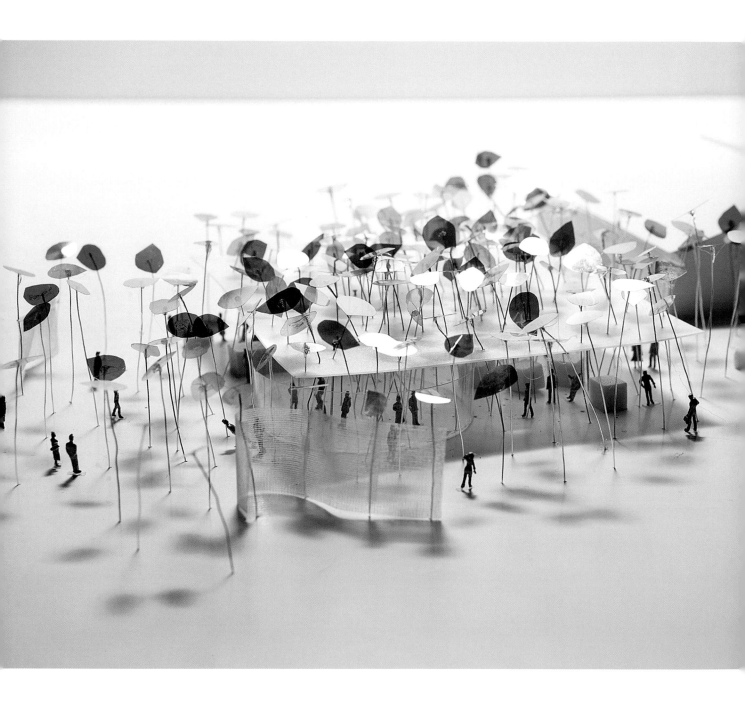

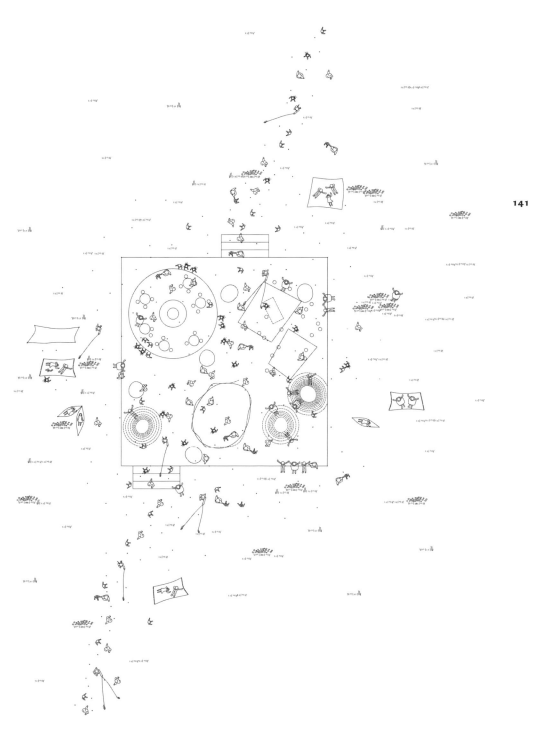

Turistroute
in Eggum

**Snøhetta
Eggum, Norway
2004–2007**

The Norwegian Public Roads Administration's E10 tourist route is a scenic drive that winds through the pastoral landscape of Norway's Lofoten archipelago. Snøhetta's scheme adds a service building as well as parking for buses, campers, and cars. The project's use of salvaged materials coupled with its network of roads, parking, and amenities that respect the contours of the landscape prove that infrastructure and site need not be mutually exclusive.

The architects worked within the profile of the site, which is bounded by mountain crags, open plains, and sea vistas, an approach that yielded formal and programmatic opportunities. The service building is discreetly inserted into a grassy knoll crowned with the stone ruins of a former radar station; the protruding facade is clad with driftwood from a nearby beach. The site gently descends to a gravel parking lot. A stepped wall of gabion blocks—filled with stones culled from the site's construction—rings the service building and doubles as amphitheater seating. While the project works with the form and materials of its natural context, it never entirely defers to its setting: its use of abstract circular forms imposed upon natural terrain recalls projects like Robert Smithson's *Spiral Jetty* and *Broken Circle*, earthworks also located in remote settings bounded by water. All three strike a delicate balance between nature and artifice.

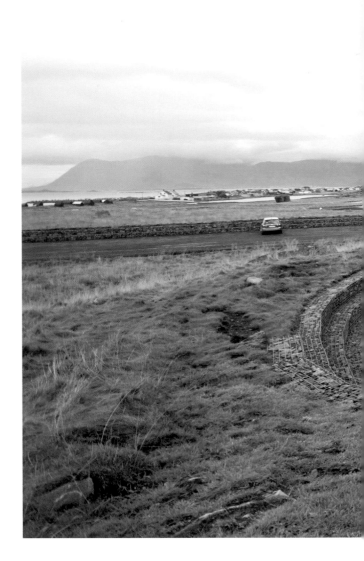

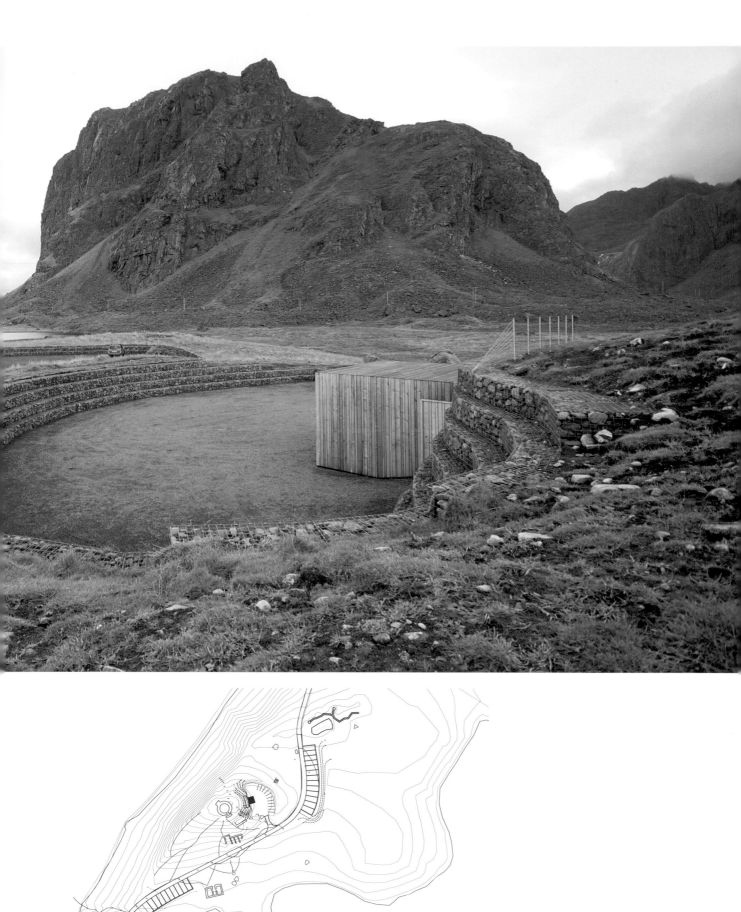

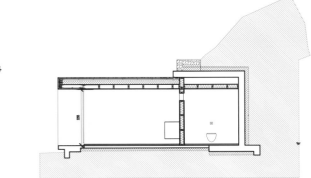

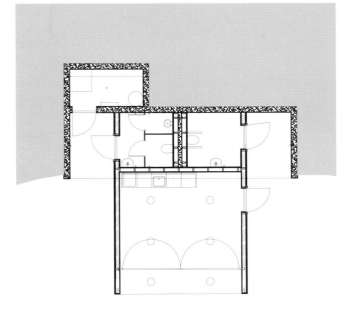

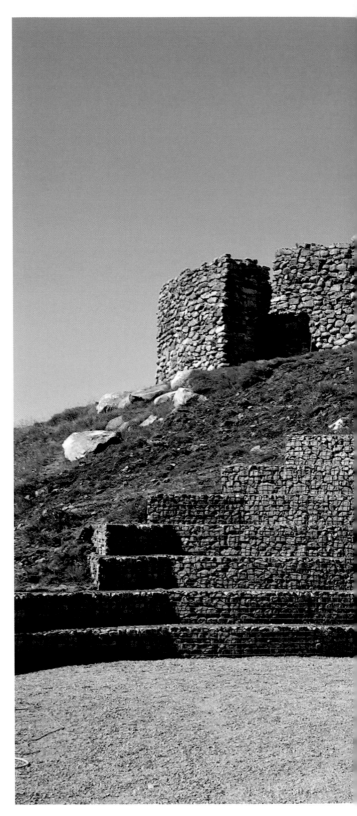

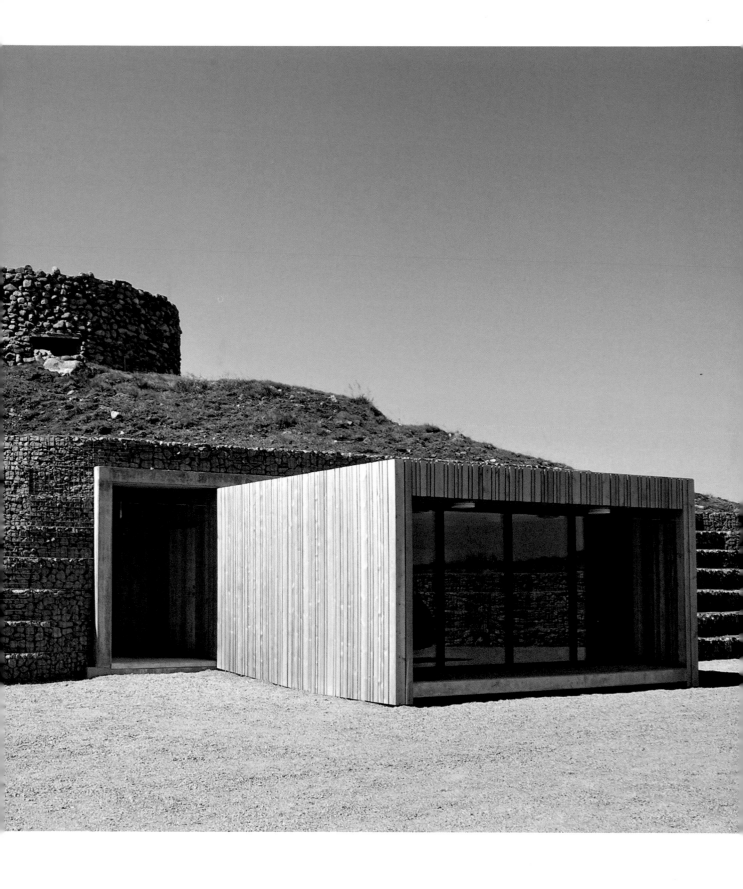

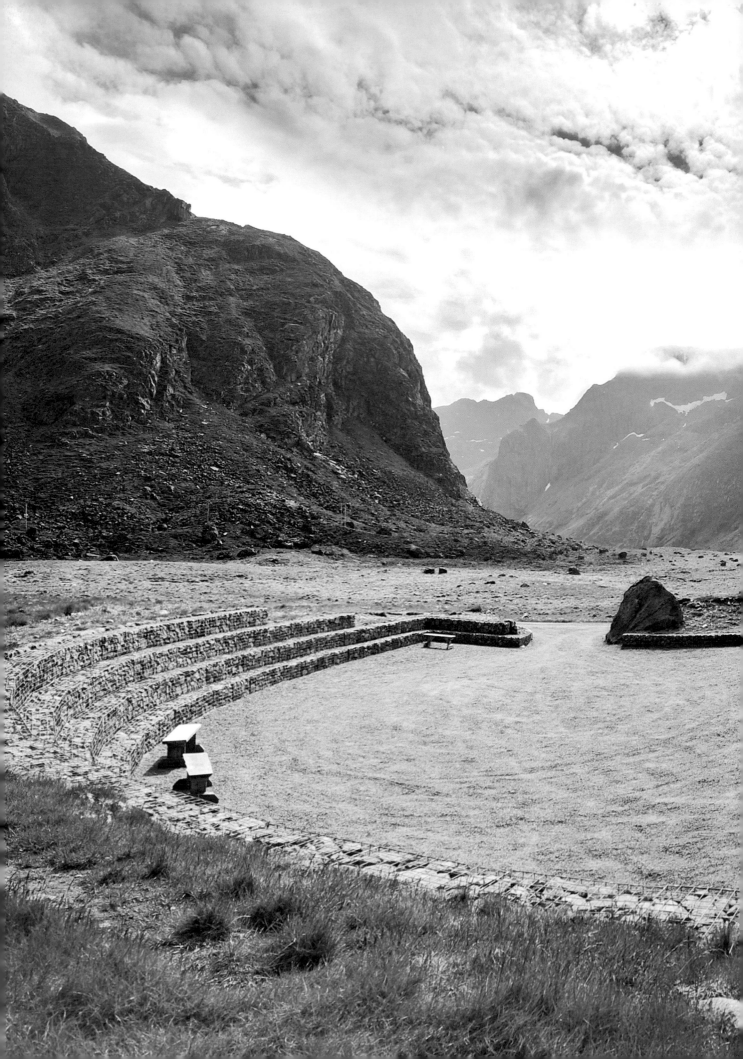

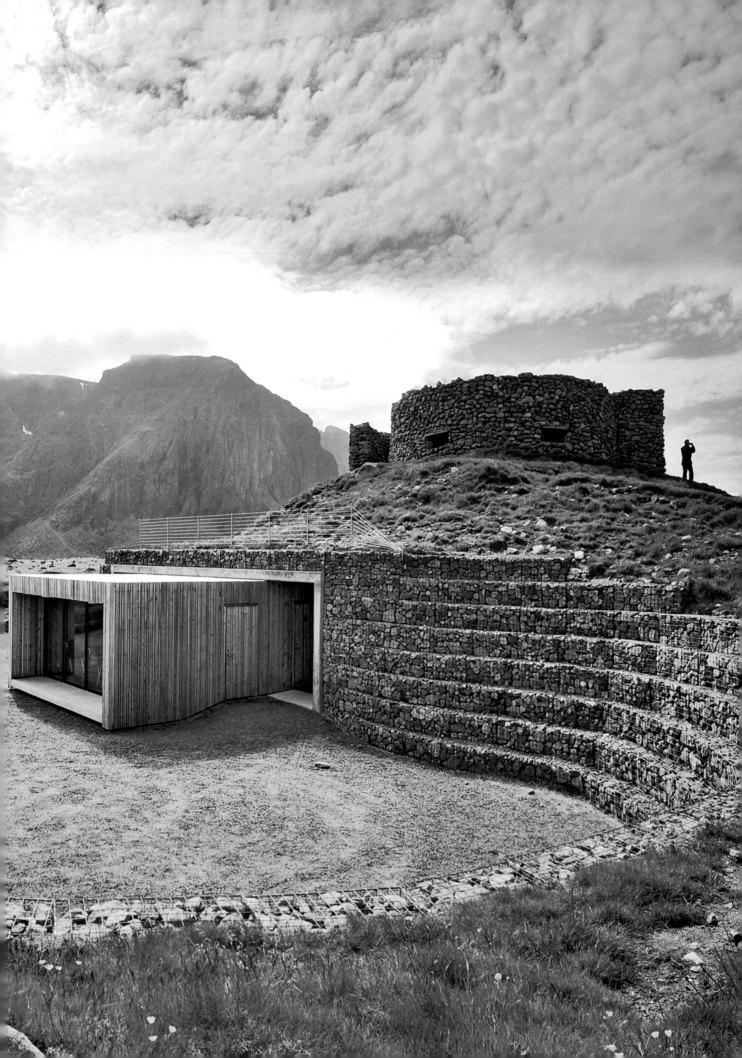

Urban Outfitters Headquarters

**D.I.R.T. Studio
Philadelphia Navy Yard,
Pennsylvania
2005–ongoing**

D.I.R.T. Studio's project for the transformation of the former Philadelphia Navy Yard into a corporate and creative headquarters for retailer Urban Outfitters exemplifies the office's design methodology for reclaiming industrial sites: new programs and ecological functions are introduced to highlight the original historical, social, and environmental forces that shaped the sites. The excavation of the red-brick Navy Yard—a site of battleship production for over a century—was also an excavation of its rich history. D.I.R.T. salvaged thick slabs of pavement and railroad infrastructure, which were used to create a collaged ground plane: concrete and asphalt were broken into flagstone-like pavers and crushed into calico-colored mulches at the base of hedgerows and native trees. The scheme required no new materials and prevented tons of demolished materials from being transported to a landfill. The Navy Yard master plan also forms larger civic connections. Curving rail lines are unearthed to delimit circulation patterns through the site, and a central dry dock serves as the public landing for a civic axis terminating at the Delaware River.

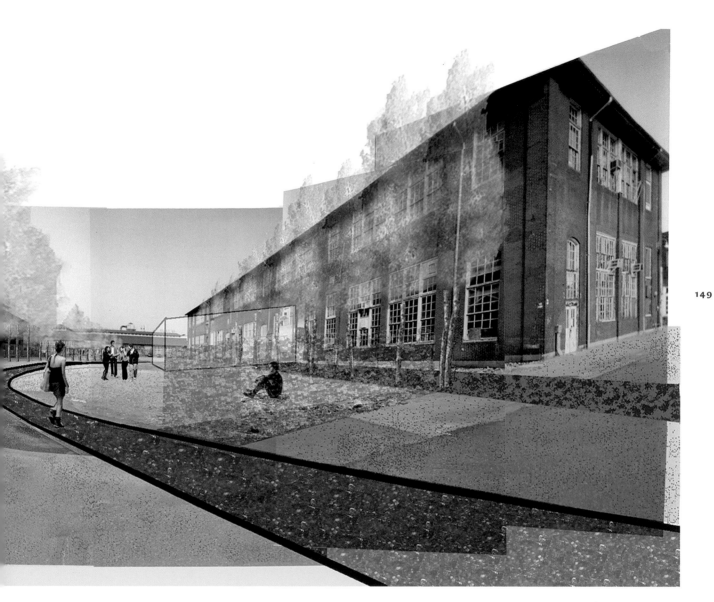

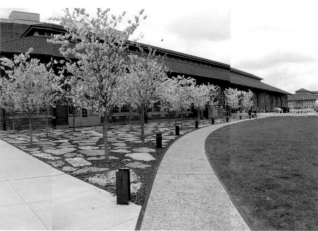

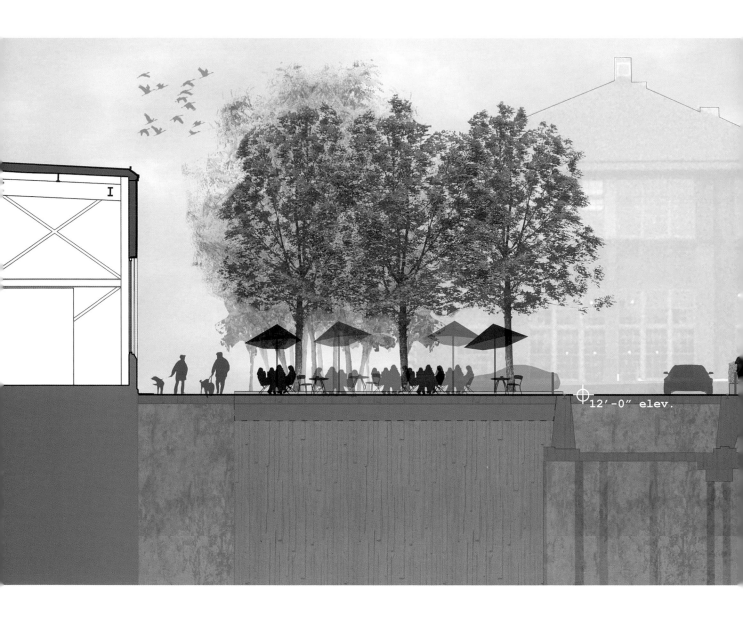

12'-0" elev.

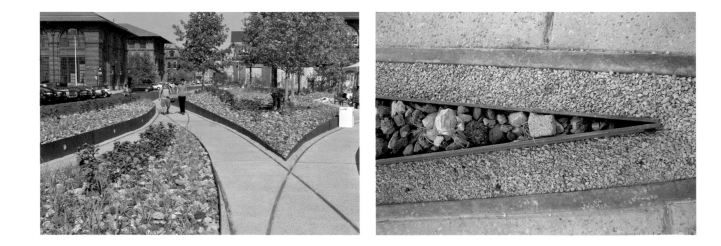

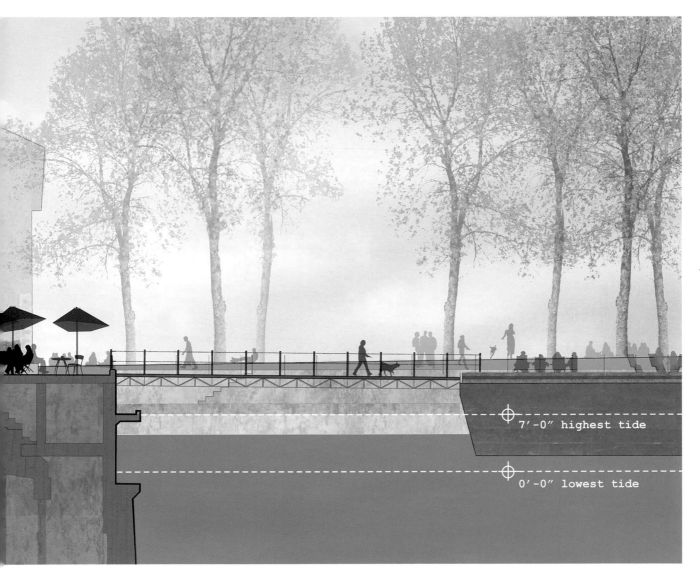

7'-0" highest tide

0'-0" lowest tide

NYC 2012 Olympic Equestrian Facility

Balmori Associates and Joel Sanders Architect Staten Island, New York 2004

As part of New York City's bid to host the 2012 Olympic Games, Balmori Associates and Joel Sanders Architect were commissioned to design a sustainable equestrian facility for La Tourette Park on Staten Island. Post-Olympics, the construction would have left behind an environmentally progressive park for future generations of New Yorkers. Departing from the convention of stadiums conceived as enormous object buildings set within naturalistic parks, the proposal treats the sports complex as an earthwork.

The scheme is composed of two principal elements, a berm and a ribbon. The berm, an S-shaped earth mound, defines two outdoor spaces dedicated to spectatorship: a grass amphitheater that provides a podium for a demountable stadium and a gently curving overlook that allows spectators to observe practice fields. Stables for two hundred horses are embedded within the mound. Threading its way through the berm, the ribbon defines visitor circulation and clads the principal programmatic elements, creating a translucent facade for the stadium and a pedestrian bridge that terminates in a green roof over the stables. An abstract pattern of Benday dots printed on a scrim wraps temporary bleachers; an identical pattern of planted dots is scattered horizontally across the ground, creating a composition that confounds distinctions between nature and artifice, landscape and architecture.

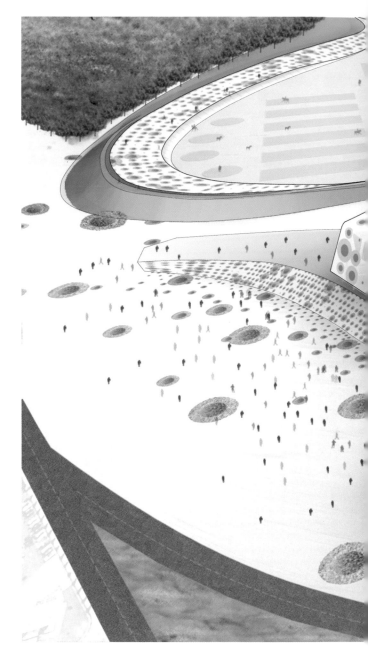

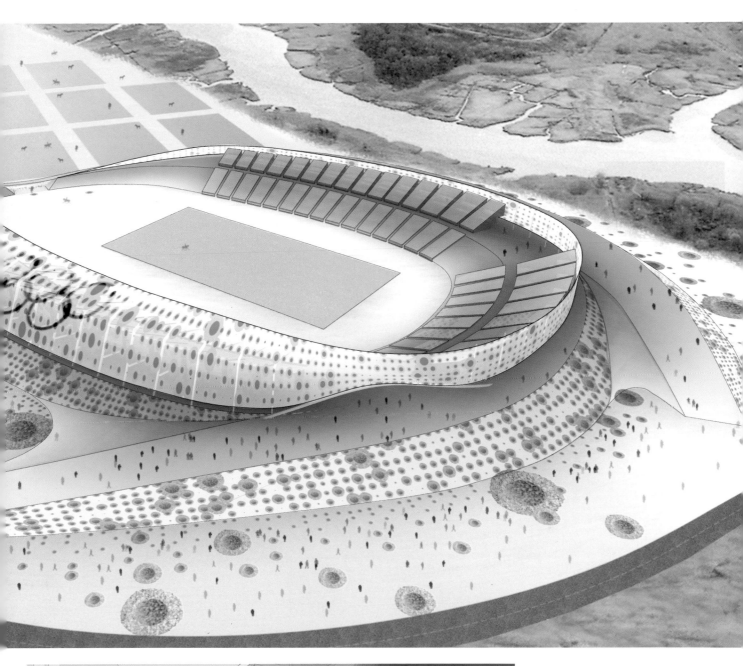

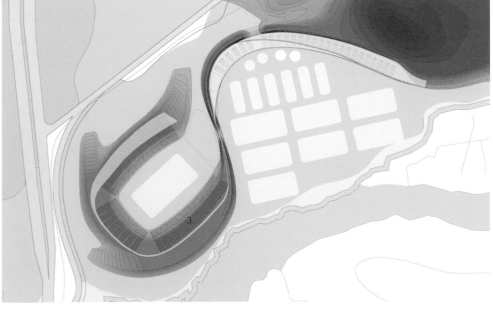

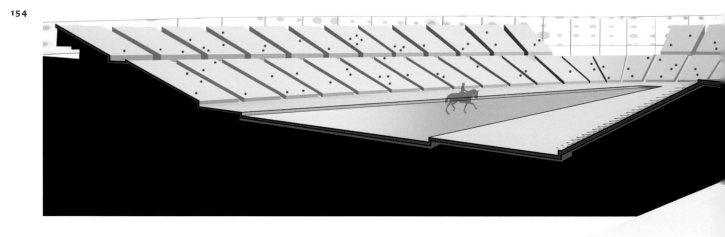

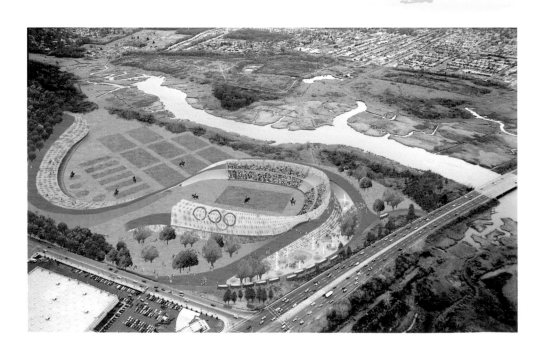

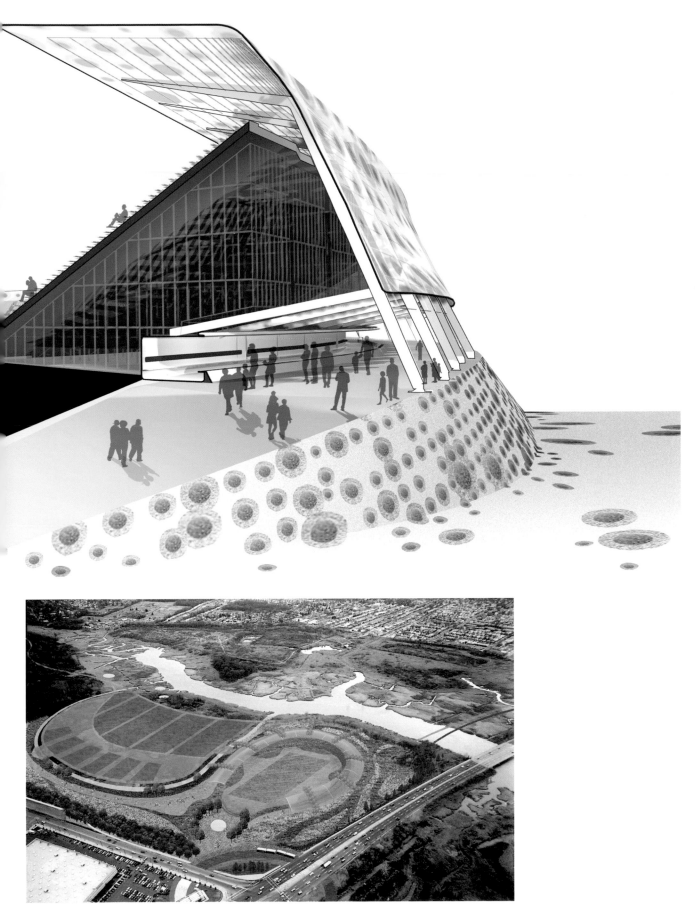

155

GROUNDWORK | ECOLOGY

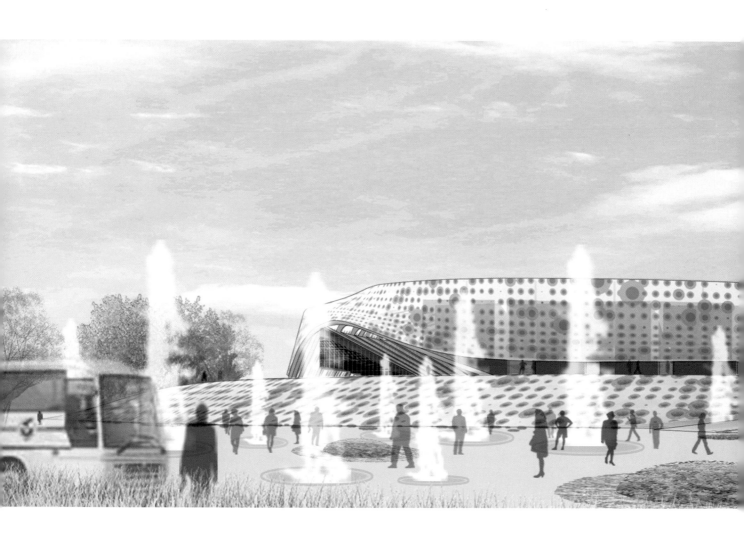

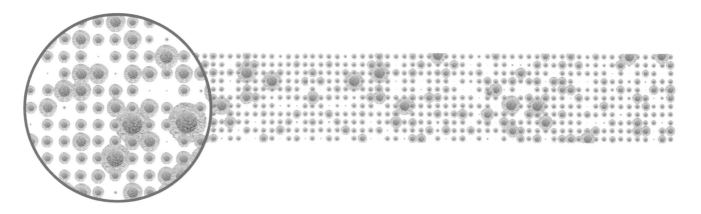

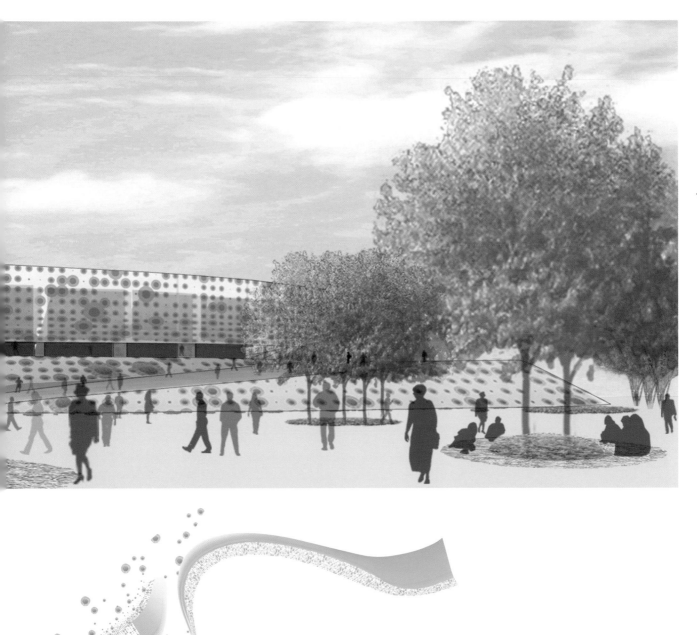

157

GROUNDWORK | ECOLOGY

Parque Atlántico

**Batlle i Roig Arquitectes
Santander, Cantabria, Spain
2006–2008**

Architects Batlle i Roig transformed a
long, narrow tract of land on the outskirts
of Santander into a public park that con-
serves its unique riverbed topography—a
stagnant watercourse that has spawned
a large native colony of reeds—while reflect-
ing on the ecological and geographical
features of the nearby Atlantic Ocean. The
scheme was informed by three issues. The
design responds to its urban context: taking
advantage of a strategic location between
two highways and near a housing develop-
ment, a sports stadium, and the University of
Cantabria, the park accommodates uses at
scales ranging from mass events to intimate
walking paths. The park's composition is
derived from an abstracted representation of
the Atlantic Ocean, translating the body
of water into a series of topographic planted
terraces that accommodate different func-
tions: the top level, parallel to the highways,
demarcates the edge of the park; the middle
level contains spaces to rest and play; and
the lowest level offers elevated walkways
that allow visitors to experience the reedbed
colony. Finally, the botanical scheme refers
to the coastal ecology of the Atlantic in an
interpretation of an arboretum that displays
plant species on levels that correspond to
their geographic latitude.

158

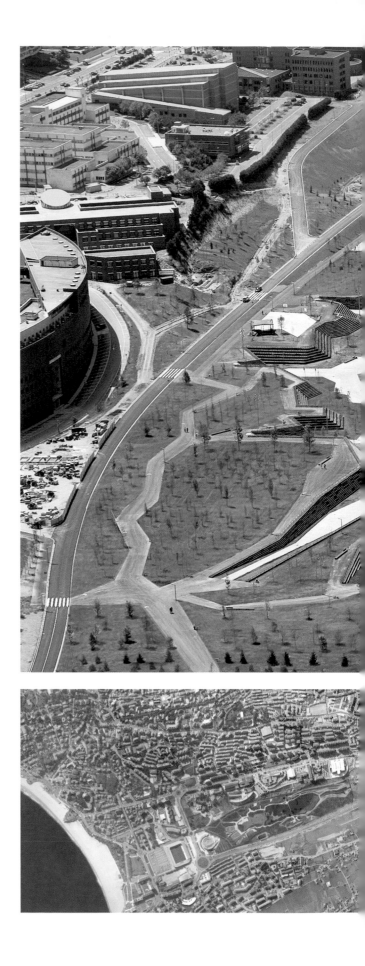

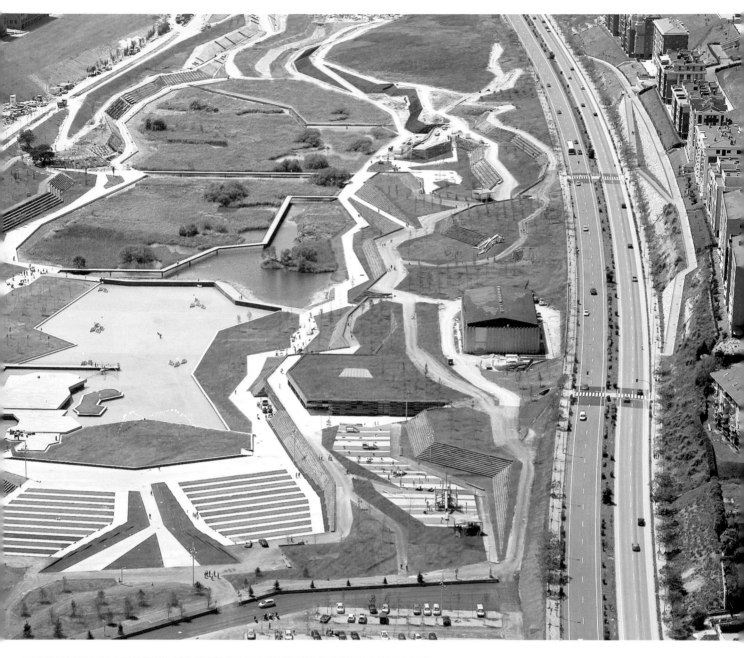

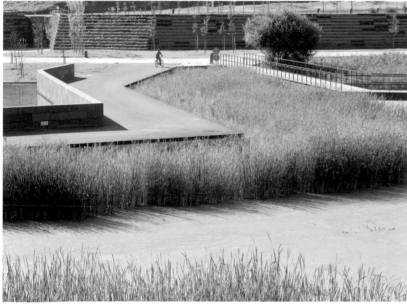

Walls

Grassland

Trees

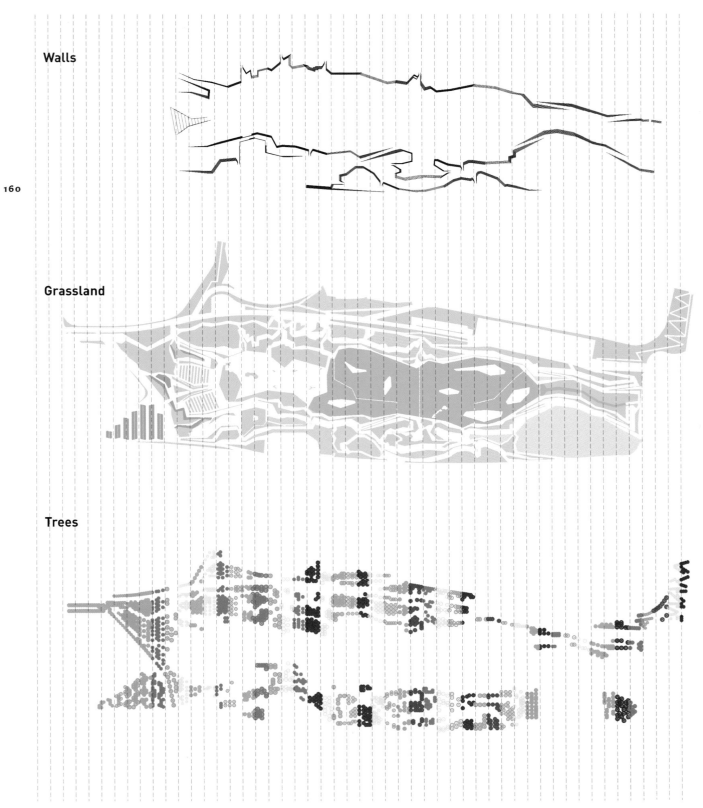

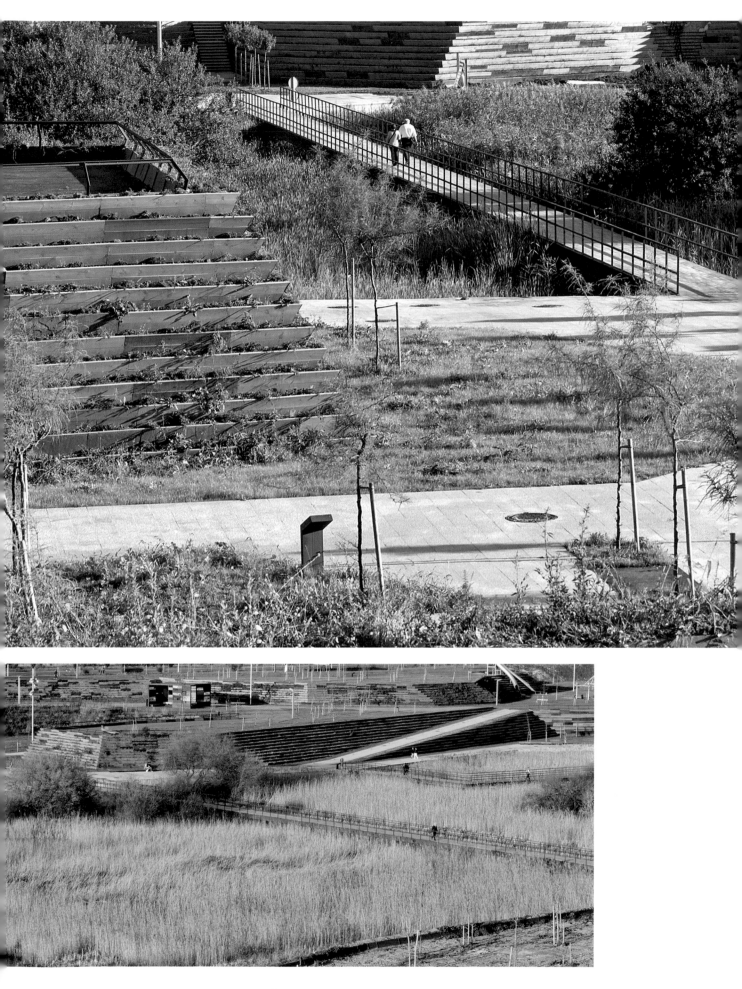

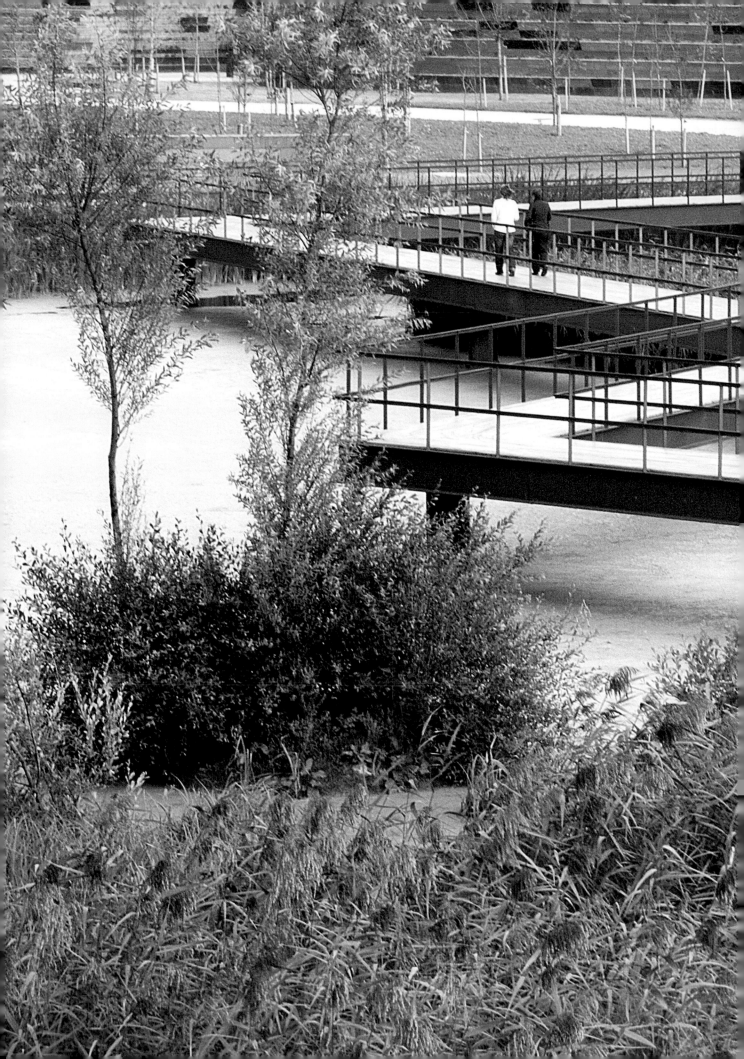

Biocomputation

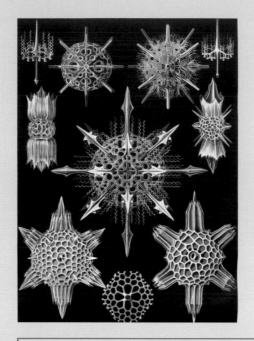

1899–1904

Ernst Haeckel, *Art Forms in Nature*

1922

Louis H. Sullivan, "Impromptu!"
A System of Architectural Ornament

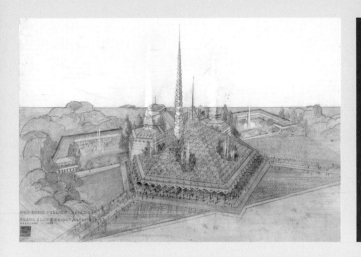

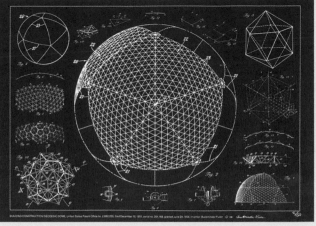

1957
Frank Lloyd Wright, "Oasis,"
Arizona State Capitol, Phoenix

1967
Buckminster Fuller, Montreal
Biosphere, Expo 67, Montreal,
Canada

Since antiquity, architects and landscape designers have sought to derive a formal language from the immutable laws of nature. From Leonardo's Vitruvian man to Le Corbusier's Modulor, architects have searched for a vocabulary based on the timeless geometric forms and proportions that they believed infused all of creation. Nineteenth- and twentieth-century designers like Viollet-le-Duc, Ernst Haeckel, Louis Sullivan, and René Binet looked to the natural sciences, gaining inspiration from the structure of living things as they searched for an alternative to classical Cartesian geometries. By the mid-twentieth century, engineers like Buckminster Fuller and Frei Otto used geometric and structural principles derived from nature to create breathtaking large-span enclosures that integrate structure and skin. Designers continue to update the structural membrane, in the case of Lars Spuybroek making a crystalline mountain of it.

Currently, various digital designers are likewise interested in aligning biology and design to tap into the geometric principles governing living things. But they subscribe to a conception of nature that is different from their predecessors' top-down, ordered cosmos. Instead, Biocomputation designers script digital codes, using algorithms that reflect the underlying diversity and complexities of biological processes, to exploit the computer's potential to emulate living systems. Advanced programs generate forms and patterns that match a conception of nature as adaptive, self-organizing, and without external control. Aranda/Lasch's interpretation of the grotto exemplifies this technique: via a computational sequence, it

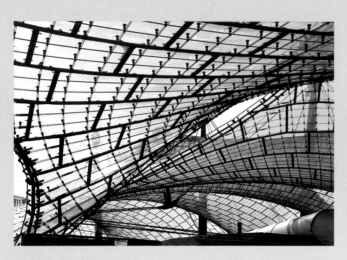

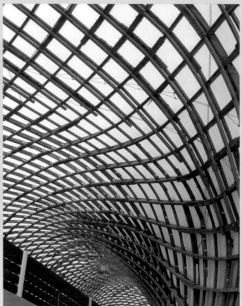

1972
Frei Otto, Olympic Stadium,
Munich, Germany

1975
Frei Otto, Multihalle,
Mannheim, Germany

assembles four polygonal modules into a non-repetitive structure that disrupts established notions of order and blurs the boundary between nature and artifice.

While designers who give form by adjusting digital parameters are best known for a focus on the design of building components—skins and membranes—Biocomputation architects and designers extend this inquiry to create surfaces that escape traditional distinctions between buildings and sites. They share affinities with both Topographic and Ecologic designers, who also use computers to generate environmentally responsible, biomorphic, inhabitable groundscapes. But what differentiates Biocomputation designers is the premise that underlies their design process: that parametrics allows them to create "performative" works ideally suited to tackling environmental issues because of a capacity to adapt to nuances of context and climate over time. EcoLogicStudio's North Side Copse House exemplifies how Biocomputation can engage ecological issues directly: its vertically patterned facade, fabricated out of locally sourced lumber, takes into account site-specific solar energy trends.

Greg Lynn's Embryological House series—customized computer-generated domiciles that respond to specific environmental conditions—represents a precedent for the Biocomputation technique of modeling complex biomorphic forms that blend structure and enclosure. In the Yeosu Oceanic Pavilion, EMERGENT with KOKKUGIA devises a sinewy membrane that replicates the look and behavior of the skins of sea

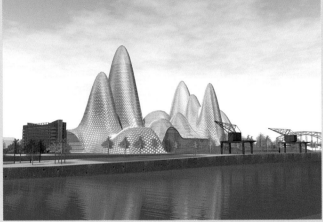

2000

**Greg Lynn, Embryological
House Series**

2003

**NOX/Lars Spuybroek, European
Central Bank, Frankfurt, Germany**

creatures. The massing, program distribution, and tendril-like exoskeleton of OCEAN NORTH's New Czech National Library is derived from the linden, the Czech national tree. Magnus Larsson literally weds biology and parametrics in his design process: DUNE combats desertification by developing crystallized sand dunes via a microorganism that turns sand into sandstone.

Other designers offer a different take on Biocomputation. The Living Architecture Lab extends the environmental interactivity made possible by digital technologies to include two-way exchanges between humans and the landscape: observers send text messages in response to feedback transmitted by floating light tubes that register environmental stimuli in New York's East River. In Local Code, Nicholas de Monchaux addresses urban design issues: he employs parametric design to create optimized ecological landscape proposals for various publicly owned, marginal sites in major American cities.

The sometimes blind faith that digital designers have in the capacity of computers to generate designs that circumvent authorship recalls and risks perpetuating a theme that has dominated the landscape professions since the nineteenth century—the quest for a scientific rather than a subjective design approach. But Biocomputation architects and landscape architects bypass the antidesign mentality that has constrained so many of their predecessors, using computers to generate performative projects that are visually compelling.

Grotto Concept

Aranda/Lasch
2005

A grotto is fictionalized nature—an artificial cave guarding hidden fountains—that was celebrated in gardens and literature in antiquity, the Renaissance, and the eighteenth century. The firm of Aranda/Lasch mined the legacy of this ancient building type for a temporary pavilion for MoMA/P.S.1, bringing it up to date with a geometric system that uses the vocabulary of twenty-first-century computation.

The Aranda/Lasch grotto, although it appears random, possesses a precise geometrical organization. It is composed of 240 expanded-polystyrene-foam boulders, modular yet irregularly shaped, in four polygonal configurations. The modules are joined via an algorithmic tiling pattern; pieces are then removed to produce inhabitable hollows. Despite its local symmetries—the pavilion has two main axes—and overall patterning, the resulting structure is non-repetitive: the regular computational sequence disrupts preconceived notions of geometrical order, creating a visual impression of nature's apparent randomness.

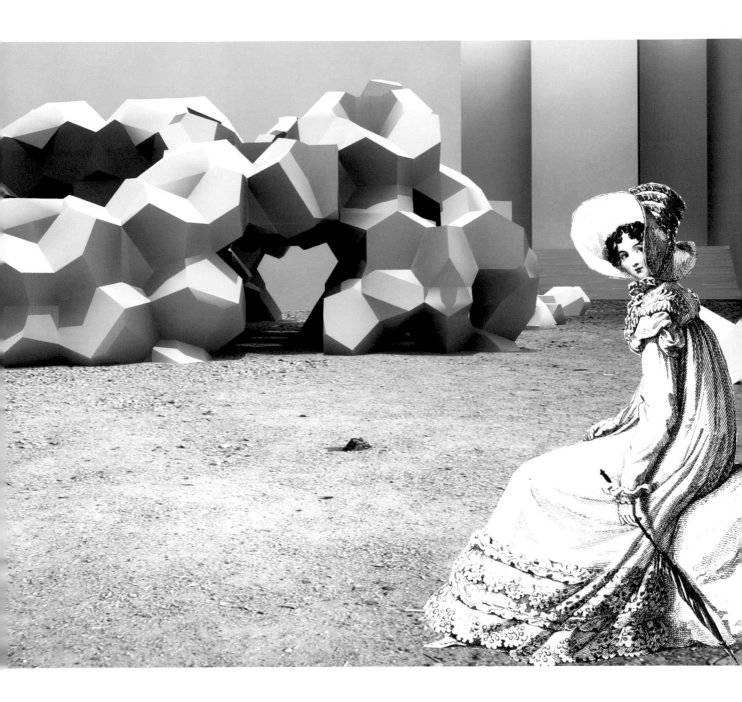

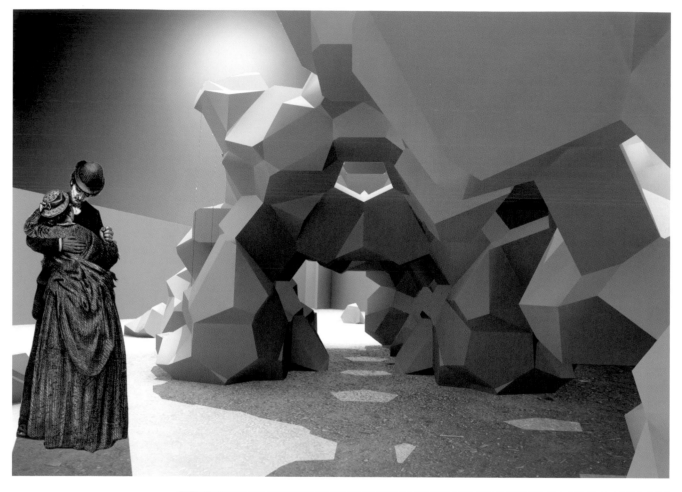

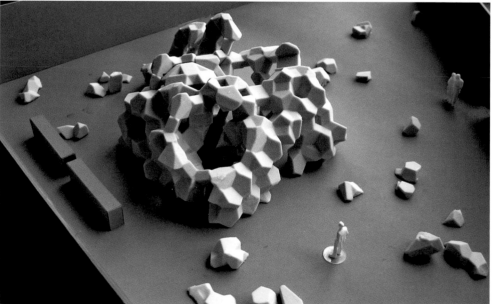

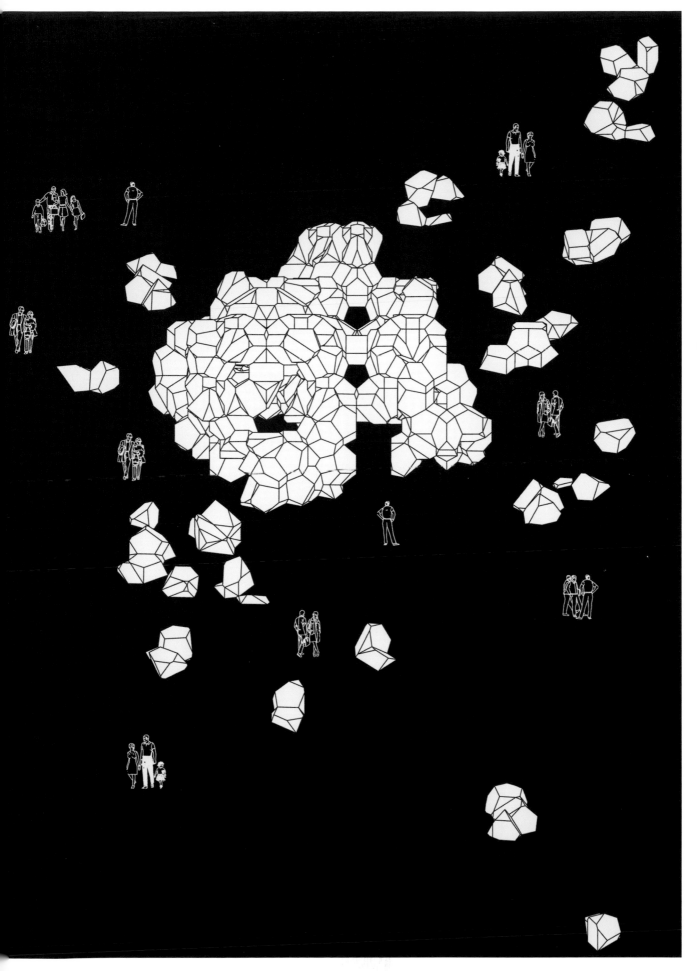

North Side
Copse House

EcoLogicStudio
West Sussex, England
2009

EcoLogicStudio's design for a private residence in West Sussex, England, uses parametric design software to analyze, design, and fabricate a site-specific house that responds to the immediate environment. The house is constructed with wood harvested from the site and converted at a nearby plant into laminated members that are used both for structure and cladding. The exterior envelope was generated by digital computation, taking into account characteristics specific to the setting: forest density, solar access, solar orientation. Framing members rise from the ground, wrapping the roof surface and forking into the ground to provide structural stability and channel collected rainwater. The irregularly spaced pieces create varying intervals that correspond to environmental stimuli, providing apertures for natural ventilation and daylighting.

The same computational modeling techniques that generate the form of the structure are used to diffuse the boundary between building and property. Grooved patterning across the ground and atop the planted roof integrates habitat for woodland flora and fauna. At once materializing the forces of a woodland ecosystem and dematerializing its own built presence, the Copse House proposes a two-way flow of influence between architecture and landscape.

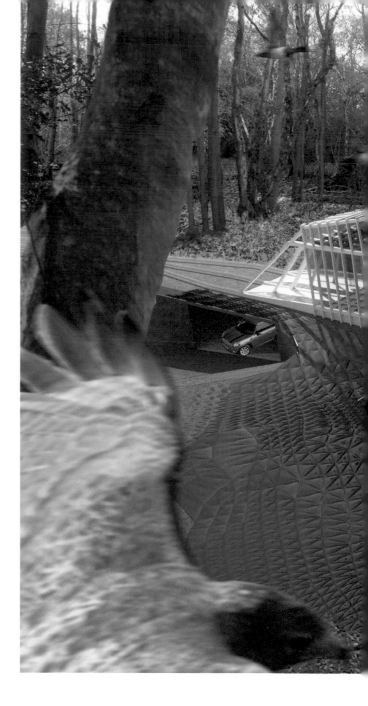

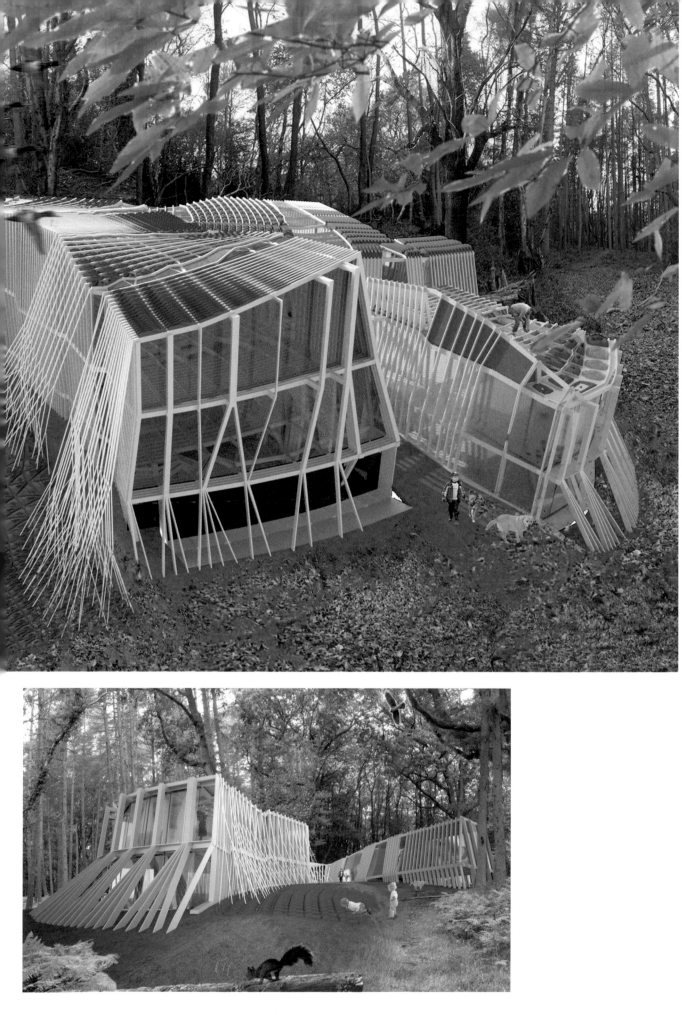

GROUNDWORK | BIOCOMPUTATION

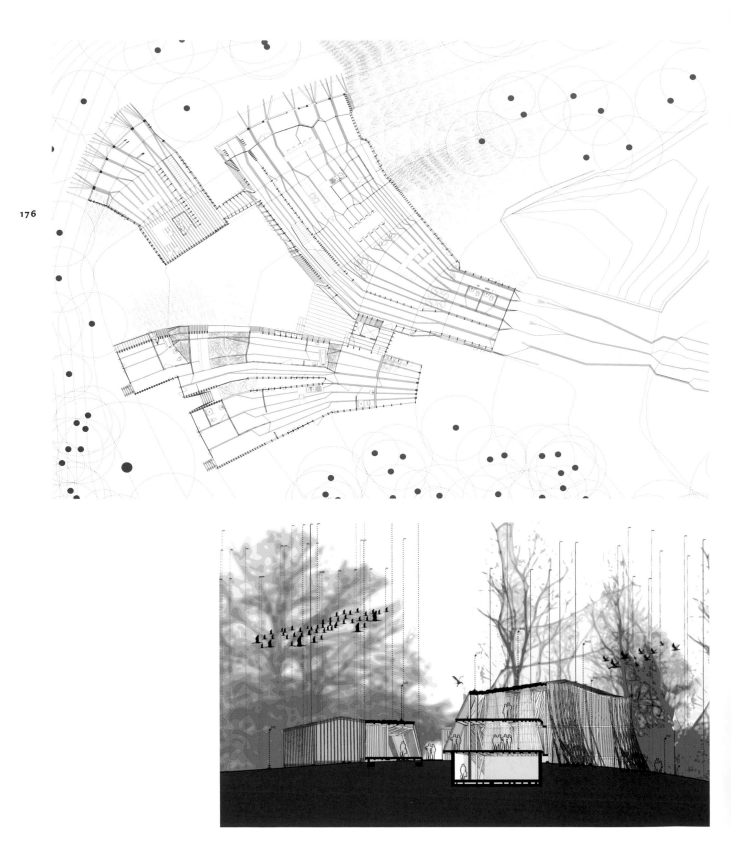

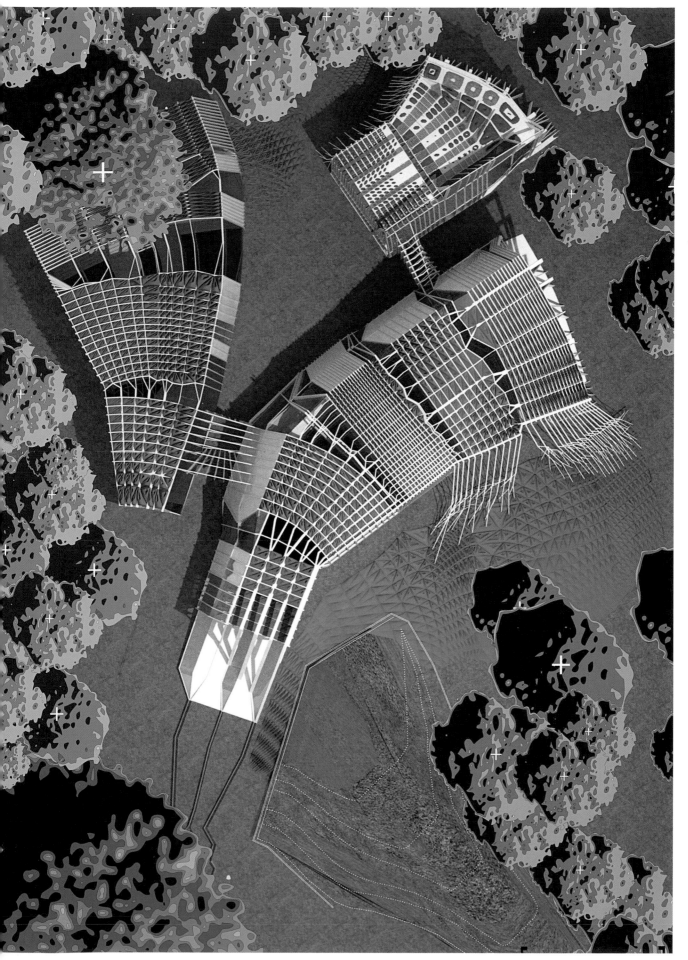

GROUNDWORK | BIOCOMPUTATION

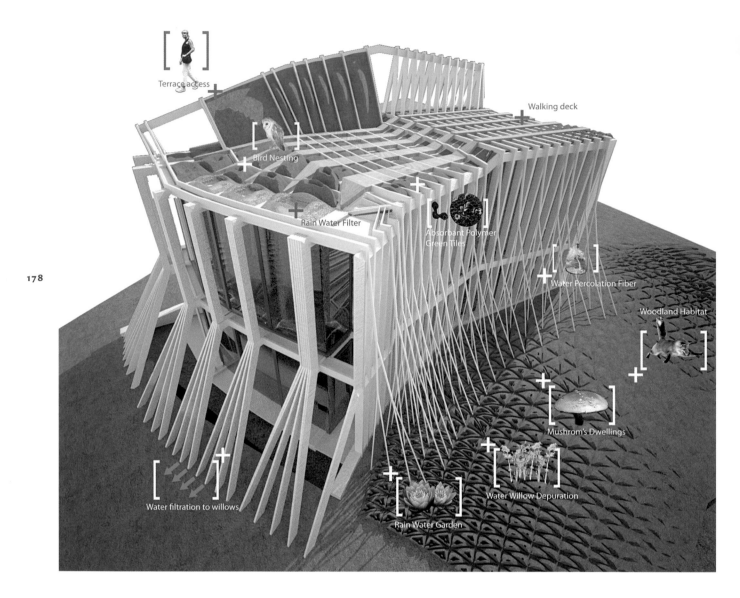

Terrace access

Walking deck

Bird Nesting

Rain Water Filter

Absorbant Polymer
Green Tiles

Water Percolation Fiber

Woodland Habitat

Mushrom's Dwellings

Water filtration to willows

Water Willow Depuration

Rain Water Garden

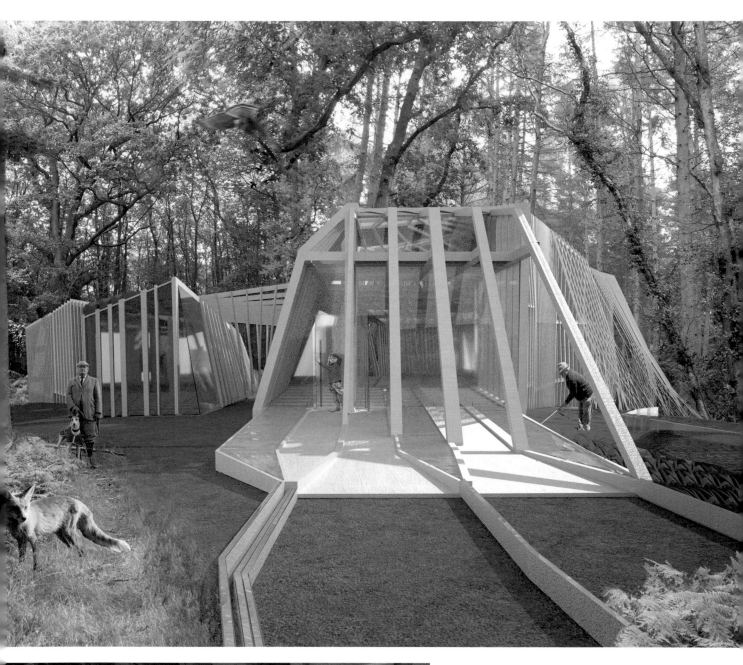

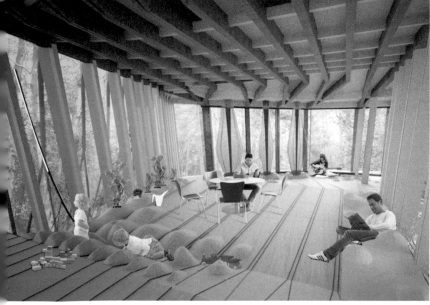

New Czech National Library

OCEAN NORTH
and Scheffler + Partner
Prague, Czech Republic
2006

OCEAN NORTH's competition entry for a new Czech National Library tests the formal and programmatic potential of parametric design. Sited between a busy roadway and a placid park, the building straddles hardscape and landscape, urbanism and nature. The heterogeneous nature of the site is mirrored in the building's design, which responds to urban and natural forces with biologically inspired forms. The building's form, structure, and programmatic distribution are derived from the linden tree, an icon of cultural growth and progression especially meaningful in the Czech Republic. The national archive occupies the "trunk," or central spine. Administrative and research spaces, cantilevered over the park, branch out like a fringed tree canopy. The intertwined aspect of form and structure is most evident in the exterior envelope: the trunk's heavy opaque mass gradually dissipates into planes of glass webbed with branching supports.

Parametric design allowed the architects to create an efficient building that not only looks like a linden tree but behaves like one. The building is realized by means of generative design software that overlays naturally occurring growth patterns and structural efficiency in a comprehensive tectonic system. Stress distribution on the frame was mapped as a series of vectors. Five principal support points were established, and the envelope's branching structural frame was derived from load patterns and behaviors. The architects' computational logic fashions a building that marries symbol, image, and optimal structural performance.

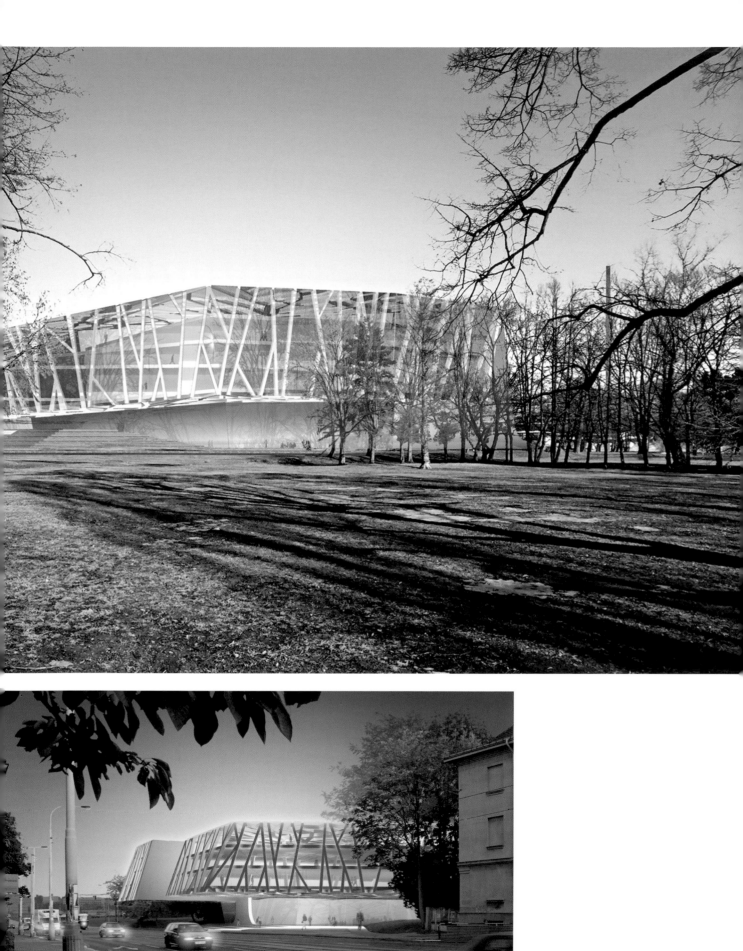

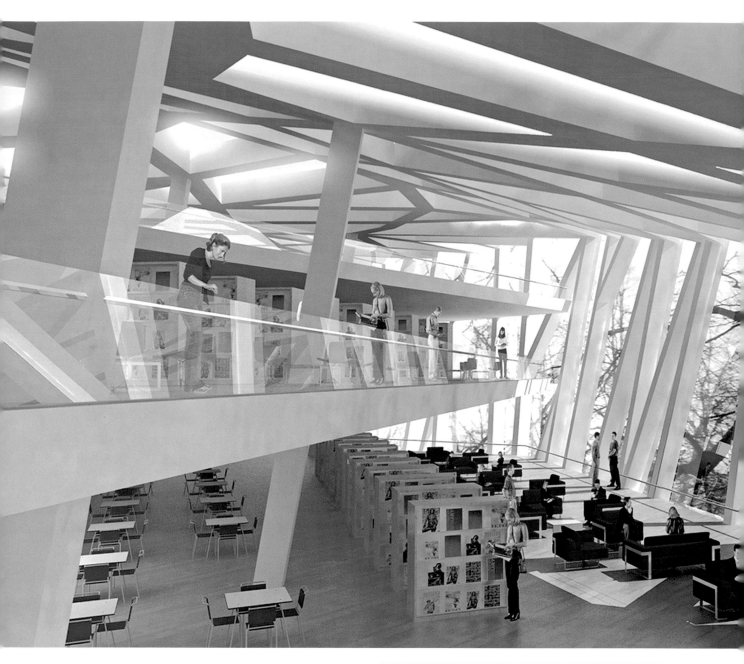

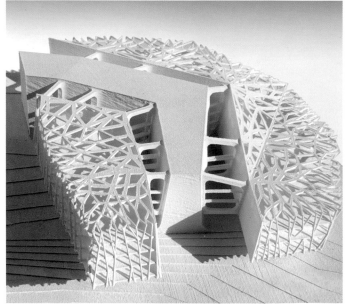

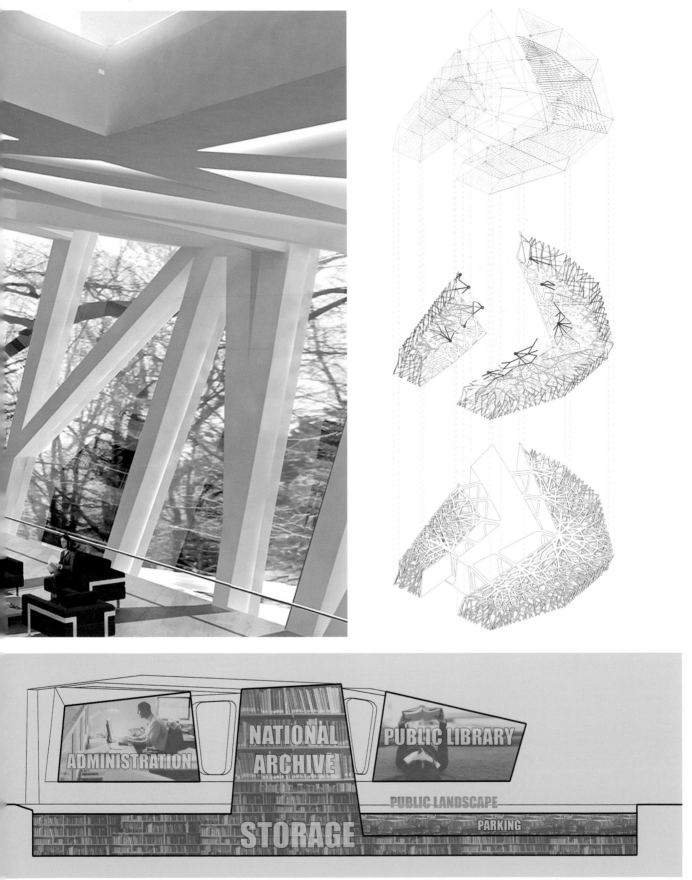

ADMINISTRATION
NATIONAL ARCHIVE
PUBLIC LIBRARY
PUBLIC LANDSCAPE
STORAGE
PARKING

GROUNDWORK | BIOCOMPUTATION

Yeosu Oceanic Pavilion

**EMERGENT Tom Wiscombe
with KOKKUGIA
Yeosu, Korea
2010**

Designed as the centerpiece for the 2012 World Exposition, the Yeosu Oceanic Pavilion is a living interface between architectural object and surrounding ecosystem. The complex is a cluster of pods housing exhibition galleries; the pods are partially submerged in the ocean to visually engage sea life below. The pavilion's exterior shell structure was inspired by the morphology of sea life. Interior functions are concealed behind soft transparent membranes, which are reinforced by stiff capillaries of compressed air threaded across their surfaces. Each soft membrane is framed within a hard fiber-composite monocoque shell; veinlike micro-armatures bridge shell and membrane to create structural and ornamental continuity.

The biomorphic forms of the pavilion negotiate several sets of variables: the aesthetic interests of design versus the forms generated by the computational logic of scripting; ornament versus structural performance; the needs of terrestrial visitors versus amphibious users. In the end, the application of parametrics funnels multiple domains and factors into a static yet socially and environmentally dynamic building.

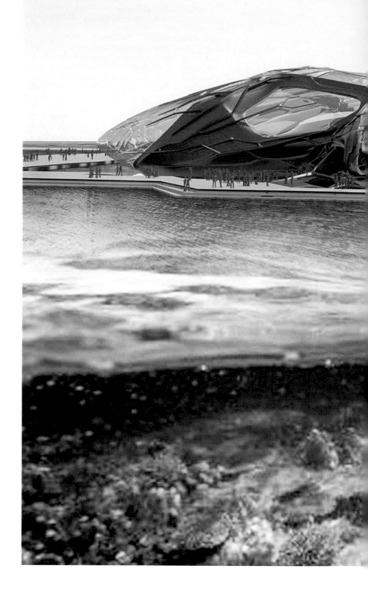

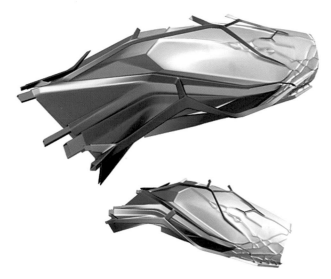

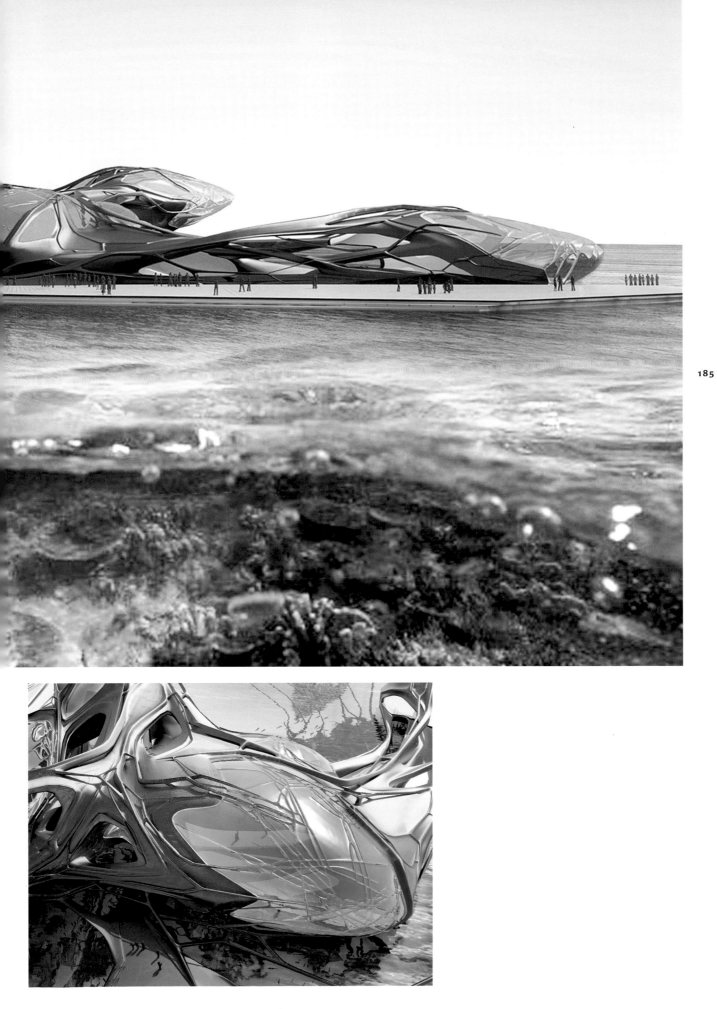

GROUNDWORK | BIOCOMPUTATION

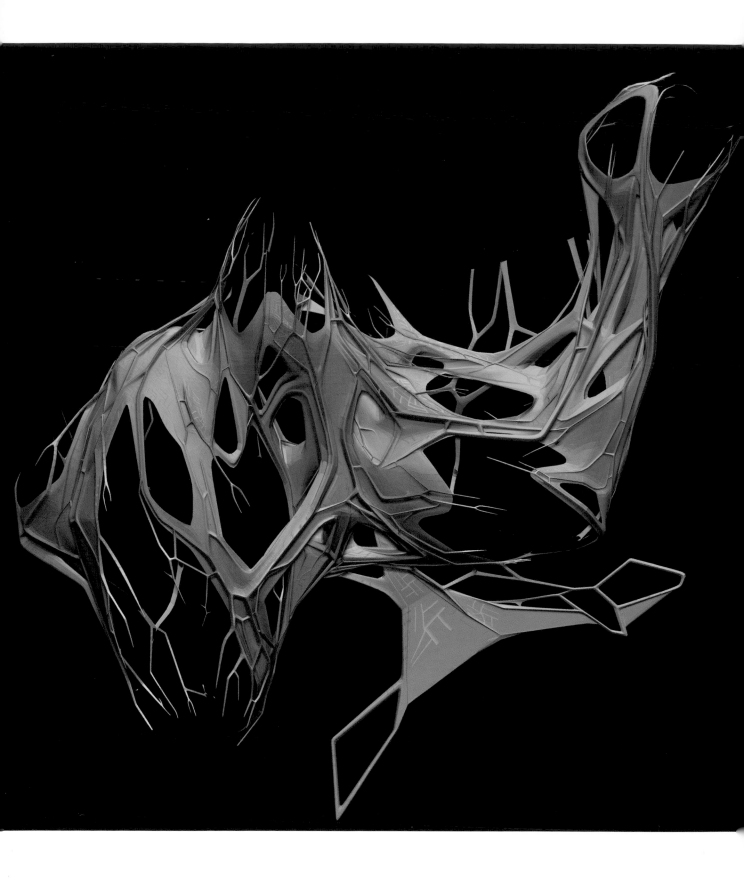

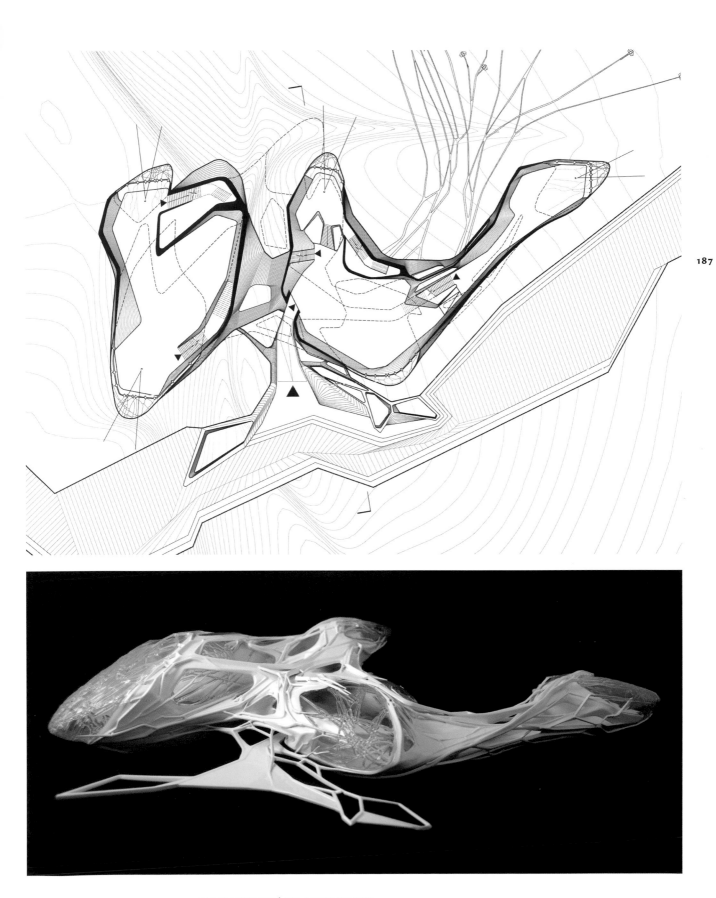

187

GROUNDWORK | BIOCOMPUTATION

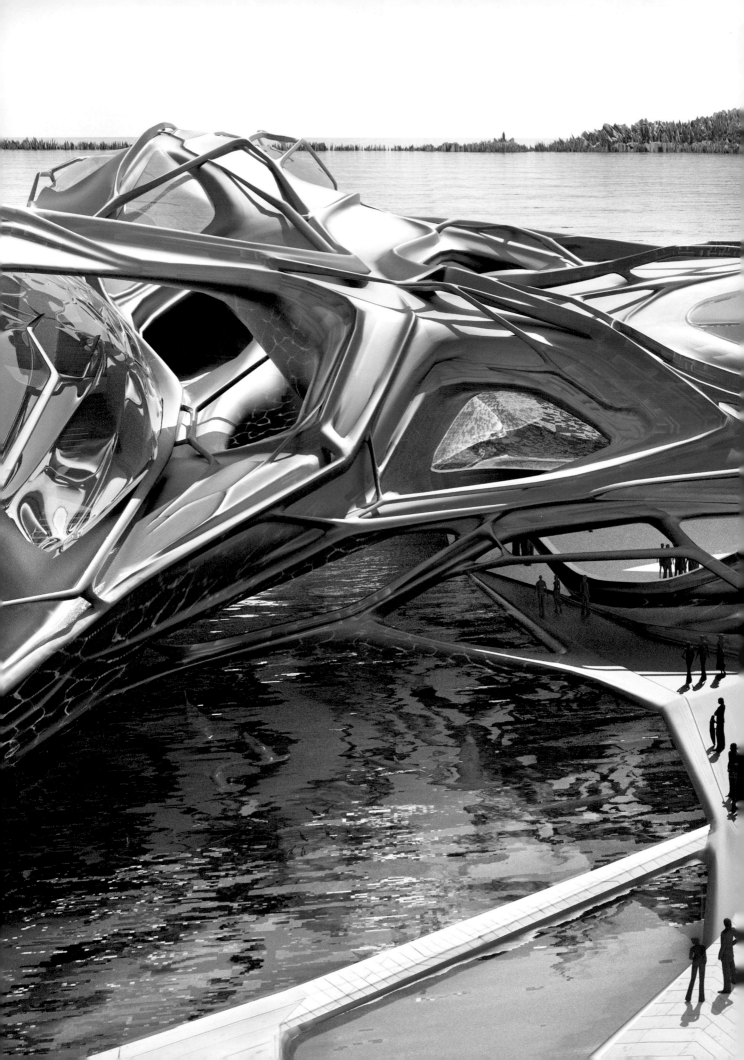

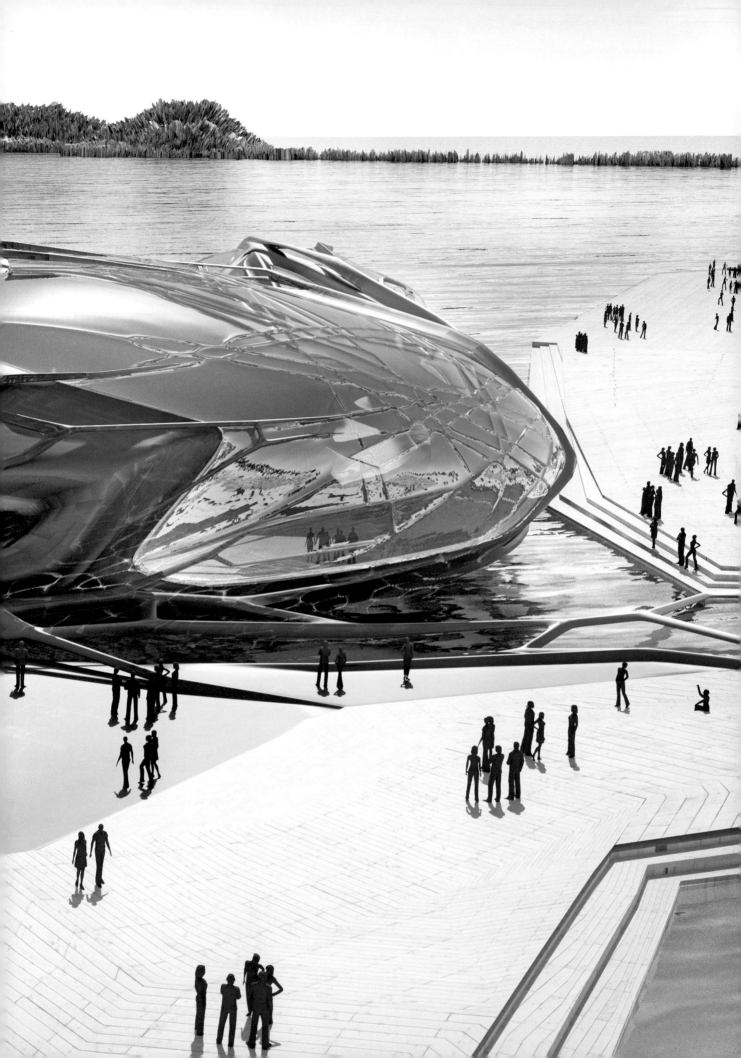

Amphibious Architecture

Living Architecture Lab at Columbia University GSAPP (David Benjamin and Soo-In Yang); Environmental Health Clinic at NYU (Natalie Jeremijenko)
New York, New York
2009

A temporary installation commissioned for "Toward the Sentient City," an exhibition mounted by the Architectural League of New York, Amphibious Architecture exploits interactive digital technologies to promote environmental consciousness. A grid of sixteen vertical tubes, partially submerged in New York's East and Bronx Rivers, supports environmental sensors below the water level and colored lights above. The sensors capture information about water quality and the presence of fish, transmitting this data through the lights. The project encourages user engagement with text messages—incoming and outgoing—that offer real-time information about the river's conditions.

Amphibious Architecture takes the river as a site of active exchange, establishing, according to the designers, "a two-way interface between environments of land and water." The project transforms the river, once an uninhabitable public space, into a site for civic participation, fusing ecology and urbanism in a feedback loop facilitated by interactive communications software.

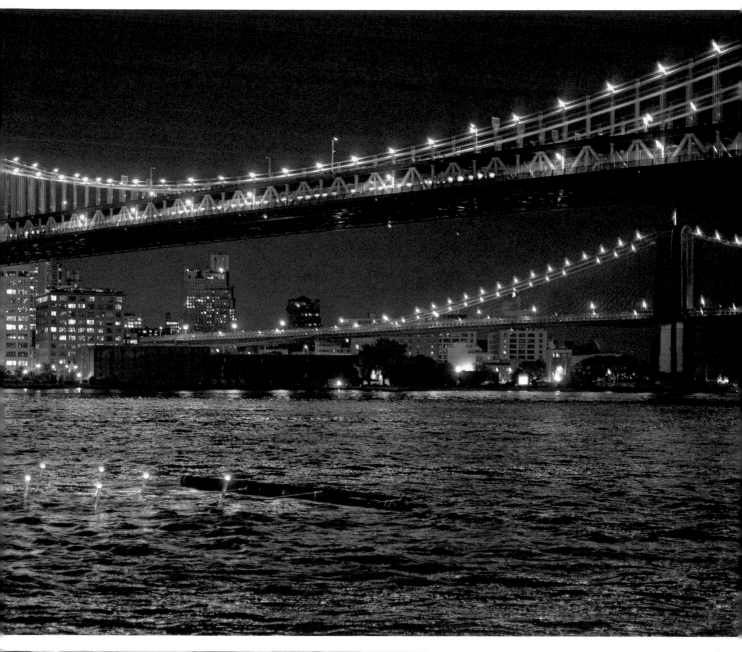

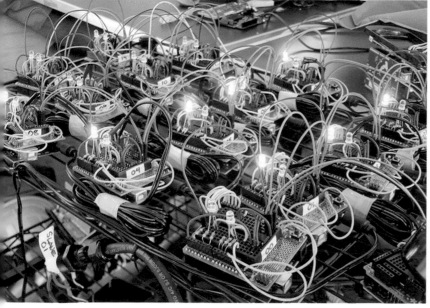

GROUNDWORK | BIOCOMPUTATION

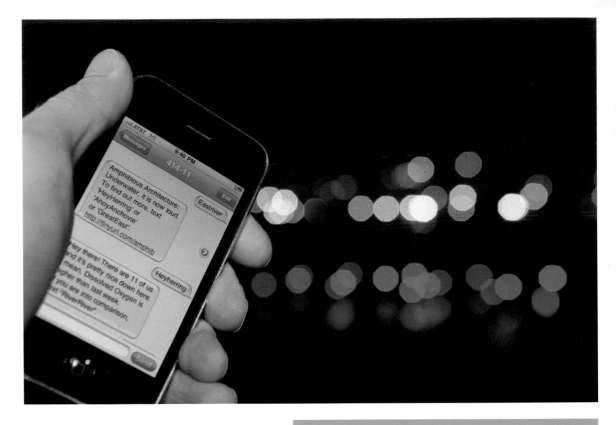

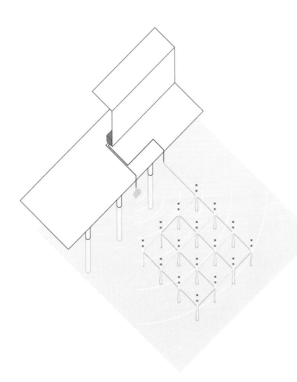

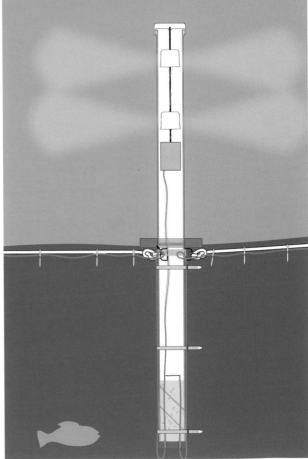

100

GROUNDWORK | BIOCOMPUTATION

Local Code:
Real Estates

Nicholas de Monchaux
2010

This planning methodology uses geospatial analysis to identify thousands of publicly owned abandoned sites in major American cities, imagining these vacant landscapes as a new urban system. Parametric design tailors a landscape proposal for each site to local conditions, optimizing thermal and hydrological performance to enhance the ecology of the city as a whole—and relieve burdens on existing infrastructure. The quantifiable effects on energy usage and stormwater remediation eradicate the need for expensive sewer and electrical upgrades. In addition, citizen participation contributes to a new, more public infrastructure—a robust network of urban greenways with tangible benefits to health and safety.

Local Code attempts "to move beyond the singular, optimized evolutionary language that characterizes much of current digital design," writes Nicholas de Monchaux. It aspires instead to be a more biologically inspired design process that abandons an idealized view of optimization in favor of diversity, robustness, and the creation of a geometric framework as the first step in a complex, continuous design process.

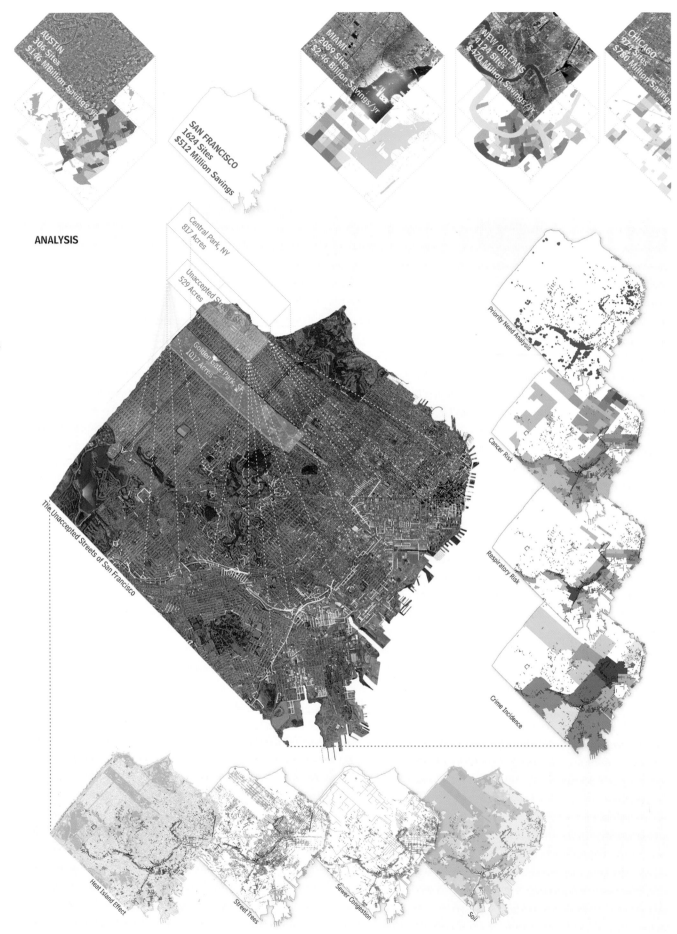

AUSTIN
306 Sites
$146 Million Savings/yr

MIAMI
2089 Sites
$2.46 Billion Savings/yr

NEW ORLEANS
4124 Sites
$420 Million Savings/yr

CHICAGO
974 Sites
$780 Million Savings/yr

SAN FRANCISCO
1624 Sites
$512 Million Savings

ANALYSIS

Central Park, NY
817 Acres

Unaccepted Streets SF
529 Acres

Golden State Park
1017 Acres

The Unaccepted Streets of San Francisco

Priority Need Analysis

Cancer Risk

Respiratory Risk

Crime Incidence

Heat Island Effect

Street Trees

Sewer Congestion

Soil

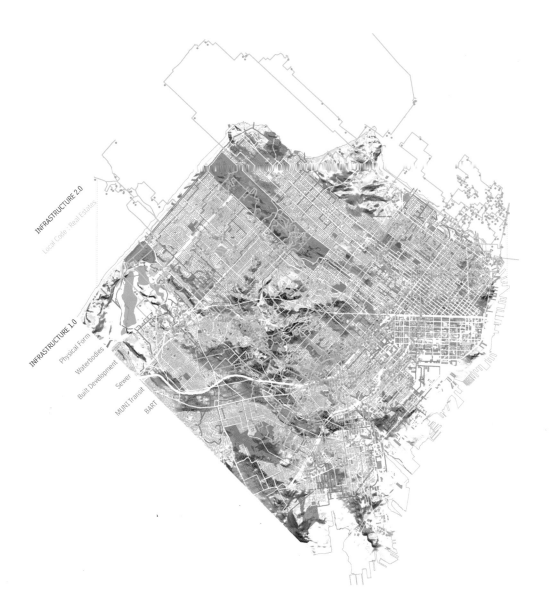

INFRASTRUCTURE 2.0

Local Code - Real Estates

INFRASTRUCTURE 1.0

Physical Form

Waterbodies

Built Development

Sewer

MUNI Transit

BART

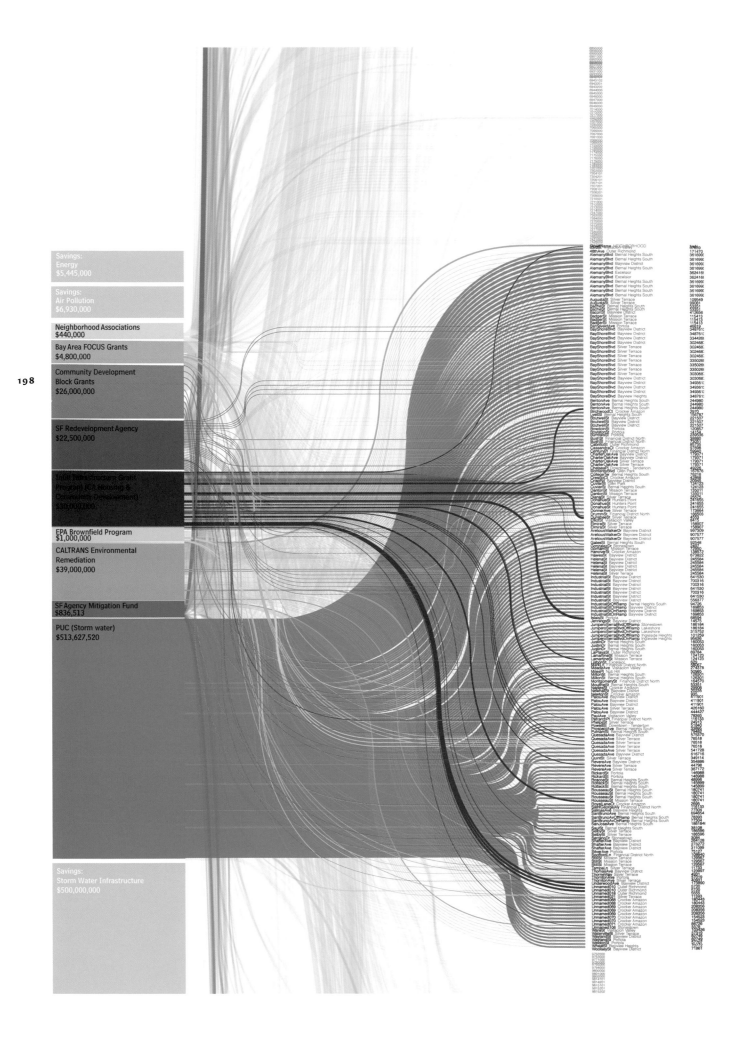

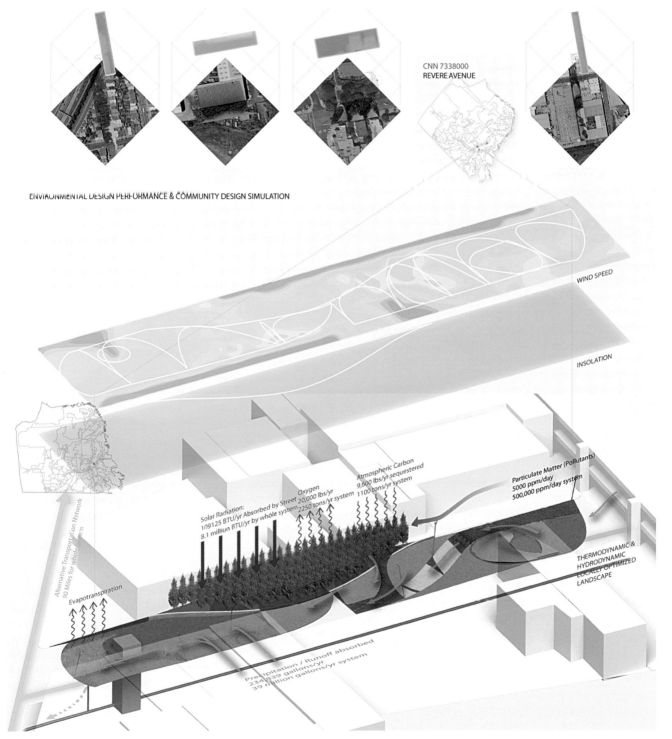

ENVIRONMENTAL DESIGN PERFORMANCE & COMMUNITY DESIGN SIMULATION

CNN 7338000
REVERE AVENUE

WIND SPEED

INSOLATION

Solar Radiation:
109125 BTU/yr Absorbed by Street
8.1 million BTU/yr by whole system

Oxygen
20,000 lbs/yr
2250 tons/yr system

Atmospheric Carbon
9,600 lbs/yr sequestered
1100 tons/yr system

Particulate Matter (Pollutants)
5000 ppm/day
500,000 ppm/day system

THERMODYNAMIC &
HYDRODYNAMIC
LOCALLY OPTIMIZED
LANDSCAPE

Alternative Transportation Network
90 Miles for whole system

Evapotranspiration

Precipitation / Runoff absorbed
234,839 gallons/yr
39 million gallons/yr system

GROUNDWORK | BIOCOMPUTATION

DUNE: Arenaceous Anti-Desertification Architecture

Magnus Larsson
2008

As the Sahara desert spreads, it threatens to destroy food supplies and force small communities to migrate. This project proposes to reverse desertification with a six-thousand-kilometer beltway of crystallized sand dunes—instant oases—stretching from Mauritania to Djibouti. A nonpathogenic microorganism (*Bacillus pasteurii*) that turns sand into sandstone is enlisted as a participant. Cultivated in massive quantities, B. pasteurii is deployed on the surface of large balloons, which function as positive/negative molds, next to shifting sand dunes. With forms derived from scripting technologies and spidery tafoni rock formations, the balloons shape a fantastic network of hardened, inhabitable interiors. While the initial solidifying reaction occurs over twenty-four hours, the project's residual effects could continue for thousands of years.

The scheme is cross-disciplinary in nature, exploiting experimental geology, sociology, and landscape urbanism to produce a network of habitats and zones for water harvesting. Complementing existing plans to mitigate desertification, DUNE offers spaces for planting and shaded comfort areas. The plan may be most curious for its self-generative logic: the microbes are propelled by the very winds that cause desertification.

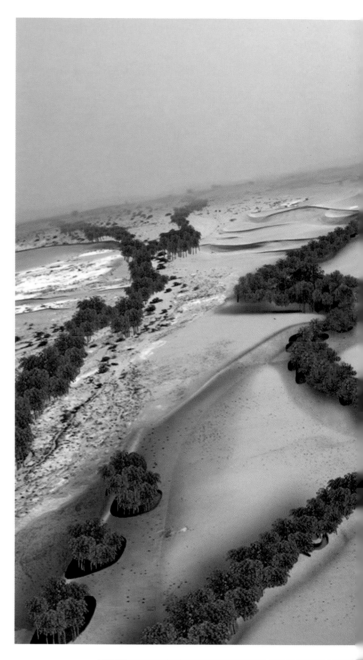

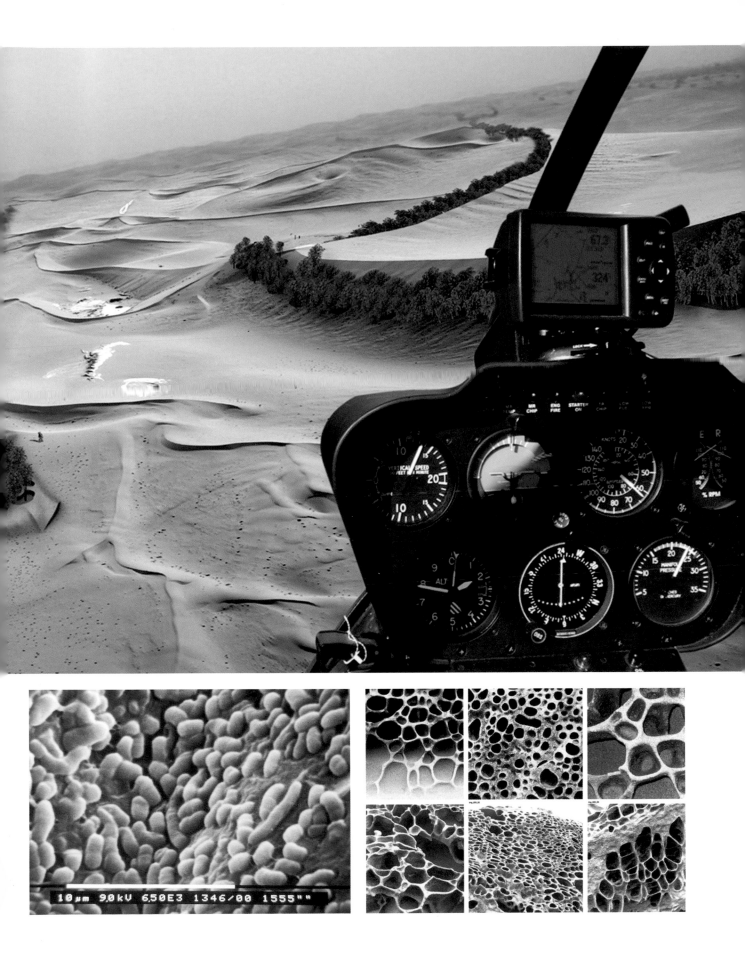

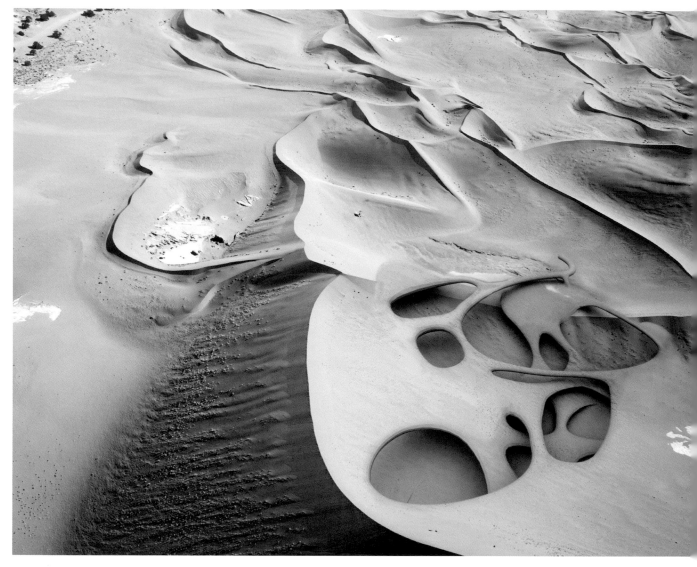

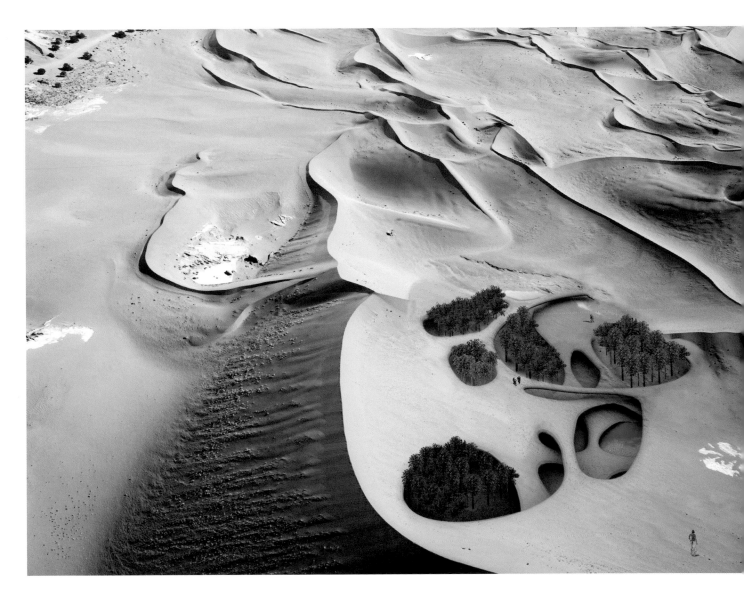

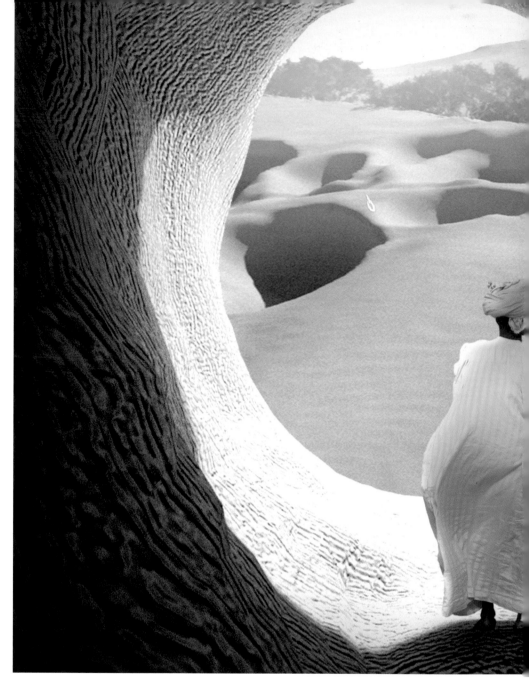

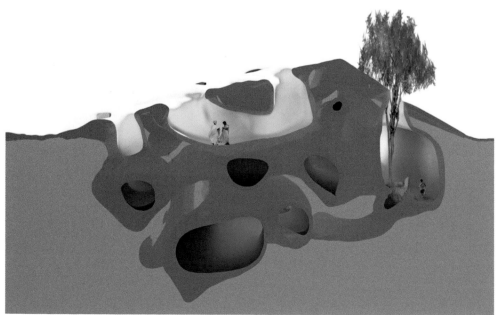

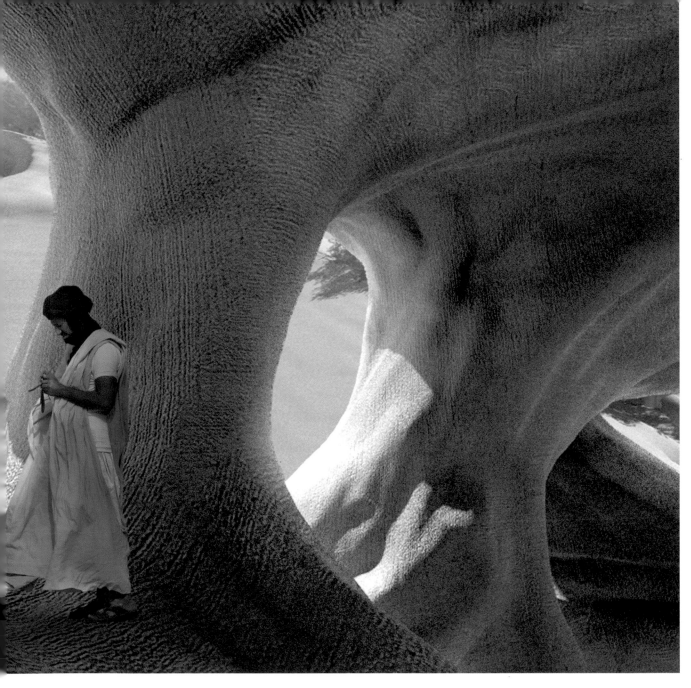

Illustration Credits

Numbers refer to page numbers.
All images have been provided by the designers except as noted below.

Cover image courtesy of the American Museum of Natural History. *Design with Nature,* Ian L. McHarg. Copyright © 1969 Natural History Press: 108 right

Photography by Benjamin Benschneider: 77 bottom, 80–81

Rien Bongers: 36

Collection Center for Creative Photography, The University of Arizona. © 2010 The Ansel Adams Publishing Rights Trust: 14 left

Richard Davies: 50 right

Albrecht Dürer, *Adam and Eve,* Yale University Art Gallery, Fritz Achelis Memorial Collection, Gift of Frederic George Achelis, B.A. 1907; reacquired in 1972 with the Henry J. Heinz II, B.A. 1931, Fund; Everett V. Meeks, B.A. 1901, Fund; and Stephen Carlton Clark, B.A. 1903, Fund: 13

Peter Frankel: 24

Courtesy The Estate of R. Buckminster Fuller: 167 right

Marte Garmann: 103

© Manuel Gonzalez Vicente, Courtesy Foundation of the City of Culture of Galicia: 68–69 top, 70 top, 71

Courtesy Jochem Grin: 15 right

Courtesy Habiter Autrement, architect Mia Hägg with curator Jan Åman: 137 bottom, 138, 141

© Roland Halbe, Courtesy Foundation of the City of Culture of Galicia: 72–73

ingeovetysnes.com: 99 bottom

Luuk Kramer fotografie: 119 top, 120 top, 121 bottom, 122, 124–25

Library of Congress, Prints and Photographs Division, LC-USZ62-8672: 14 right

Åke E:son Lindman: 99 top, 100 top, 101, 102, 104–5

London Borough of Richmond upon Thames Local Studies Collection: 37 center

Photograph by Elizabeth Meyer, 2001. Image courtesy of SAH ARA (Society of Architectural Historians Architecture Resource Archive) and the Fiske Kimball Fine Arts Library, University of Virginia: 50 left

Maris Mezulis: 140

Satoru Mishima: 51 left

Courtesy of Avigail Moss, 2009. Art © Estate of Robert Smithson/Licensed by VAGA, New York, NY: 109 left

Nagano Consultant: 59

Courtesy of the National Park Service, Frederick Law Olmsted National Historic Site: 17

Paisajes Españoles, S.A. Courtesy Foundation of the City of Culture of Galicia: 68 bottom

Penzance Library, Cornwall: 37 right

Jorge Póo: 159, 161, 162–63

Steve Proehl: 48 left

Courtesy RIBA Journal: 108 left

robota.fr: 137 top, 139

Chie Rokutanda: 58, 60 top, 61, 62–63

Eduardo Sentchordi: 168 left

Smithsonian American Art Museum, Washington, D.C./Art Resource, NY: 15 left

Sven Stromann-Bräuer: 168 right

Drawing reproduced from *A System of Architectural Ornament* by Louis H. Sullivan (Press of the American Institute of Architects, Inc.: 1924, 9). Chicago Architectural Sketch Club Collection, Ryerson and Burnham Archives, The Art Institute of Chicago. Digital File #casc.1924_009 © The Art Institute of Chicago: 166 right

Photography © Paul Warchol: 77 top, 78

© 2011 Frank Lloyd Wright Foundation, Scottsdale, Az./Artists Rights Society (ARS), NY: 166 left

Joel Sanders

Joel Sanders is the principal of the New York–based practice Joel Sanders Architect. He is an adjunct professor of architecture at Yale University and was the director of the graduate program in architecture at Parsons School of Design and an assistant professor at Princeton University. He is the editor of *Stud: Architectures of Masculinity* and his monograph, *Joel Sanders: Writings and Projects,* was published in 2005.

Sanders's projects have been featured in numerous international exhibitions, including "Figuration in Contemporary Design" at the Art Institute of Chicago, "Open House" at the Vitra Design Museum, "Glamour" at the San Francisco Museum of Modern Art, "New Hotels for Global Nomads" at the Cooper-Hewitt, National Design Museum, and "The Un-Private House" at New York's Museum of Modern Art. Among the awards he has received are six New York AIA Design Awards, two AIA New York State Awards of Excellence, and an *Interior Design* Magazine Best of Year Award.

Diana Balmori

Diana Balmori is the founding principal of Balmori Associates, a New York–based landscape and urban design studio. She is a member of the U.S. Commission of Fine Arts and holds a joint appointment with the Yale School of Architecture and the Yale School of Forestry and Environmental Studies. Balmori is also a senior fellow in Garden and Landscape Studies at Dumbarton Oaks in Washington, D.C.

She is the coauthor of *Redesigning the American Lawn: A Search for Environmental Harmony; Transitory Gardens, Uprooted Lives;* and *Land and Natural Development (LAND) Code: Guidelines for Sustainable Land Development. A Landscape Manifesto,* published in 2010, presents Balmori's theory and practice of urban landscape design.

Balmori's work has been featured in many in exhibitions, including "(Re)Designing Nature" at the Künstlerhaus in Vienna; "The Urban Living Room" at Come Se gallery in Rome; and "Figuration in Contemporary Design" at the Art Institute of Chicago. In 2005, Balmori was part of the team that realized "Robert Smithson: Floating Island to Travel Around Manhattan Island," organized by Minetta Brook and the Whitney Museum of American Art.